D0895300

POTLUCK SUPPER WITH MEETING TO FOLLOW

POTLUCK SUPPER
with
MEETING
to
FOLLOW

ANDY
STURDEVANT

Photos by Carrie Elizabeth Thompson

COFFEE HOUSE PRESS
MINNEAPOLIS 2013

Copyright ©2013 by Andy Sturdevant
Cover and book design by Andy Sturdevant and Linda Koutsky
Illustrations © Andy Sturdevant

Coffee House Press books are available to the trade through our primary distributor, Consortium Book Sales & Distribution, cbsd.com or (800) 283-3572. For personal orders, catalogs, or other information, write to: info@coffeehousepress.org.

Coffee House Press is a nonprofit literary publishing house. Support from private foundations, corporate giving programs, government programs, and generous individuals helps make the publication of our books possible. We gratefully acknowledge their support in detail in the back of this book. To you and our many readers around the world, we send our thanks for your continuing support.

Visit us at coffeehousepress.org.

LIBRARY OF CONGRESS CIP INFORMATION
Sturdevant, Andy.
[Essays, Selections]
Potluck supper with meeting to follow : essays / by Andy Sturdevant.
pages cm.
ISBN 978-1-56689-337-4 (pbk.)
I. Title.
PS3619.T857P68 2013
814'.6—dc23
2013003662
Printed in the U.S.A.
First edition | First printing

ACKNOWLEDGMENTS

This book is named *Potluck Supper with Meeting to Follow* for an agenda item in a Maoist newsletter published on the West Bank of Minneapolis in the seventies, reproduced on page 103. That agenda item seemed to me to summarize some critical aspect of collaborative creative work in the cities of the Upper Midwest, for Maoists and non-Maoists alike: sharing food and drinks, and then having a discussion to make sure everyone gets some input on all of the upcoming projects.

The works in this book came from all over the place, and I'd like to thank all of the editors, writers, and artists that had a hand in making them. I have shared some meals and had many meetings with all of them: Susannah Schouweiler at mnartists.org; Tiffany Hockin, Ariel Pate, and Troy Pieper at *Art Review and Preview!*; Michael Fallon at *Secrets of the City*; Julie Caniglia at the *Rake*; Darsie Alexander and Olga Viso at the Walker Art Center; Susan Albright, Joel Kramer, Corey Anderson, and Kaeti Hinck at *MinnPost*; James Norton at *Heavy Table*; Eric Lorberer at *Rain Taxi*; and Christina Schmid at *Quodlibetica*.

A big thanks to Anitra Budd, Caroline Casey, Linda Koutsky, and everyone at Coffee House, and of course Chris Fischbach, who imagined there might be a book in all these writings to begin with.

Additional gratitude is owed to Carrie Thompson, for her beautiful photographs. Gratitude also goes to Ben Heywood, Paula McCartney, Alec Soth, Chris Larson, Abby Robinson, Katie Hargrave, Jon Oulman, Mary Rothlisberger, Stuart Klipper, Peter McLarnan, Isa Gagarin, Frank Gaard, and Allan Mueller. Also to Mickey Hess, Molly Priesmeyer, Colin Kloecker, Shanai Matteson, Pierce Gleeson, Caitlin Warner, Joe Meno, everyone at Springboard for the Arts, Bill Lindeke, my Common Room associate Sergio Vucci, Peter Schilling, Jr., Mayor Mike Haeg and the people of Mt. Holly, Minnesota (pop. 4), Paul D. Dickinson at the Clown Lounge International Research Library, and the old Electric Arc Radio team: Geoff Herbach, Stephanie Wilbur Ash, Brady Bergeson, Sam Osterhout, Kurt Froehlich, David Salmela, and Jenny Adams. And of course, big thanks to Brad Zellar, a great Minneapolis writer who gave me forty dollars out of his own pocket at a party in 2006 so I could go make more copies of the zine I'd just given him.

A final thank you to my family and to my parents, Ann and Steve, for their support and love, and for their endless encouragement in drawing pictures of flags out of the Grolier *New Book of Knowledge*.

YOU'RE NOT NOWHERE!

An introduction to the area

TRADING POSSIBILITY FOR EXPERIENCE

A prologue, a travelogue, some formative experiences, and an education

REGULARS

A few artists and forty-three artworks

PUT UP DRYWALL, SEW, COOK, PLAY KEYBOARDS, MIX DRINKS, WRITE GRANTS

How to make it as an artist, using only Xerox machines, abandoned Taco Bells, pictures of Cretan antiquities, fluorescent copier paper, and trick sandwiches; also: how to kiss a curator

I LOVE *LOVE POWER*

On the road and in the streets: billboards, highways, murals, futuristic birdhouses, stadia, liquor store signage, and the legend of the United Crushers

CIRCLE ME, BERT, IT'S MY BIRTHDAY

Railyards, ballparks, and the neighborhood art supply shop

THE WRY MYTHOLOGY

Minneapolis explained:
by Mary McCarthy, Jorge Luis Borges, Studs Terkel, and others

At night over the prairie we see a splendid mirage, a vast territory arising around us, a village in the air, with hay-cocks like castles, mirrored in the sky with no division between real and unreal.

—A NINETEENTH-CENTURY MINNESOTA SETTLER,
quoted in Meridel Le Sueur's *North Star Country,* 1945

At first sight Minneapolis is so ugly. Parking lots like scabs. Most buildings are narrow, drab, dirty, flimsy, irregular in relationship to one another . . . a set of bad teeth. After a few days, one's eyes are opened to variations in prairie levels, which seem much less flat; one sees creeks and small trees; and even sees a beauty in the dark rackety buildings of Minneapolis.

—SINCLAIR LEWIS, AS QUOTED BY ROBERT KILBRIDE,
New Twin Citian Magazine, 1970

There is a richness to walk down familiar streets and know everyone. You have made an investment in that town. Your hometown is money in the bank.

—MINNEAPOLIS PAINTER FRANCES CRANMER GREENMAN, 1954

YOU'RE NOT NOWHERE!

An introduction to the area

·

The Artificial Heart: Visualizing the Midwest Vernacular

·

The Artificial Heart:
Visualizing the Midwest Vernacular

WHAT DO YOU KNOW ABOUT THIS MYTHICAL, so-called heartland, wellspring of America's strength, ingenuity, and goodness? If you know one thing about it for sure, you know this: it is flat.

That's the line you generally hear. *It's really flat. You can see for miles. The landscape goes on forever.* (One also hears, "It's empty," which is a no less important and very closely related point we'll touch on momentarily.) The flatness is what people refer to about the Midwest when they drive through from the East, or the South, or the West—from the mountain ranges, or the towering, ancient forests, or the canyons or the cliffs, or the lolling bluegrass hills. Nearly everywhere else in America, the landscape is defined in terms of its verticality. *Purple mountain majesties, above the fruited plain.* See: the fruited plains are defined in their relation to the purple mountain majesties. There's an x axis (plains), and a y axis (mountains majesty). Not so in the Midwest, goes the story: it's all x axis.

Of course, that's not entirely true. When the Wisconsin Glacial Episode ended ten thousand years ago, it left wide swaths of pancake-flat prairie from the Dakotas all the way to northern Ohio. However, it also carved out the bluffs along the Upper Mississippi, the badlands of South Dakota, the Great Lakes themselves. I mentioned this notion of the Midwest's utter flatness to an artist I know who grew up in Winona, Minnesota. Winona rests in the scenic bluff country that runs along the river through the southeastern part of the state, known for limestone peaks and the towering rock formation known locally as "Sugar Loaf." My friend scoffed and waved his hand. "Winona," he said with great disdain, "is not flat."

Of course it's not, no more than it's empty. But it's the flatness that most people experience, and then tell you about when you meet them and mention you're from one of those mysterious, blocky states between the Great Lakes and the Rockies. This flatness is easily conflated with emptiness. Perhaps this is merely a result of the way the interstates are laid out; as writer Michael Martone has noted, they "skim along a grade of least resistance,"[1] bypassing any elevation or charm for grim, straightforward, midcentury efficiency. A trip through the region on the interstate gives the impression of a headlong automotive sprint through a vast, empty space, barely populated except for billboards, grain silos, and garish come-ons for gas, food, or shelter (more on those later). Or perhaps it's the way the region appears from an airplane, all tidy blocks of land, parceled out endlessly in squares, interrupted only very occasionally by a river

or highway. Basically, anyway you travel through, over, or past it, you have the impression of a vacuum all around you.

Again, my friend the artist from Winona, or I, or anyone else who lives and works here would scoff and wave our hands at that idea as well. Of course it's not a vacuum. Of course it's not empty. *We* live here, after all.

On the other hand, it's hard to dismiss this interpretation outright. Over the course of the past few hundred years, the land *has* been thought of as empty by almost everyone who has passed through it. A space, waiting to be filled.

And what is this empty space filled with? What do you envision? A short list: roadside attractions, summer resorts, rock gardens. Native American burial grounds, caves, mom-and-pop diners. Barns with tobacco advertisements painted on the side, motor lodges proclaiming air conditioners and color television, historic battlegrounds with solemn, bas-relief markers. An oddball amalgamation of timber, faux-leather buckskin, stones, garish paint, fiberglass, vinyl, varnish, concrete, neon lights, and ambiguously ethnic decorative patterns, coexisting in a kaleidoscopic crush of color, texture, and origin that seems a little bit familiar to anyone and a little bit otherworldly to everyone. It seems alternately disposable, modern, seedy, wholesome, and improvised, a strong, overstated reaction to the flatness and barrenness surrounding it. This is the visual language of the American vernacular, the hybrid style that filled the vacuum in the middle of the continent and eventually became shorthand for the whole place. "Americana," right?

Empty is how the people who made the decision to come live here originally thought of it. That mythical idea of the West, where you begin again from scratch, where you build a house, a farm, a town, a region, using only the best elements of what you know from back home, while jettisoning the parts you didn't like—the repression, the poverty, the crowds—and build a new life wherever you've ended up. There's this insistent idea, too, that any attendant culture could be started again. There's no tradition, no heritage—or, at least, not in the same way a European would recognize those concepts. Or, actually, even in the way a Southerner or New Englander would recognize them. Those parts of America are filled with reminders of events long-since past, solemnly preserved and paid constant lip service to.

It's not hard to imagine that's one of the reasons people came to the empty and flat expanses of the middle of the continent in the first place, especially from the East—to get away from all of that goddamn history. For example, plug the phrase "old, Boston MA" into Google Maps. The screen you see subsequently depicts a metropolitan area that seems to be suffering from a severe outbreak of acne. Little red dots highlight the various "old" points of interest: the Old North Church, Old South Church, Old South Meeting House, Old State House, Old

Saint Stephen's Church, Old Harbor, Old Colony Avenue, old building this, old road that. Walking around in a colonial city like Boston or Philadelphia or Charleston, the weight of history constantly crushes down around you.

Not so in the Midwest. Whatever "heritage" there may be is handmade from the ground up. It's heritage based not upon longevity and lineage, but instead on sheer force of will: disposable, modern, seedy, wholesome, and improvised. These parts were assembled by a heterogeneous cast of characters, from all over, with wildly different ideas and intentions. This particular strain of Americana is utterly democratic, taking visual cues from anywhere, paying homage to any idea that may seem important at any given moment. A friend recently found himself in a small crossroads village in the Dakotas. Near his motel he found a town square-cum-municipal park decorated with a painted World War II tank, some dinosaur bones, and a statue of an Indian with a dog. The utter sincerity and utterly un-self-conscious strangeness of their arrangement together speaks more honestly about the lives, values and aspirations of the people who live than a forest of neoclassical marble columns would.

With a few critical exceptions, no one has been in the Midwest for all that long. Certainly not in the geologic or historical senses, and not really even in terms of the four-centuries-long lifespan of the American nation. You meet few people in the Midwest who can claim a lineage in this area stretching back past their great-grandparents. Most people, when asked, will give you a variation on the narrative that has defined the region in the popular imagination for several generations—"My parents came here from New York," they'll say. Or: "My grandparents came up from Illinois, where their parents had settled after leaving Ohio." Always in prepositional phrases—*up* from Tennessee, *across* from Pennsylvania, *over* from New England. Or even farther out. "My great-grandfather was from Finland and came here for a mining job on the Iron Range." "Babcia came from Poland." "My dĕdeček came from Bohemia." Even the old money, the families whose names one finds attached to homegrown multinational corporations and arterial city streets, were canny, opportunistic eastern corporate marauders, arriving only a few generations ago. I, like many of my peers, personally have no claim on my adopted hometown, Minneapolis. No claim, that is, other than the fact that I've lived here just long enough to gesture to certain sites from bus windows and be able to say, "That's the gallery where I met my friend Geoff a few winters ago." Looking at my own family's trajectory, most of the arrows one might draw on a map to mark progression would go left to right, from here back to Kentucky, then Ohio, then up into Pennsylvania and New York state and then at some point back across the ocean to provincial towns in England and Scotland and Holland, and back into that misty, unknowable era of buckled Pilgrim shoes.

As Jonathan Raban suggests in *Bad Land,* his account of driving through the Dakotas and Montana, to travel east in America is traveling backwards through time.[2] The forward momentum is always westward; to travel west is to travel forward in time. One even sees a variation of this idea of time and distance on a micro level, in the urban centers of the Midwest. You start by the lake or the river on which the city was founded, near the oldest buildings, the warehouses and churches and mills and social halls. You then travel through time outward, until you splat against the modernist blandishments of the first-ring suburbs or the sixties, whichever comes first. I am certain one could break this down into a driving game with a measurement-based mathematic formula of some kind—once you've passed the Alleghenies or Cumberland Gap, you add, say, five years for every mile westward you go starting at 1800, accelerating until you've hit the Continental Divide or the fifties. Whichever comes first.

The only people who could claim any long-term relationship to this land are Natives—the Dakota, the Ojibwa, the Creek, and a hundred others who set up hunting and settlement cycles sometime in the fifth century and thrived until they were pushed out and eliminated by a succession of white Manifest Destiny–crazed colonists and invaders. Before the conquest was even complete, they were blithely absorbed into the popular imagination, "a proud yet primitive people finally giving way to a more accomplished society foredestined to supplant them," as cultural historian Michael Kammen explains it.[3] Henry Wadsworth Longfellow's massively popular 1855 poem *Song of Hiawatha,* set in this mythical midwestern neverland, had already consigned the Plains Indian to dreamy historical myth, even decades before Little Big Horn and Wounded Knee. As the *New York Times* wrote of the poem at the time, it embalmed "the monstrous traditions of an uninteresting, and, one may almost say, a justly exterminated race."[4] The Midwest was empty, perhaps, because it was consciously emptied.

The names given to these empty spaces mirror the confused, improvisatory jumble of the manmade landscape. They're cribbed from everywhere—French mispronunciations of Indian words, legitimizing Latinate and Greek fragments mashed together, references to religion, the landscape, history, or to other cities entirely. Chicago, Minneapolis, Milwaukee: Wild Onion, City of Water, Good/Pleasant/Beautiful Land. St. Louis, St. Paul, St. Charles, St. Cloud. Omaha, Peoria, Waukegan, Fargo. Madison, Lincoln, Jefferson City. Des Moines, Detroit, Champaign, Fond du Lac. Green Bay, Grand Rapids, Grand Forks, Little Falls, Garden City, Platte City. Some flourish overnight, some dry up and disappear. Some die choking, undignified deaths. Millions and millions of people, spread across thousands of miles of open space, and unless they're Native, nearly no one there for significantly longer than anyone else.

ANDY STURDEVANT

That's why I've always found the idea of "the heartland" as a metaphorical flourish so odd and inappropriate for the Midwest. The heart is the center of the body physically, just as the plains of the Midwest are the geographic center of the country. But think of driving through the exurban interstate corridors in the region's right-wing strongholds and coming across those antiabortion billboards that picture a gurgling baby proclaiming, "My heart was beating at three weeks!" The heart metaphor in "heartland" is getting mixed here, since the heart is also among the earliest organs to develop. The rest of the body grows out from the heart. How could someplace as recently populated and as hastily improvised as the Midwest be the heart of a country at least a century or two older than it is? If the Midwest *is* the heart of this land, it's an artificial heart, one that's cobbled together from the parts that were lying around.

That very self-conscious, deliberate manufacturing of heritage creates a certain compression of nostalgia. Oftentimes, especially here in the urban parts of Minnesota, you'll hear people talk about the "old Minneapolis," or the "old St. Paul"; they're talking about things that aren't more than forty years old, which almost anywhere east of here is a millisecond, the snap of a finger. They're not delusional. The Minneapolis or St. Paul they knew *is* in fact gone, paved over or demolished to make way for something else. The next time you're on a Minneapolis junket, find an artist older than forty-five and ask him or her about, say, Rifle Sport Gallery or the New French Café. The painful story you'll hear subsequently happened just twenty short years ago, but it will be told in such a way that it sounds like it might have happened in a Jacques-Louis David painting. It's not just Minneapolis, of course. Go to Fargo and ask someone about Ralph's Corner Bar. Or Madison and ask about Manchester's. Or Milwaukee and ask about the Schlitz Brewery. Or . . .

Maybe, come to think of it, the heart isn't a bad metaphor for this place after all. The heart pumps away, billions of times in a lifetime, and new blood rushes through it, replenishing itself every few minutes. So it goes here. An endless, reflexive cycle of renewal, the substantive oxygen-carrying matter replenishing itself every few decades. One has to grab whatever might seem like *heritage* and hold on to it so that it's not carried away in the next cycle. Driving through the still-empty expanses of the heartland and coming across the crumbling remains of lakeside resorts, railroad towns, motor lodges, and farming homesteads, only a generation or two removed from use, one realizes how swift and merciless this process can be.

One does not associate the Midwest with acts of spontaneous creation in the twenty-first century. It is a closed frontier, a punch line about the wasteland that ambitious kids flee from, away to the excitement and opportunity of the coasts. It is a region that, depending on whom you speak to, has permanently

plateaued, or is actively now in bad decline. A laundry list of midwestern dysfunction and decay would include the broken, internally crumbling cities of the Rust Belt, the desiccated and foreclosed farmsteads of the Plains states, or the sprawling exurbs and interstate off-ramps filled with interchangeable fast food restaurants and big box stores that have killed off the mythical mom-and-pop Main Streets.

That said, I sense I am slipping here into mythmaking and idealization, just the sort that I suspect people came to the Midwest to escape. The prairie is not a sentimental place. There is certainly room for regret—and one cannot travel through these cities or farmsteads without feeling it—but largely, the vernacular landscape is a testament to constant improvisation and a compulsive need to renew and reinvent. The past is not necessarily something to preserve wholesale, but something to strip down for parts. The inherent problem with such an improvisatory landscape is that once you begin anew, it's hard to not keep beginning anew over and over, until you've done it so many times you've lost sight of the things that might give that landscape substance.

The last time I was in Fargo, it happened to be the fifth anniversary of the demolition of the aforementioned Ralph's Corner Bar. Ralph's and its green-and-red buzzing neon "OFF/ON" sign was an old-man forties dive bar across the river in Moorhead, Minnesota. It boasted, apparently, the finest jukebox between Seattle and Minneapolis, and was the only real stop for any touring band that was traveling along that old Empire Builder route between the West and East. The weekend I was in town, it just so happened that there was a two-night concert memorializing the bar's demise, held at a venue just a mile or so from the old site. Most of the attendees were roughly my age, but it sounded like they were talking about events that had transpired back in the territorial days. Perhaps this is simply aging hipster nostalgia, but I think it's something more complex. For example, some kid hanging around the bar had on one of those ubiquitous CBGB t-shirts, and I was struck by how strangely contemporary and timeless that equally defunct punk rock venue seems, particularly when compared to Ralph's. CBGB was also destroyed to make way for new developments, but it also seems less absent, more of an eerie, malingering presence. It only feigns death, living on through merchandise and branding. Ralph's doesn't impart that sense—Ralph's isn't coming back, in any form. It's a memory, treasured by a few thousand North Dakotans and Minnesotans. Ralph's and its sputtering neon sign—the kind one could easily imagine appearing in any number of dry transfer color photographs of similar old-man-bar marquees anywhere between Bismarck, North Dakota, and Bloomington, Illinois, at any point in the last seventy-five years—never fell into decay, because it was not allowed to decay. Instead, it vanished almost overnight, leaving only a vague sense of collective guilt at the cruelty and violence

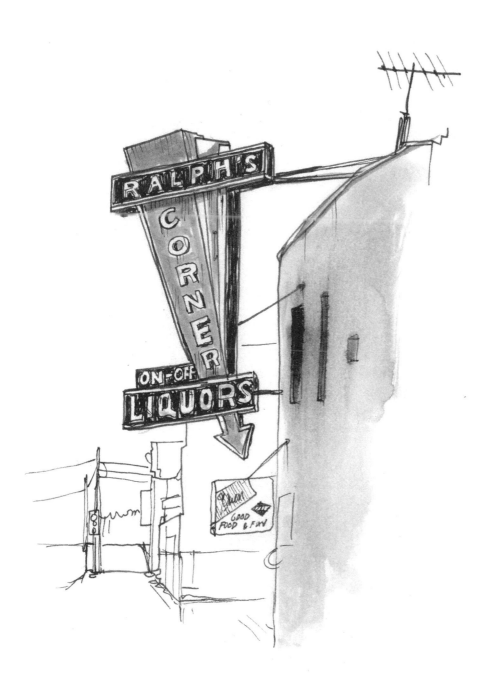

of these endless cycles. The Carnegie libraries of the Midwest—those still standing—are full of picture books teeming with grainy, historic black-and-white photographs of whole city blocks that were built, lived in, used up, and then taken down again, all generations before you were born.

There is a kind of antipreservation at work in the visual elements that *are* left behind: the decaying bar signs, tourist camps, timber lodges, no-tell motels, barn sides, fiberglass teepees, and hand-painted billboards that dot the midwestern landscape, in the rural and urban parts. There is a kind of dignity in the fact that they were permitted to remain at all, that they weren't flattened as soon as they outlived whatever usefulness they might have been assigned at the time of their creation by the people that envisioned them. Writer Brad Zellar notes: "What these things usually say to me are 'This is who we are!' Or 'This is who we were!' Or 'This is who we'd very much like to be!'" The fluidity between those categories is significant; in fact, to this list I might even add a poignant, "This is who we would have liked to have been!" So much of this past, as close to the surface as it is, is both genuinely celebrated and willfully obscured, to the point where one begins to forget what is worth preserving and what is disposable. It keeps changing. The landscape is filled, and emptied, and filled again, over and over and over.

Zellar continues: "Their other primary function, it always occurs to me, is that they are proclamations to the effect of 'Believe it or not, you're not Nowhere!'" Indeed you are not, because this heartland and the scatterings of people strewn across its flat and endless expanses have been actively, painstakingly creating a Somewhere as long as they have been here. They keep creating and re-creating Somewhere, too. If we are lucky, we can catch glimpses of the raucous, ramshackle, and glorious-in-spite-of-itself artifacts they leave behind, before it is all torn down and made into a distantly familiar but still-new Somewhere once again.

ENDNOTES

[1] Michael Martone, "The Flatness," in *The Flatness and Other Landscapes* (Athens: University of Georgia Press, 2003), 1.

[2] Jonathan Raban, *Bad Land: An American Romance* (New York: Knopf Doubleday Publishing Group, 1997)

[3] Michael Kammen, *Mystic Chords of Memory: The Transformation of Tradition in American Culture* (New York: Vintage Books, 1993), 85.

[4] Anonymous, "Longfellow's Poem," review of *The Song of Hiawatha*, by Henry Wadsworth Longfellow, *New York Times*, December 28, 1855, 2.

TRADING POSSIBILITY FOR EXPERIENCE

A prologue, a travelogue,
some formative experiences,
and an education

•

"Don't you think it's extremely arrogant to presume that because
I enjoy the music of Wayne County & the Electric Chairs I am
somehow obligated to share your worldview?"

•

That Sense of Possibility

•

The Fat Tears of Governor Paul Patton

•

Airport Shoeshine: Point-Counterpoint

•

At Matt's Bar, in a Blizzard

•

"Don't you think it's extremely arrogant to presume that because I enjoy the music of Wayne County & the Electric Chairs I am somehow obligated to share your worldview?"

THERE IS A PHOTO MY FRIEND ANDREW TOOK a few years ago, during one of my trips back to my hometown, Louisville. It's me and my brother Nate, standing inside a Buffalo Wild Wings on Bardstown Road.

The Buffalo Wild Wings is located inside the shell of an old theater that once housed the Bardstown Road Youth Community Center, or the BRYCC House. The BRYCC House was an all-ages venue in which I and Nate and our noisy post-adolescent rock band played about two dozen shows between 2000 and 2002, alongside many other noisy postadolescent rock bands with names like Lowercase O, Ayin, the Blue Goat War, Grand Prix, the Pointy Kitties (the early 2000s were a golden age for bands named for obscure *Simpsons* references), Monorail (see?), and Totally Ointment.

The BRYCC House closed sometime in 2004. After that, it became a carpet warehouse. Then it became a Buffalo Wild Wings.

Nate and I are pictured in the photo gazing wistfully at the shattered remains of our youth. The shattered remains of our youth have been slathered with Spicy Garlic, Asian Zing, Caribbean Jerk, and Mango Habanero–flavored barbecue sauce, served in a fast casual dining atmosphere. Nate and Andrew and I had been walking down Bardstown Road one weekday afternoon, passed the Buffalo Wild Wings, and realized we'd never been inside post-BRYCC. We stepped inside to see how it looked.

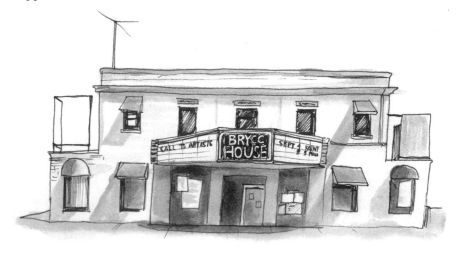

The interior of the building looked very much the same as it used to, except with flat-screen televisions and neon signs for popular American and Dutch beers on the walls. There was a jukebox, so we thought we ought to punch in a few appropriate numbers as a sad elegy while we creepily hung around and refused to be seated. It was a slow afternoon, so the waitstaff didn't seem to care if we hung around not ordering beer or wings. For some reason, there were no selections on the jukebox by Sleater-Kinney, the Raincoats, Gene Defcon, or Richard Hell & the Voidoids. Instead we played a few songs from the first Strokes record, which seemed to be most appropriate in terms of the spirit of the era.

Did Nate and I look out of place in the photo? We looked out of place. We both had exaggerated grimaces on our faces.

I believe it was Glenn Danzig that was once described by Henry Rollins as being "one of those men who reach such an acute limited excellence at twenty-one that everything afterward savours of anticlimax." I rarely feel that way myself, but when I do, I am reminded of the fact that anything important to you at the age of twenty-one will eventually be turned into a Buffalo Wild Wings. We waited for the song to end, and then we walked back outside, into the sunlight, and headed toward a neighborhood bar that had not existed the last time I'd lived in the neighborhood.

These are all thoughts I typed up and then put on the Internet, with the photo of me and Nate. People clicked "like," my trip to Louisville ended, and I returned to Minneapolis. I forgot all about it until a few days later, when I received the following e-mail. Coincidentally, it came from Minneapolis, not Louisville.

Dear Mr. Sturdevant,

We were glad to see you'd mentioned Buffalo Wild Wings on social media today. We're very proud of our Highlands / Bardstown Road location in Louisville, and I was a little disappointed to see you dismiss us so quickly (and particularly without trying any of our signature dishes or enjoying a beer). It's true, B-Dubs is not the same as an all-ages punk rock venue, but it is a fun, edgy, high-energy, and easygoing restaurant—much like the personalities of our guests. Andy, I don't believe there is so much distance between the venue you once rocked out at, and the relaxed, comfortable atmosphere where people hang out with their friends, play trivia on our Buzztime Trivia System, and watch their favorite games on one of our many big-screen TVs. I think, in a small way, we're making a difference in people's lives, and giving them an outlet for fun and camaraderie, as I am sure you were trying to do in the very same space a decade ago with your music. I'd invite you to come back to our Highlands location next time you're in Louisville and give us a fair shot. Print out this e-mail and we'll treat you to six hand-spun wings with the sauce of your choice, totally on the

house. I'll try to see if we can get some Richard Hell on the jukebox, but I can't make any promises there (and anyway, I am more of a Wayne County & the Electric Chairs sort of guy myself).

Regards,

[redacted]

Senior Associate Director, Marketing and Brand Communications

Buffalo Wild Wings

I was at first baffled, then slightly horrified at having received a personal e-mail from someone at Buffalo Wild Wings, and then a little bit irritated at his condescending tone. A Buffalo Wild Wings is the spiritual equivalent of an all-ages punk venue? Ridiculous. Insulting! Later that day, I sent him a reply.

Dear [redacted],

I appreciate your e-mail, and I will certainly consider taking you up on your kind offer of the free wings, but I really do think you're a little off-base here. BWW is probably a great place where many people love to hang out, but I think you're nuts to suggest it's the equivalent of the BRYCC House (and come on, if you're namedropping Wayne County & the Electric Chairs like it's no big deal, I feel like you should understand that on some level). The BRYCC House was a community-led, not-for-profit initiative that featured very young artists and musicians that would have been unlikely to find a comfortable niche for their work anywhere else, and especially in the sort of chain establishments BWW represents. "Fun and camaraderie" certainly do enter into the equation somewhere, but the circumstances under which those qualities are enjoyed differ greatly between the BRYCC and BWW. I'm not saying BWW is a bad place or that I wish it didn't exist. But I do think, all things considered, that the BRYCC was better for the neighborhood, and with all due respect to your organization, I wish it was still there.

Best,

Andy

I received this e-mail the following day.

Dear Andy,

Don't you think it's extremely arrogant to presume that because I enjoy the music of Wayne County & the Electric Chairs I am somehow obligated to share your worldview? Moreover, don't you think it's similarly arrogant to assume that a community of young musicians and artists is somehow inherently superior to the community of patrons we serve at our restaurants? Do you know anybody that regularly patronizes a BWW? You said yourself you didn't try a drink or even have a seat while you visited. I can tell you, from our demographic studies,

that the folks that hang out at the BWW on Bardstown Road are not suburban-
ites or conventioneers or tourists—they're people that, for the most part, live
in the same area code. Many of them work in businesses in the Highlands
neighborhood. They're locals.

Why did none of these people, I wonder, come to the shows your band
played at the BRYCC House while it was open? Could it be because they felt
excluded? Not "cool" enough to join in? I don't live in Louisville, unfortunately,
so I don't know what the old BRYCC House was like. But coincidentally, you and
I do live in the same metropolitan area. Digging around a bit, I see you often
host artistic and literary events around Minneapolis. Would a guy like me, or the
types of guys that hang out at the BWW in Dinkytown, near the University of
Minnesota, be welcome to attend those? Or would they feel excluded? I think
it's reasonable to say you'd feel more welcome at a BWW than one of our regu-
lars would be at one of your art openings.

Moreover, I found the MySpace page for your old band, and listened to some
of the tracks. Cool stuff, and I sincerely enjoyed it—but certainly not world-
shattering. It sounds like a lot of bands sounded in 2001. Some Kinks, some
MC5, some Kill Rock Stars. I don't understand how this sort of work makes your
presence in that space more important than ours, though. This will sound harsh,
but I mean it in the most critically constructive way: could it be because your
work in that band just wasn't good enough to exist outside the context of the
BRYCC House? Doesn't it presume a certain amount of privilege to assume your
work is more valid than ours, just because fewer people consumed it?

I should point out I am not some free-market fanatic that is going to go all
"let the market decide" on you—there is certainly a place for nonprofits that fea-
ture challenging and adventurous art in the cultural ecosystem of any com-
munity. But I don't think it's fair to say these venues or organizations, or the
people that frequent them, are in someway superior to the individuals that like
watching sports on flat-screen TVs and eating Spicy Garlic–flavored buffalo
wings at our restaurants. I feel like you should understand that on some level.

Regards,

[redacted]

Senior Associate Director, Marketing and Brand Communications

Buffalo Wild Wings

I had a sinking feeling that he was right, so I didn't respond. Later, I found
out he was featured on the cover of an industry magazine spotlighting his
innovations in direct e-mail marketing techniques.

After that, I heard he quit BWW to devote more time to writing fanzines and
playing drums in a noise rock band.

ANDY STURDEVANT

That Sense of Possibility

I MOVED TO MINNEAPOLIS in February 2005, but I had made the decision to leave Louisville for an as-yet-to-be-determined American or Canadian city about a year and a half earlier. My original plan was to be gone by the time I turned twenty-five, a mark I ended up missing by about two months. In late 2003, I had one more semester of school left, and was on track to graduate from the University of Louisville with a BFA in painting in May 2004. I was twenty-four years old, and turning twenty-five seemed like it was going to be a really big deal. If I were going to make some major change in my life, I thought, that was the time to do it.

This is not to say I didn't find worthwhile things to keep me occupied in Louisville. In the months prior to and following graduation, I was singing in a charmingly ramshackle trash rock band that later traveled to the UK to open for Slint. I shared a cooperative gallery/studio space with a collective of Howard Finster and Big Daddy Roth acolytes near a pork rendering plant on the outskirts of downtown—the neighborhood always smelled like bacon, and at night you could actually hear the hogs screaming as they were slaughtered. I worked in a mom-and-pop art supply store that had employed me since I was nineteen. Here I learned a battery of skills that have been endlessly useful to me in my own work over the years, such as hand-lettering block type and script, and negotiating with angry, temperamental artists.

All the things I was doing were interesting to me, but it felt like I'd accomplished most of what I'd wanted to do in my hometown (this is the sort of absurdly grandiose thinking only a twenty-three-year-old is capable of). I had a good reputation; my old roommate Joel Javier and I were voted #2 and #3 visual artists in town by the local alt-weekly around this time, a fact we found endlessly amusing because we'd made all of our friends write us in. My friend Katie Beach and I had a successful two-person show at one of the local colleges. It was a fairly productive period. These things all sound very romantic to me now. The hog rendering plant, the mom-and-pop store, the ramshackle band with tenuous connections to Slint, the Howard Finsterites painting mountain scenes on wooden planks. This was all great postundergraduate fun, but I was feeling restless.

In the early 2000s, and probably still today, the obvious choices for Louisville natives looking to relocate were Chicago or Portland. You can very easily divide the expat community into Chicagoans (a lot of local bands had connections to labels like Thrill Jockey and Touch and Go), or Portlanders (who'd followed

a similar ex-Louisville rock band diaspora west). I certainly considered Chicago very strongly, but something about it didn't quite feel right. It seemed too easy. I suppose, after living in Louisville most of my life, and not having done much traveling during college, I wanted a challenge, something closer to what's usually called a "project."

I decided, after some deliberation, to move somewhere that loosely fit five criteria: (1) A million or more people lived there. (2) It was in that blue part of the country attached to Canada on all of those hotheaded "United States of Canada/Jesusland" diagrams making the rounds after the 2004 election. In its aftermath, I remember looking at that large swath of red that covered Kentucky and all the adjacent states, and wanting to get out. (3) It had a major art institution the majority of knowledgeable people considered important. (4) It was geographically isolated. (5) I didn't know anyone there.

Before 2005, I knew nothing about Minneapolis. Not even about obvious things, like the Twins—all the baseball teams I followed were in the National League Central Division. I had never even visited, though I'd known people over the years who had lived there (a prickly MCAD alum I'd worked with at the art store; the ex-girlfriend of an acquaintance who'd studied at Carleton). I had a vague sense that it had a good civic reputation. I don't remember a single moment where I thought, "All right, I've decided, it's Minneapolis, let's do it." All the other options just slipped away one by one—San Francisco seemed too expensive, Austin too lackadaisical, Seattle too granola, Detroit too gritty, New York too intimidating, Toronto and Montreal too complicated—until Minneapolis seemed like the only viable choice left. It was a left-wing enclave with a Walker Art Center and a major-league baseball team, located about as close to Canada as you could get without needing dual citizenship. The Replacements lived there. There was no safety net, either: no acquaintances to fall back on for social support, no easy weekend getaways to more familiar regions available. Minneapolis is at least a six-hour drive from anything.

Here is an excerpt from a short story by a writer and former Louisvillian named Mickey Hess, written in 2007 after he came to Minneapolis on a book tour and stayed with me. It may shed some light on this subject. I made him change my last name in the story to "Schondelmeyer" because, in it, I fall asleep at a bar, and later, I accidentally break the toilet in my apartment. I was afraid this information would turn up in Google searches for my name, and it didn't seem like the sort of thing I wanted potential girlfriends and future employers to know about me, even if it was all true and I *did* fall asleep in a bar and break my toilet while he was in town.

Andy Schondelmeyer has a moustache that makes him look like he comes from an Old West photograph. He often wears scarves.

I met Andy Schondelmeyer when we both lived in Kentucky, before he moved to Minneapolis for what he called no reason at all.

"Do you have friends there?"

"No."

"Is it for school or a job or something?"

"No."

I think, secretly, that Andy's love of scarves is the reason he moved to the colder climate of Minneapolis.

Scarves. That sounds as plausible as anything.

Here is the thing about this story: it has nothing to do with why I decided to stay in Minneapolis once I'd arrived. The story of why I remain in Minneapolis is actually a much different one. It's best summarized in an e-mail discussion I got into with a friend from New Orleans, on the eve of the overtime Vikings–Saints playoff game in 2009, at the end of that bizarre season with Brett Favre as quarterback. My friend dismissed the Vikings as a "mercenary and geriatric team," devoid of the genuine symbolism that made the Saints appealing. Nonsense, I told him. There was some great symbolism in the Brett Favre story.

Minneapolis is different from St. Paul, or Duluth, or the Dakotas, or Wisconsin, or anywhere else in the Upper Midwest in one critical way: it is a city of what you might call *mercenaries*. It is a place people come to from elsewhere with the intention of trying out another geographic option, and it works for them, so they have remained.

In day-to-day experiences in Minneapolis, I'd find in the coming years, I met lots of native Minnesotans, but didn't meet a lot of native Minneapolitans who were around my age. I met a lot of what are called *transplants*. St. Paul, the older of the Twin Cities, is full of people that grew up in St. Paul and know the neighborhoods and parishes, but not so much with Minneapolis proper. Even people from old Minneapolis families tended to grow up in suburbs, far from the street corners their grandparents might have played on as kids. Sure, I'd meet a few Minneapolis city kids who grew up riding the bus around the southside or northside and whose parents grew up near their own childhood homes. But not most of them.

More often, I'd meet people like Brett Favre. Not literally like Brett Favre, in the sense that they were forty-year-old football players, but that they were people who loved Wisconsin but couldn't find a way to make it work there, took off for New York, crashed and burned, and then found a home for themselves here in the City of Lakes. Minneapolis is where the drama queens and burnouts and weirdos and misfits of the rural and suburban Upper Midwest wind up. It's a city full of people who, though they'd never say it, secretly suspect they don't belong here, that they're not *Minneapolis* enough, because they

didn't go to a city high school, or because they didn't hang out at First Avenue when they were teenagers, or because they came from the suburbs, or from outstate. They came from the Iron Range or Fargo–Moorhead or Blooming-ton or White Bear Lake or Collegeville, or from Chicago or California or the Pacific Northwest or Mexico or Somalia. Wherever they came from, Minneapolis is their home now, and it belongs to them. It belongs to us.

It was on February 3, 2005, that I first arrived in Minneapolis, not knowing any of these things but with the intention of joining the ranks of these transplants. Who moves to Minneapolis in February, the worst month of them all? Planning is not always a strong point for me. I didn't plan to fall asleep in that bar or break my toilet when Mickey was visiting, either.

My friend Dave helped me load a U-Haul trailer hitched to my old Mercury Tracer wagon on the morning of February 1, and I arrived in Minneapolis two days later, just in time for rush hour. We unloaded all my personal effects into a pile in the living room of my new apartment. There was two feet of snow on the ground. A neighbor wandered over to say hi, and told us not to worry, spring was coming, and when it came, there would be a big parade in the park. Maybe this is why I've never believed the cliché about Minnesotans being a standoffish people, because in those first few days, people seemed to walk up to me all the time, all of them bearing strange facts about my new home.

Dave and I leafed through a copy of the *City Pages* from a nearby news-paper box to find the closest bar for dinner. It happened to be Matt's, a few blocks away, where we each had a Grain Belt beer and a Jucy Lucy, a type of cheeseburger native to south Minneapolis with molten cheese cooked into the middle of the patty. We announced to everyone in the bar that I'd just arrived in town, and asked where we should eat the next day. A woman one table over told us that the only good Italian restaurants were in St. Paul, and we should eat at Mancini's. But Dave and I both liked Matt's so much we went back the next morning for breakfast. The waitresses from the night before were working in the morning, and they all found our Jucy Lucy doubleheader very amusing.

Dave took a plane back to Louisville the next day. After that, it was just me. I was alone in the city and had nothing in particular I needed to be doing. I had nowhere to be. I had no job. I didn't know anybody. I'd saved up enough money to put off having to find a job for a month or two.

The dreams are what I miss most about those first two months, oddly. I didn't know how to find my way around, besides the most basic notions of where my house was located. At night, my unconscious would fill in the con-siderable gaps and I would dream of mountains and hills and tunnels and

ANDY STURDEVANT

winding streets and scenic overlooks—clearly a dream, since there are no hills or mountains in Minneapolis. I dreamed of alleys that turned into bridges, and skyways that led to the innermost parts of the Cathedral of St. Paul. I'd sometimes drive around in those first two months and be struck with a flash of familiarity, and try to remember where I could find that hill with the beautiful view of the Basillica. Then I'd remember there was no such hill; it had been a dream. I couldn't remember if cavernous, bustling Italian restaurants I'd heard recommendations about were in St. Paul, or in a dream. The boundaries between my waking life and dream life seemed much blurrier in those first few months than they'd been before or have been since.

Eventually, of course, I filled in the gaps. When you move somewhere, you slowly trade possibility for experience. The experiences match the possibilities, or fail to meet them, or exceed them altogether. My experiences in Minneapolis in the intervening years have, in their own modest ways, been as surprising and wonderful as those early dreamscapes. The greatest gift that the city has given me is that it has *never* lost that sense of possibility. I mean, it was years before I finally made it to Mancini's.

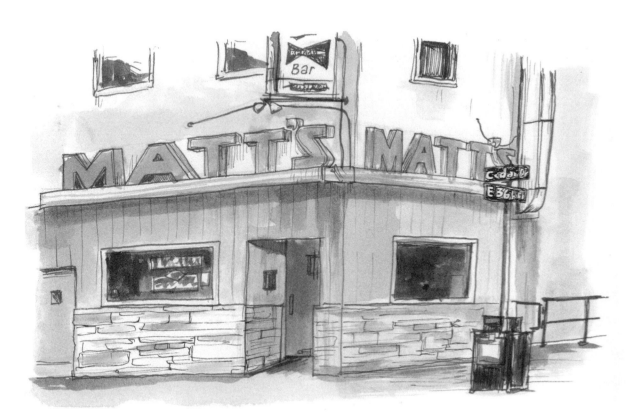

The Fat Tears of Governor Paul Patton

ONE SATURDAY AFTERNOON, on a visit back home to Louisville, my brother Danny lent me his bicycle so I could get around town while he was at work. I took a few hours to bicycle around the coffee shops and bookstores of the Highlands, where I lived in my early twenties.

Somewhere along the way, I passed a bank, located next to a tattoo parlor. The bank had a cornerstone announcing that the building had been erected during the gubernatorial administration of one Paul Patton. I hadn't thought about Paul Patton for many years, but his name, in proximity to the tattoo parlor, reminded me of a story.

On September 20, 2002, Kentucky Governor Paul Patton held a press conference where he admitted to an extramarital affair with a nursing home operator he was alleged to have bestowed with political favors. He had spent the past several weeks denying the affair after the *Louisville Courier-Journal* broke the story, but decided to finally came clean. He did so in a manner befitting the hammy, overwrought quality of politics in the South: with big, fat tears streaming down his face. The next day, the *Courier-Journal* ran a half-page, full-color photograph by Associated Press photographer Ed Reinke on the front page of Governor Patton's tear-streaked visage.

The next morning, I saw the photograph in the morning papers that were lying around the University common areas. I immediately thought what any heartless twenty-two-year-old painter would think: *wow, this would make a great painting.*

Working fast in order to keep up with breaking events, I stretched a 4'x4' canvas, gridded the drawing on top of it, then dry-brushed on a bunch of cadmium reds and yellows and zinc whites until I had a messy, meaty sub–Francis Bacon portrait of the governor's tear-drenched face completed. A pre–Shepard Fairey sidenote here: at no point did it occur to me to credit Ed Reinke, or even significantly alter the image, though I used his exact cropping in the finished piece. I don't know what *you* were learning in art school in the early 2000s, but I sure never heard a word about copyright and fair use until my schooling was well over. Maybe they teach that stuff now.

I carried the enormous painting from my apartment on Gaulbert Avenue to my school's art studio on foot. Along the way, cars stopped on the street to honk and people shouted their approval at me. It felt great, though also somewhat disconcerting, as I wasn't sure what, precisely, these passersby were approving. Presumably they just generally approved of political blood sport.

The painting went over well with the art school crowd, and was subsequently forgotten as I forged ahead in my work. It languished in storage until I graduated a few semesters later, in early 2004, when I transferred it to a studio I was renting in Butchertown.

It was there that a man visiting the studio saw the painting and decided he had to buy it. The scandal remained in the news for a long time, as Patton had refused to resign, and somehow remained governor until 2003. The following year, memories of the whole affair were still fresh in people's minds. This fellow, like most Kentuckians, would have still immediately recognized the image. He contacted me, expressed his interest in purchasing the piece, and asked for a price.

Besides not learning about fair use, another thing I didn't learn in undergrad was how to price my work appropriately. The problem with painting as a medium is that you're stuck with your paintings if you don't sell them, and 4'x4' paintings take up a great deal of space. So I was happy to move this one to what seemed to be a good home. I gave him an arbitrary figure: five hundred dollars. Five hundred dollars in that place and time would have covered my studio rent for almost half a year.

He didn't blink at the number—it was a fair price, and in fact, a little on the low side, which I believe he knew. The problem was, my patron didn't have that kind of disposable income. He instead wondered about the possibility of an in-kind trade. Professional services, perhaps. Labor for art.

He was the proprietor of a well-respected tattoo parlor. "Do you like tattoos?" he asked me.

"Uh, sure," I said.

"Do you have any tattoo work?" he asked.

"Uh, no." I said.

"Well, tell you what," he told me. "I would like to offer you five hundred dollars worth of tattoo work."

I knew almost nothing about tattoo art at that time. I did know, however, that five hundred dollars worth of tattoo work was an enormous amount. A few hours, at least. I believe that's a sleeve's worth. Or if not a whole sleeve, then the majority of one.

Of course, I accepted. I was mostly just happy someone was interested enough in my work to offer something in exchange for it.

The problem was I suddenly had five hundred dollars worth of credit at a tattoo parlor I had no idea what to do with. As I told him, I had no tattoos. I didn't have immediate plans to get one.

Lots of people had ideas for me. My friend Dave wanted him, me, my brother, and his brother to get four matching tattoos. This seemed like a good

idea, but no one could agree on a design. Dave's idea was to commemorate the suburb we all grew up in, but the problem with that was the suburb we all grew up in was quite boring, and the more we thought about it none of us seemed eager to immortalize it. The idea eventually fell away.

My girlfriend at the time told me she thought I should give the credit to her, since I didn't apparently want it. She did have a tattoo, and had plans for more. She asked if she could have the credit.

"No way," I told her.

Our relationship was then in its waning days—she was preparing to take a job in a rural part of an adjacent state, and we had no intention of continuing our relationship long distance. We would break up within a few weeks.

"Why not?" she asked.

"Because," I said, "I don't want you to think about me every time you look at your tattoo." I don't have any tattoos, so I really don't know how they work, from an emotional standpoint. I figured whenever you looked at your tattoo, you would reflect on the circumstances through which you came to have it. I figured if she got one using the five hundred dollars credit, she would think of me whenever she saw it, and feel sad, or angry, or however it is ex-girlfriends feel when they think about me. That seemed unfair and a little creepy.

She was not happy. "That is absolutely ridiculous," she told me. She did have a good point: it was sort of ridiculous. She would, after all, have a pretty elaborate tattoo now if I'd given her the credit, as opposed to no one having the tattoo at all. But something about it didn't seem right to me.

I kept the patron's business card, not knowing quite what to do with it. He'd told me to come in anytime to have the work done, and I think for a while I planned to, though I never figured out what exactly I'd have done. About nine months later, I moved to Minneapolis. The business card is long gone, and though I am sure the offer still stands, I don't remember the fellow's name, or what the tattoo parlor was called, or where it is, or really any other details.

A good deal of your early thirties is spent coming to terms with the questionable behavior of your early twenties. There are a few lessons here, I believe, I'd be wise to reflect on.

The most important lesson is that it's not right to rip off the work of photojournalists. If I owe anyone an apology, it's Associated Press photographer Ed Reinke. The fact that I did not profit from his work is merely a result of my own inaction, and certainly wasn't for lack of trying. If anyone deserves the five-hundred-dollar tattoo credit, it's probably him. Unfortunately, I discovered while writing this that Ed Reinke passed away in Louisville in 2011.

Secondly, there's the tattoo artist, to whom I also probably owe an apology. If he still owns the painting and has it hanging somewhere and looks at it, he

might feel somewhat guilty, knowing that he obtained it without compensating the artist. And not even as a result of his own actions! He *tried* to compensate me! I inadvertently undervalued his work by not taking him up on his offer, which seems almost like a slap in the face. I still am not sure what would have been the best course of action here: should I have refused to take compensation, knowing full well I'd likely not have use for that amount of tattoo work? Or should I have gotten the tattoo, using the transaction as an opportunity to do something I might not have otherwise? Should I have refused to sell him the work without monetary compensation? I don't know where that painting would be if he'd not come into possession of it. Probably at my parents' house, in the basement, in the suburb I didn't want immortalized in ink on my forearm.

I wonder what his clients make of the painting now, if indeed it still hangs in a tattoo parlor somewhere: ten years on, the tear-drenched Patton scandal is a little-remembered footnote in Kentucky political history. I wonder how many remember the story. I'd only remembered after seeing the plaque on the bank commemorating the former governor.

Probably, all things considered, my ex-girlfriend had been right. Perhaps I should have just given her the credit as a gift and let her do as she wanted with it. Perhaps at some point a tattoo's origin is divorced from the tattoo itself. I still don't have one, so I don't know. My patron willed a five-hundred-dollar tattoo into existence when he purchased my painting, a five-hundred-dollar tattoo that does not exist anywhere. As it stands now, all that remains is a 4′x4′ painting hanging somewhere in Louisville, those meaty impasto teardrops reminding all who see them of the painful emotional economies of art-making in the Upper South in the waning days of the Patton administration.

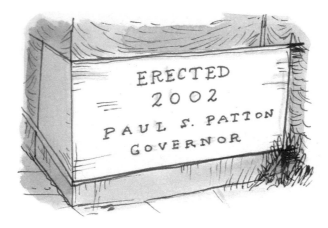

Airport Shoeshine: Point-Counterpoint

ANDY:

SOME TIME AGO I found myself walking through the terminal at Minneapolis–St. Paul International Airport on my way to catch a flight. It was fairly late in the evening on a Sunday, so the concourse was uncrowded. On the way to the gate, I passed a shoeshine stand. The man working there looked as if he hadn't had a customer for hours.

"Hey!" he said as I walked by. "Get your shoes shined."

I was in my summer aeronautical casual attire, which consists of a pair of pinstriped slacks rolled up into highwaters, and a pair of beat-up brown leather penny loafers with no socks. I wondered why he thought I might need a shoeshine. I am all for shiny shoes, and if I'd been wearing oxfords, I certainly might have considered it. But *I wasn't wearing socks*. Doesn't that negate any benefits that a shoeshine might offer?

"Sorry! Thanks!" I replied.

"Come on! Your shoes look terrible!" he said. I found this bit of editorializing unnecessary.

"What?" I asked incredulously. "I paid five dollars for these shoes. They don't need to be shined." This is true. I bought these penny loafers for five dollars at the St. Vincent de Paul near my house, and I wear them so I don't have to worry about getting them messy. He was correct in pointing out that they looked terrible, because I'd spent the whole summer tromping around warehouses and city beaches and outdoor patios in them. They're the cheapest pair of shoes I've ever owned. The shoeshine would have been more expensive than the shoes themselves. It would have been a total waste of time and money. I would have looked crazy walking around in highwaters and no socks and a pair of gleaming, polished brown shoes. Surely this guy gets that?

The man just waved his hand in disgust.

SHOESHINE MAN:

I was at the end of my shift at MSP on a Sunday night recently, getting ready to pack it in. It had been a slow night, with only one or two customers. No one needs their shoes shined. People look like crap when they fly these days. There was a time when people dressed up to fly—suits, dresses, smart leather shoes. Now it's all sweatpants and highwaters. No one even *wears* leather shoes anymore, except a handful of business jerks.

As I'm packing up, this hippie with an unkempt beard walks by. He's wearing a cruddy pair of slacks, no socks, and some brown loafers. He looks terrible, so I think a shoeshine might help the guy out. He could take a little pride in his appearance when he deplanes to see his family or wife or whomever. I just can't stand to see a pair of nice loafers so mistreated.

"Hey!" I said to him as he walked past. "Get your shoes shined!"

He declined and kept walking by.

"Come on! Your shoes look terrible!" I said, hoping I could shame him into looking halfway presentable.

He glared at me and mumbled something about the shoes being five dollars and not needing a shine. As if that makes a difference! Scuffed-up loafers are scuffed-up loafers!

Like I said, people used to look presentable when they flew, and now this hippie is going to deplane in whatever city he's going to and his shoes are going to look like shit. And no one is even going to care.

At Matt's Bar, in a Blizzard

ABOUT 9:00 P.M. ONE NIGHT, toward the end of a massive blizzard, I got sick of being entombed inside my apartment and decided to trudge out into the world. I laced up my knockoff Red Wings and hiked across the mile of South Minneapolis that separates me from Matt's Bar, snow still coming down.

Generally, I've tended to equate the hours directly following a period of heavy snowfall with complete silence. I expected my walk to be completely quiet and devoid of any human contact.

There were few cars on the road, so I could walk down the center of the back streets I was traveling to avoid the unshoveled snow on the sidewalks and feel completely alone. The longer I walked though, the more sensitive I became to the noises around me. I realized I wasn't alone at all: each block had at least a half-dozen people on it, noisily shoveling their sidewalks and driveways. The sounds they were making were agreeably rhythmic and suited to the sort of methodical trudging one must make over three feet of unpacked snow. First, there's a metallic skid as the shovel hits the sidewalk, then there's a muffled plop as the shoveled snow hits the fresh snow behind it. Repeat that, then multiply it a few times per block, and add in incidental conversation in English or Spanish if the shoveler has a partner helping out. On what I imagined to have been the quietest night of the year, these residential South Minneapolis streets seemed livelier than I'd experienced them at any point in the previous five months.

Matt's has one of my favorite jukeboxes in the city. It's nothing spectacular, but it does have Big Star, Otis Redding, and—until a few months ago—*It's a Shame about Ray*. It also only plays music when it's been programmed to do so; no ghostly electronic cycling through the catalog to pass the time between quarters. A dollar buys you three, so more often than not, you'll hear suites of three songs, then silence again. While I was eating a burger and reading whatever political biography I'd brought with me, some other blizzard refugee had programmed a cycle of three songs, ending with "More Than This," by Roxy Music.

I always remember the first time I heard "More Than This" at Matt's Bar. It was during my first year in the city, and I was having dinner with the girlfriend from a few girlfriends ago. She was a New Yorkish East Coast gal I was tentatively trying to persuade to move to Minneapolis, and I was finding my powers of persuasion hilariously ineffective. Her visit was, in retrospect, sort of a disaster, but a disaster that unfolded very slowly. Maybe it only looks that

ANDY STURDEVANT

way in retrospect. In fact, *disaster* is too strong a word—it's not like anyone got hit by a truck—but a lot of those few days consisted of a slow, steady accumulation of small arguments, petty resentments, and general uneasiness. Like the jukebox: short three-song suites of enjoyment, punctuated by long bouts of silence.

However, we were having a great time on that night in particular—she really loved the burgers at Matt's, as anyone with a heart will—and the Roxy Music song coming on over the jukebox sewed it up. We'd been talking about Roxy Music recently, because Roxy Music is a great band to talk about when you're trying to project a certain type of self-aware cool to a similarly minded boy or girl. The song came on, and she sighed and asked if she could come sit next to me in the booth. This was sort of the boyfriend equivalent of being called over to talk to Johnny Carson after giving a monologue. The whole mess would be over within a few months, but that meal, seated side-by-side in a booth, was certainly one of only a handful of times when being in love felt like being inside a three-minute pop song.

So whenever I hear "More Than This" at Matt's, I am always vaguely irritated. This time in particular though, I was more irritated than usual, because on top of hearing the song, it was also in the middle of a blizzard, which always makes you feel like you're the butt of a cosmic joke. "I see what you're doing, Universe," I grumbled, probably poking a French fry into the air. "You're trying to do the old compare and contrast, because I am by myself and sweaty and covered in beardcicles and feeling gross because I've just hiked a mile over two-foot-tall mounds of snow on the street corners and because I am sitting all by myself, drinking beer, reading an eight-hundred-page biography of Lyndon Johnson, and I probably have french fries in my beard. And I am emphatically not sitting next to a beautiful New York girlfriend who's a little tipsy and seems, for the time being, to be crazy about me." I ate the fry and continued.

"Well, it's not working and I am not buying it. Because first of all, I am feeling just fine right now, and not just right now at this moment in particular, because Lyndon and I are having a fine old time together, but about my life in general, give or take a couple things. Secondly, the specific experience you are referencing was certainly a treasured moment I will also think of with great fondness for years and years to come. But all in all, it was a small part of what was a difficult experience on the whole, which, it should be pointed out, ended pretty badly. Furthermore, I think Bryan Ferry would have my back here, because it is more like Bryan Ferry to be sitting somewhere by himself in a bar thinking about love than almost anything else, although he would probably be wearing an eye patch and a pair of epaulettes and not a pair of

knockoff Red Wings and he would also be drinking something fancier than a Grain Belt Premium, but it's still a *lot* closer."

The song's synthesizer outro hung in the air for a moment. Then there was silence, because it was the last song in the person's dollar cycle. And I realized I had proven the Universe wrong, and I was right about "More Than This"— Bryan Ferry had my back, and most of my decisions were sound. I was in a bar I liked, in a friendly neighborhood, in a city I loved.

Maybe the Universe wasn't doing a compare–contrast exercise with me at all, and I had misinterpreted its intentions to begin with. It's hard to tell what's going on in a blizzard. So I finished my drink, put my coat back on, and headed back out into the snow, exchanging a few words with whatever shovelers I happened to pass on the way home.

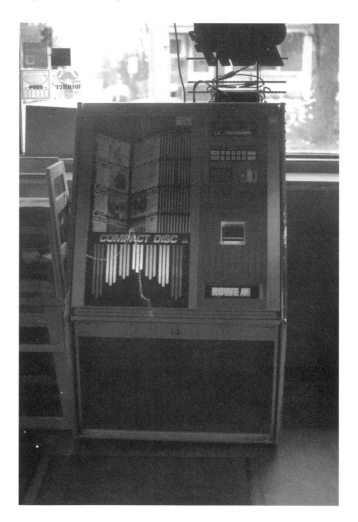

ANDY STURDEVANT

REGULARS

A few artists and forty-three artworks

A Plentitude of Lumber:
Chris Larson's *Deep North*

One will not expect to find here the mellowness of cities, villages and country-
sides in the older States. With the exception of a few villages, mostly in the
southeastern section, the towns can claim little charm; the unbeautiful brick
stores and banks of Main Street testify to grim physical work. Not many of
the New England settlers had leisure to indulge their esthetic tastes, and the
immigrants who poured into the State in the 1850's were all too glad to
exchange the picturesqueness and discomfort of their Old World stone
cottages and thatched barns for a plentitude of lumber.

"MINNESOTA TODAY," *THE WPA GUIDE TO MINNESOTA, 1938*

ROCHESTER IS JUST SUCH A MINNESOTA TOWN, and one that can lay claim to very
little charm, at least in its physical manifestation. It is through and through
a company town—that company being the Mayo Clinic—and with the excep-
tion of a few picturesque old buildings like the Kahler Hotel, its downtown has
little of the stereotypical romance of a small, midwestern Main Street to rec-
ommend it. Unlike Red Wing or Stillwater or Winona, there's almost no
romance to Rochester, despite its being tucked away in some the most beau-
tiful landscapes in the state. It's a city-sized primer in contemporary institu-
tional architecture, a series of sprawling, interconnected layers of frosted glass
and steel and cement, plopped down atop the framework of an old street grid,
oblivious to its own charmlessness and content simply to hum along with the
important business of healing the sick. A few blocks off of the downtown core
at the head of one of the city's main thoroughfares stands a statue of the two
Mayo brothers, Charles and William, side by side in their surgical scrubs. The
two doctors gaze upon downtown Rochester with a slightly bemused clinical
detachment, as if to suggest, "Yes, this is all in order. Now, we have a one o'clock
surgery to get to."

There's a certain hard-bitten Protestant work ethic, a testimony to "grim
physical work," that runs as an undercurrent in the Minnesota psyche, trans-
mitted from those New Englanders and Scandinavians who originally settled
here. It's an ethic that is expressed well in the roll-up-your sleeves, all-business
feeling one gets from the Mayo Clinic and the town that surrounds it, the idea
that it was all built by a plentitude of lumber and Lutheran grit. This is an ethic
that St. Paul artist Chris Larson understands.

It was particularly appropriate that the first time I saw his work in one place was in Rochester, at an exhibition at the Rochester Art Center in 2008. At the time, Mary Abbe, drawing on these regional myths, noted that there is a "hard-working carpenter quality" to Larson's work "that does makes him seem very Minnesotan." It's perhaps no coincidence, then, that the centerpiece of that particular show, a video called *Deep North* and a series of photographs and sculptures derived from and referring to the video, referenced Minnesota more explicitly than, perhaps, any of his other works. The body of work that made up *Deep North* feels like, perhaps, one of the great pieces of art about Minnesota. Larson even managed to incorporate the state's most widely reproduced piece of art into the piece: the 1918 photograph *Grace* by Eric Enstrom, depicting an old man in lumberjack attire bowing his head in prayer before a meal of soup and bread. If referring to this show as a great piece of art about Minnesota sounds like I'm damning it with faint praise, I am pointedly not. It's an extremely difficult thing to invoke regionalism in art without seeming provincial or hackneyed or boosterish about it, and Larson's work is all the

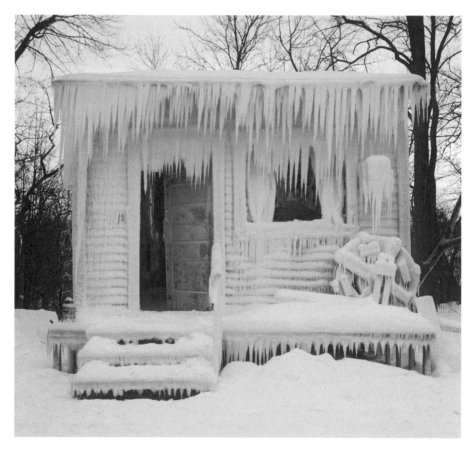

　　　　　　　　　　　　　　　　　　　　　　　　　　ANDY STURDEVANT

more remarkable for avoiding all three of those pitfalls, instead reaching for something more resonant.

I purchased a copy of *The WPA Guide to Minnesota* the first year I lived here, because after a lifetime of *A Prairie Home Companion* references to Norwegian bachelor farmers, I was interested in gathering some other perspectives. Assembled under the auspices of the Federal Writers' Project in the depths of the Great Depression, the *WPA Guide* is one of my favorite nonfiction books on the subject of Minnesota. I admire it for the charmingly dated, Rooseveltian qualities of the prose, but also because it's so curious and thorough in its assessment of the state and some of the people who built it. Though ostensibly a travel guide, in true WPA fashion, the book's emphasis is on the *work*, the process through which things are built and created—whether that's the land, the traditions, the social fabric, or the great institutions. "Fame and success were to be the reward—if in less measure—for all who had talents for the arts or sciences," notes one of the WPA writers, reflecting on the path Minnesota had traveled on its journey from frontier to commonwealth. "The only requisite," the writer adds, "was that everyone should work."

"There is something about who I am that is dictated by this place, the Midwest," Larson himself has said. "There is something about the work ethic, about making things."

> Yet if he is to understand the Minnesota of today, he must keep in mind that within the span of a single lifetime 54 million acres of forests, lakes, rivers, and untouched prairies have been converted into an organized area of industrial cities and rich farms. . . . The men and women who accomplished this were for the most part New Englanders, Germans and Scandinavians— probably as hardy as the world has produced—and it is their children and grandchildren who determine today the patterns of the contemporary scene.

"MINNESOTA TODAY," *THE WPA GUIDE TO MINNESOTA, 1938*

At the heart of *Deep North*'s video component is one of the enormous, hand-carved wooden machines that Larson has used in much of his work— almost too large and complex to believe it's all fashioned from wood, but there it is. In fact, in the exhibition in Rochester, the machine was suspended from cables on the third story, out of its original context, and the whole contraption hovered just over a balcony in one of the negative spaces that gives the building its vertiginous sense of interior height.

In the video and the photographs, the machine is lodged inside a small, roofless house, the kind of modest one-story cottage you see in working-class

neighborhoods like the East Side of St. Paul, sitting in rows on small plots of land. It is winter and snowy all around, and the roof has been sheared off, exposing the interior of the house to the elements. The machine looks as if it has been implanted in the middle of it by some powerful force, clearing out any human inhabitants instantly. Indeed, the house is full of small, carefully observed details of domestic life (the stove is half-open, eyeglasses and a Bible sit on the bedstand, Enstrom's *Grace* hangs on a bedroom wall), but ice utterly encases everything, icicles hanging off of nearly any surface that will support them. The takeover is so complete as to suggest that the ice is a sort of hostile, invasive species; the effect is very unsettling. In the middle of this frozen tableau, the machine noisily cranks out chunks of ice, which slide down chutes and plop down on the floor, piling up around the edges of whoever's abandoned home this is. This is truly one of the most unsettling aspects of *Deep North,* that all the domestic details conclusively point to the fact that *someone* lived here, and that they are gone, probably for good.

The ice, the forsaken house, the wooden behemoth at its center—it's an utterly inhuman scene, and yet humanity is intimately involved. Three women impassively operate the enormous machine, turning the gears over, depressing levers, dressed for their labors in gray woolen jumpsuits and gloves, their breath visible as they work. And their work looks difficult and cold. Larson has a knack for great casting in his videos, using former Hüsker Dü drummer Grant Hart or the Minneapolis gospel group the Spiritual Knights to augment the effect of the whole, for example, as he did in 2006's *Crush Collision.* The three women Larson cast in *Deep North,* including performance artist Britta Hallin, are similarly well chosen for this project; they look, well, *icy,* as if they were carved from the frozen stuff themselves. I mean that in a positive way, too: their faces are wiped clean of any emotion and drained of expression, even in those close-up moments captured on video where you can clearly see them physically straining in their labor.

All this visible strain and chilly displacement, all of this labor, accomplishes . . . what exactly? Over the course of a single lifetime, we are told by the *WPA Guide,* Minnesota is transformed by incredible feats of labor into the place we know now, nature completely tamed, our tireless work ethic triumphant in the end. And yet we are reminded every winter that our labor never ultimately triumphs over nature; we are reminded every time that arctic air blasts down across the prairie that we're only one serious calamity away from living in a world like the icy, posthuman interior of Larson's cottage. Our efforts merely hold nature's extremes at bay, and only temporarily. The world in winter is akin to one of Larson's complex, perpetual-motion machines, where humanity and nature are locked in an unending, cyclical struggle for dominance that is never

ANDY STURDEVANT

resolved; the best one can hope for is a sort of grudging, mutual respect between the contending parties and a sense of dignity imparted by the toil.

It's no surprise that Larson's work is suffused with Protestant imagery. It calls to mind verse from the first book of Peter: "But if, when ye do well, and suffer for it, ye take it patiently, this is acceptable with God." God may or may not be in Larson's particular scenario, but the nobility of work, seemingly futile or not, is underscored all the same. That little *Deep North* house, split wide open and exposed and humming with activity, and its contents, the machine and the workers, the ice and the ephemeral objects it envelopes—all these constituent pieces metaphorically comprise the entire psychic history of a way of life predicated on work, a way of life that seems, to me, particularly tied to Minnesota.

In an interview in the exhibition catalog, Larson refers to "foundational stories," these tenets and myths that he can't seem to escape. "It is hard for me to think outside of them or around them, especially if I am trying to talk about the beautiful mundanity of humanity," he says. Regarding these foundational stories, Chris Larson is the child and the grandchild of the men and women the *WPA Guide* references above; and their heirs are charged with determining the "patterns of the contemporary scene." So what patterns has Larson determined for our contemporary scene, then? The answer seems to be that the patterns don't change much, really; we just keeping on working and keep on working, with a plentitude of lumber and grit.

On Paula McCartney's *On Thin Ice, In a Blizzard*

IT'S DIFFICULT TO TALK ABOUT COLD WEATHER in a place like Minnesota in a way that feels authentic to the immediate way in which you experience cold weather. Talking about cold weather is so deeply ingrained in the region's identity that any language you might use to describe the way it feels—TV weatherman phrases like "arctic blasts," "bone-chilling winds," "subzero temperatures"— just seems like a rote recitation of meteorological clichés. These are phrases that have almost lost their meaning through repetition—when you're talking about how cold it is outside today with your coworkers or friends or the other people at your bus stop, you're reciting a little meteorological liturgy. The lines have been written long ago, and you're simply repeating them almost verbatim, without focusing a lot of thought on what they mean. That's because you've repeated them so many times, you almost forget what they really *do* mean. You know the rites: "Cold front coming down from Canada. Looks like snow. Supposed to get about five inches. It's going to be a cold one." Then the half joke about why anyone lives here to cap it off, as a sort of doxology.

There's something comforting in sticking to this script. It fosters a sense of community and shared experience. No matter how cold it gets, the basic language remains the same. It normalizes the experience for all involved.

But this cold weather script does really belie how bizarre the weather in this part of the world can seem, especially to transplants and outsiders and others coming from more temperate climates. I recall my first winter in Minneapolis, after spending my entire life in the mid-South; in particular, I remember the first time I experienced one of those standard-issue "arctic blasts" you hear so much about from TV weather personalities.

Of course, there was nothing "standard-issue" about it.

It felt like being physically assaulted by an alien force in the form of a gust of air that has traveled at blinding speeds, over thousands and thousands of miles; air that had traveled from another world completely unlike the one I knew, and penetrated my world absolutely. It didn't even *feel* like air in the sense that I knew air. *Alien* was the only word I could think of to describe the experience.

Perhaps it takes an outsider to appreciate how alien the everyday experiences of cold weather can seem. Photographer Paula McCartney grew up in Kansas and Pennsylvania, two places that are cold in a completely different way than the upper Midwest. Her 2012 book, *On Thin Ice, In a Blizzard,* is a series of photograms that draw on the visual characteristics of snow and ice in such

ANDY STURDEVANT

a way that highlights the unsettling strangeness of the natural wintertime land-scape. Its title strikes a note of menace—cracking ice, white-outs, impending arctic doom.

Appropriate, then, that the title of the book wraps this menace in the relative warmth of two classic cold-weather clichés. It's a clever hat tip to the hackneyed language that we use to talk about the weather, and once inside the pages of the book, McCartney turns that language on its head.

The photograms wordlessly capture the strange, monochromatic world of swirling snow and slowly forming sheets of ice. There is a sense of awe at the alien quality of the world in midwinter, a sense that captures that unreal feeling of stepping, for the first time, into a below-zero landscape in the darkest stretches of December.

If it seems unreal, that's because, in some sense, it is. McCartney's photograms were constructed entirely in the dark room, using only light and water. The blackness of the open spaces in her images—and the swirling points of white that seem to be snow—echoes the natural world, but it doesn't reflect

the precise visual language of it. These are not "landscapes" in the understood sense; there is no sign of humanity. It's all blizzards and thin ice in their purest, most elemental forms. The micro and the macro are totally eliminated, as well. The images alternate between gusts of snowy white specks and plates of ice, cracking and breaking down into ever-smaller pieces. These images could be vast swaths of northern Minnesota lake land as seen from satellite, or small instances of condensation seen on a kitchen window.

It seems at first like this exercise is McCartney's way of exerting control over powerful natural forces; of bringing these phenomena inside the comfort of the studio, where they can be controlled and mediated. This is a common response to the obliterating harshness of a midwestern winter—a sort of denial. A cultivation of the idea that overcoming the cold is nothing more than a simple act of willpower, and that by simply willing away the elements, one can just *get through it*. I recall adopting this attitude in my earliest days in Minnesota, and I see it a

ANDY STURDEVANT

lot in others recently arriving in this climate. It's difficult to not read some auto-biography into this on McCartney's part. Perhaps confronting the elements from the safety of the darkroom is her way of navigating the experience, a denial of the power that winter holds over anyone who's chosen to live here.

Tempting to think, I suppose, but I don't think that's quite what's going on here. It's much too simple a reading of a complex and beautiful suite of images. First of all, the darkroom is not a particularly safe place, as anyone with pho-tographic experience knows. Sure, it's not unsafe in a physical sense, and it's not as if you'll die of exposure, but in an artistic sense, it's risky and it's easy to get wrong. The process of printing photographs—of which the photogram is sim-ply the most basic distillation—can be as arbitrary and capricious as any win-ter storm. Any number of factors, from environmental to human error, can alter or ruin the most carefully laid darkroom plans. Thin ice indeed.

The images in this book are one way of answering the question of how one can confront the great fact of life in this part of the country—the weather—without falling back onto a backlog of carefully honed clichés, whether those clichés are linguistic or visual. Icy breath, arboreal trees, animal footprints, the smallness of a figure against a snowy landscape, all the regular signifiers of man vs. nature—McCartney has stripped all of these away completely. What we're left with is a pure and (quite literally) elemental expression of the world in wintertime.

"Have a seat, citizen, I'm here to help": The Completist's Guide to the Thirty-Nine Gubernatorial Portraits of the Minnesota State Capitol

OFFICIAL PORTRAITURE IS A THANKLESS BUSINESS. Depicting politicians on canvas for posterity is a task at which few artists can really succeed, and even when they do—well, who wants to go see a bunch of oil paintings of past governors? Or, more to the point, read about them? Not many people, sadly. It's not high on most people's lists for afternoon cultural outings.

This is too bad, because these types of paintings, in both the Minnesota state capitol and your own state's capitol or major universities or public buildings, can be fascinating. They're almost always free to go see in person, and typically, they are the work of the state's most accomplished painters. For many years—and even now, to some extent—getting a call from the governor to make his or her portrait was one of the highest honors that could be afforded to a living artist. In Minnesota's case, some of the names are still pretty well known in the local art community. This is probably true in your state or municipality too.

Better yet, it's a chance to see how styles change over time in a very carefully defined cultural space. A collection of gubernatorial portraits is a great shorthand history of painting over the past two centuries. I am tempted to write "shorthand history of a certain *type* of painting," since most of the works you see are pretty straightforward portraits, but that's not entirely accurate. You can definitely follow the broader history of painting as you move forward through time, watching the artists adapt their styles to fit the sometimes-conflicting demands of tradition and contemporaneity. The dominant schools earlier on tend to be academic and historical, generally concerned with portraying narratives—perfect for a politically charged portrait of a governor. However, in the past century and a half, you run through impressionism, cubism, fauvism, expressionism, surrealism, and many more, moving away from narrative and representation into vastly more complicated realms. I went to art school so you didn't have to, so I'm not going to summarize the entire history of painting here. But I can try to show the places where these influences have peeked through.

Official portraiture has to pull off a few tricks. Primarily, portraits have to reflect power and gravitas, and so necessarily can't stray too far outside a few preset boundaries (a solemn gaze, a dark background, a hand on a desk, maybe some books or papers or curtains somewhere in the background). Essentially,

ANDY STURDEVANT

it's a conservative medium—if a portrait veers too far off into either abstraction or symbolism, the subject appears unserious, trendy, radical, dated, or, worst of all, irrelevant. In this sense, the entire body of gubernatorial-themed work in Minnesota's capitol or in any other is a massive, multigenerational collaborative single work. It demonstrates, above all, continuity and legitimacy. If every painting looks generally like every other, it suggests that the government derives its authority from continuous succession of governor to governor, and that this unbroken consistency is a sign of the continuity and unity of the state government. Right?

On the other hand, the artist has to somehow show, visually, what made the subject not just another politician in a long line of politicians, but a *statesman*. (And so far, they've all been men.) It needs to possess some hard-to-define quality that makes the work stand out in some way. The smart artist will borrow tools and techniques from the mainstream art world to do just that. The best portraits are the ones that imbue the conventions of the official portraiture with some idiosyncratic gesture that reminds you, for all their power and influence, these were just regular people doing a job they were paid to do.

Once you learn the language, you can being to investigate the images more carefully. Is there any sort of a correlation between each governor's policies while in office, and the way they chose to be painted? Did more conservative governors have more conservative paintings? Did radical governors choose more radical portrayals?

To a certain extent, that may be true. We'll focus specifically on the thirty-nine portraits of Minnesota's governors, but the broad outlines of this guide will be accurate anywhere that governors have sat in chairs in front of red curtains and worn black suits with their hands placed atop piles of books. Which is to say, anywhere in America.

Back to the question of correlation between ideology and aesthetics. Governor John Lind, the subject of my favorite portrait at the Minnesota state capitol, was almost certainly the most progressive governor up to that point, and his portrayal by Max Bohm is a clear stylistic break with the past. But this isn't always the case—for example, Carl Bohnen painted portraits of both conservative Republican J. A. A. Burnquist and radical Farmer-Laborer Floyd Olson, two men whose political viewpoints were almost diametrically opposed. Yet he painted both of them ably, sensitively, and with no apparent preference for ideology. It's sometimes tough to find a correlation.

Many of these men whose portraits are featured in those halls are still living, and the memory of their administrations is still fresh in the minds of Minnesotans. Many of the political circumstances that animated their decisions are

still in play; not only that, but the various way in which each has chosen to be painted still resonates with how Minnesotans have collectively thought about themselves in the past few decades. The intersections between art and ideology are easier to pinpoint when we know the actors and the issues firsthand. Minnesotans know many of these faces well.

Most of the really good portraits come later; the early ones are quite pedestrian. Nearly every early governor was an Easterner who'd struck out for the old Northwest to make a fortune in lumber or fur trapping or some other growth industry, and wound up sticking around Minnesota. The state and its leaders were very eager to prove themselves worthy peers of their established Eastern neighbors. Therefore, the portrayals of these first few governors—**Henry Sibley, Alexander Ramsey,** and (to a lesser extent) **Henry Swift**—are safe, stately, and unremarkable, and generally painted by an Easterner or European. They're meant to be legitimizing and sober depictions of respectable, suited men that countered the popular perception of Minnesota as a wild, violent, frontier battleground. The swirling, earthy backgrounds of Swift's portrait, by an unknown painter, suggest a certain untamed natural wildness that must have seemed uniquely Minnesotan to the contemporary viewer. But for the most part, these early portraits are dull to the point of being drab.

The painting of **Stephen Miller,** by one "B. Cooley," is the first one that departs from the formula. It's actually quite crude, almost outsiderish in its slightly strained proportions and the governor's flat, two-dimensional expression. The crudeness seems more accurately reflective of the emergent state at that time, more so than the first three. In that, it's quite a charming piece of not-quite-folk art.

Next are **William Marshall, Horace Austin,** and **Cushman Davis,** and then skipping over John Pillsbury for a moment, **Lucius Hubbard** and **Andrew McGill.** All five of these portraits were painted, over the course of a decade, by the same artist, Carl Gutherz. Gutherz had a much more interesting career than these competent but unremarkable paintings would suggest: he was Swiss, and studied in Paris, Rome, and Brussels before coming to the United States and living in St. Louis; Cincinnati; Washington, DC; and Memphis.

While in Europe as a youth, he fell in with the Symbolists, a decadent gang of painters revolting against the hardscrabble naturalism of the era, whose quasi-mystical works drew on dream imagery and poetry. The Symbolist movement seems to have been a good home for Gutherz, artistically; he created many allegorical paintings of classical subjects and dreamy landscapes. But apparently it was portraiture that paid the bills—it's hard to detect much influence of the Symbolists in these works. Or, for that matter, much of the artist's hand. Would you guess that this is all the work of the same painter, much less one whose

Sibley

other paintings had names like *Sappho*, *Awakening of the Spring* and *Light of the Incarnation*? It seems very clear to me that this is work for hire. It's government contract work!

The eighth governor, **John Pillsbury,** has to my eyes the first exceptional official portrait. Pillsbury passed Gutherz over and had his portrait made by John Antrobus, an English-born painter based in Chicago who also made portraits

Pillsbury

of Presidents Lincoln and Grant. Antrobus depicts Pillsbury before a dark red curtain, his left hand resting on a book and his right hand clutching a pair of reading glasses. The expression is serene but commanding. There's a spark there; Pillsbury actually looks like a real person. Technically, the painting is stronger, as well. Antrobus's hand seems surer than Gutherz's.

ANDY STURDEVANT

Lind

Gutherz also painted the first Scandinavian-born governor, **Knute Nelson,** and it's definitely the best of the seven official portraits he made. Nelson looks stately and determined, standing in the sort of atmospheric statehouse environment most of these works are set in. But there's a dignity to Nelson's portrait that

seems missing in Gutherz's other work. Gutherz died a few years later, having spent over thirty years creating portraits of Minnesota governors.

David Clough is another competently painted enigma hiding humorlessly behind a giant beard. Skip it! **Samuel Van Sant's** portrait, despite a certain affable quality, is similarly forgettable.

Between them is **John Lind.** A Swedish-born reformer and progressive, his portrayal by Cleveland-born Max Bohm is one of the few pieces written about here that is, in addition to being a great portrait, also a great *painting*. It's unlike anything before it, or really after—it's not naturalistic at all, in that it's a scene that almost certainly never happened in life, outside the painter's imagination. Lind stands in front of a tree on a prairie landscape dominated by towering cloud formations, his arms folded behind him, lost in contemplation. The brushwork is loose, to the point where the landscape behind him is nearly abstracted. Wild, surreal-looking flora grows around him. Max Bohm, too, was a European-trained Romantic, and this scene has a certain dreamlike quality that none of the other portraits even attempt. Lind, who's hiding a left hand he lost in a farm accident, doesn't look dreamy, though. He has the determined look of a visionary reformer.

Next are two strong portraits of **John Johnson** and **Winfield Hammond,** both painted by Minnesota-born Nicholas Richard Brewer. There's more of an air of humanity here than in previous examples; both are seated comfortably, and look less stiff than their predecessors. Brewer was well known nationally, and heavily influenced by John Singer Sargent, the most famed portraitist of the era. Singer's works depicted powerful people in more casual, naturalistic settings, with looser, less hurried brushwork. Brewer isn't quite on that level, but these are agreeable portraits in that vein.

Adolph Eberhart is next, painted by Arvid Nyholm, a Chicago-based Swedish-born portraitist. Eberhart was a slick politician, apparently, and he regards you with the sort of insouciant bemusement you might expect from a fellow who actually changed his name from "Olson" so as not to be confused with all the other Olsons around. Fittingly, there's a certain high-collared Gatsbyish jauntiness to all of it. In fact, that cool, crisp Arrow shirt collar seems nearly to be the focal point of the piece. "They're such beautiful shirts," sobbed Daisy Buchanan, a few years after Eberhart held the office. She may as well be talking about this shirt.

Next is **J. A. A. Burnquist**'s portrait. This was the first painted by Carl Bohnen, an artist with St. Paul roots who took Carl Gutherz's crown as preferred portraitist of our state's top executives. Starting with Burnquist's portrait in 1919, Bohnen would paint the next seven governors. While Bohnen would prove himself to be an outstanding portraitist in the years to come, this first painting is quite odd—Burnquist is shown at three-quarters, facing to the right

Eberhart

with his hands clasped behind his back. He's lit by a strong light source coming in from the left, one that casts a dramatic shadow against the wall Burnquist stands in front of. It's actually somewhat ominous, reminiscent in some ways of the shadowy, ambiguous spaces in the work of Bohnen's Italian contemporary, Giorgio de Chirico. Perhaps the idea here was to indicate that Burnquist's legacy casts a long shadow over the affairs of the state, but it seems a bit sinister.

J. A. O. Preus and **Theodore Christianson,** two conservative Republican governors of Scandinavian descent, get a fine, more traditional treatment from Bohnen. The two are finely attired, handsome, serious-looking men who could just as easily be prominent bankers, attorneys, or businessmen as governors. Bohnen's work has fully caught up to the twentieth century—it respects the convention of the official portrait genre, but shows a willingness to tweak those conventions as needed, in composition, coloration, and brushwork.

There is a confidence to these paintings, and in the paintings of Bohnen's to follow, which nicely reflect Minnesota's standing in the nation in the early twentieth century. No longer an upstart young state overshadowed by its eastern neighbors, Minnesota is in this era an economic powerhouse with booming cities and thriving industries. These paintings depict leaders who are as comfortable and confident in their power and influence as any scion of New England.

Next is one of the most portrayed leaders in Minnesota history, **Floyd Olson;** his portrait stands as one of the greatest in the capitol. The first governor elected from the radical Farmer-Labor Party, Olson was a rising star on the national scene who might very well have attained higher office had his life not been suddenly cut short by stomach cancer in 1936. This portrait is a definite turning point in the collection: it's the first to make unmistakable reference to Minnesota specifically.

Some of the earlier portraits had hinted at the wild sublime in their background compositions (Henry Swift and John Lind, for example), but Bohnen depicts the actual physical landscape of the state behind his subject, with the capitol to the east, and the skyline of Olson's hometown of Minneapolis to the west. This is not a portrait of a governor ensconced in his private chambers away from the public view, nor is it a portrait that pays lip service to the self-consciously tasteful, restrained modalities of official portraiture—this is a man out in the state he serves, both a part of it and towering over it.

The other key detail is the microphone Olson clutches in his right hand. The governor may have been interested in regionally specific details, but he wasn't provincial, and the inclusion of the radio must have made this portrayal seem strikingly modern at the time. Like his contemporary, President Roosevelt, Olson embraced the new medium as a way to get his populist message

Olson

out to as many people as possible. The presence of the microphone here seems
to indicate that Olson's words were heard by millions. This portrait was painted
very shortly after his death, so there is certainly a more grandiose, commem-
orative quality than in many of the others. But it's one of the boldest, and one
of the best.

Hjalmar Petersen and **Elmer Benson,** Olson's Farmer-Labor successors, receive excellent portrayals by Bohnen. Benson's portrait is particularly strong—he sits purposefully by a small table with a few books on it, wearing a dark suit, looking both youthful and commanding. Next is **Harold Stassen,** remembered today more as a punch line for his numerous ill-fated presidential primary campaigns. This was Bohnen's final official portrait, and much like the one be began his career with, it's quite an odd one. Stassen appears to be in an empty room, gripping a chair in front of him with an almost nutty intensity, evident in his expression. Reflecting upon it further, I wonder if it's meant to convey the idea of Stassen as a *servant* ("have a seat, citizen, I'm here to help"), but it makes him seem strangely unmoored. A few years after this was painted, Bohnen died at age seventy-nine, having painted portraits of Minnesota's governors for more than three decades.

Luther Youngdahl's portrait, depicting him sitting at a desk in a double-breasted suit signing a bill into law, is stodgy to the point of near-parody.

C. Elmer Anderson and **Elmer L. Andersen** are both portrayed by Edward Vincent Brewer, a beloved Minnesota illustrator best known for his iconic painting of the chef on the Cream of Wheat packaging. Once called "Minnesota's answer to Norman Rockwell," he was the son of Nicholas Brewer, who painted John Johnson and Winfield Hamilton as mentioned earlier (and in fact, his grandson, Allen Brewer, is a noted St. Paul–based artist). Despite Brewer's pedigree, I find these portraits difficult to get excited about. They're as well-executed as any on display, but they appear to me to be too stiff and overly formal, too much like magazine illustrations. They don't seem to convey anything about the character of these men, beyond the fact that they held positions of authority.

The portrait of **Edward J. Thye,** between Anderson and Andersen, is another where regionalism comes into play. Theodore Sohner, the artist, was a noted portraitist, but was also known for painting scenes of small towns created during the New Deal. Sure enough, some darkened, rolling hills appear behind Thye, alongside a farm scene right out of the Federal Art Project, and the glimmering city lights of St. Paul in the distance. This might seem hokey if it weren't executed well. But it is, and I admire the genuine attempt to fit portraiture conventions into a specifically midwestern artistic context.

The work of regionalist painters of that era (Minneapolis-trained Grant Wood, for example) did a lot to advance the cause of arts and culture in the Midwest, and Sohner seems to be consciously drawing on that. I do have a bad feeling, though, that this sort of regional scenery portends a late twentieth-century descent into kitsch.

The descent begins with **Orville Freeman,** who has the distinction of being the first governor painted by a female artist, the Hungarian-born Californian

Elizabeth Milhayi. Unfortunately, this is one of the poorer portraits on display. Freeman wears what should be a chic, Kennedy-era three-button suit, but it seems instead like a comically oversized zoot suit. The decision to paint Freeman without his trademark plastic-rim glasses is puzzling as well. His smile is nicely humanizing, but otherwise, it's quite a bland depiction. The brushwork is only average, and Freeman stands in one of those stiff poses never seen in a human not posing for an official portrait. This is a good example of how playing it safe can leave a once-popular, photogenic politician like Freeman with an unmemorable painted legacy.

Karl Rolvaag is painted by Frances Cranmer Greenman, one of the unsung heroes of Minnesota art. Born in South Dakota, trained on the East Coast by the likes of Robert Henri, and author of one of my favorite Minneapolis memoirs, *Higher Than the Sky*, Greenman settled in the Twin Cities as a youth. She navigated both ends of the social spectrum in the city, serving as a much sought-after society painter and head of the local WPA art programs. Her style was loose, sketchy, and highly stylized—in a few deft strokes, she captures not only the likeness of Rolvaag brilliantly, but also the uncertain, exciting tenor of the postwar era. Rolvaag sits in front of a mass of color that looks almost like a Mark Rothko painting. Of all the paintings in the capitol, this is one of the few that bridges the gap between the expectations of official portraiture and the contemporary artistic zeitgeist. It's a bold statement that's also not the slightest bit kitschy—a combination I'm afraid we won't be seeing more of.

Harold LeVander is portrayed by Barbara Brewer Peet, daughter of Edward Brewer and granddaughter of Nicholas Brewer, each of whom painted two governors. Peet's portrayal is engaging and modern, very much of its time and place and in the vein of Greenman's portrait of Rolvaag. The only slightly odd touch is the presence of George Peter Alexander Healy's 1869 painting of Abraham Lincoln in the background, positioned in such a way that it looks like Father Abraham is perched on LeVander's shoulder, like a guardian angel of some kind. It's a reasonably appropriate choice for a Republican, to be sure, but an oddly literal one nonetheless.

Regarding ideology and aesthetics, in one case, there is a negative correlation between the two: that of **Wendell Anderson,** portrayed by Richard Lack. This is, for me, maybe the greatest governor's portrait of the modern era. It exemplifies everything a traditional official portrait should be. It's confidently painted, and pays respect to the conventions of the genre without being too flamboyant. Anderson looks—for lack of a better word—stunning. His suit is neatly tailored and stylish, his hair is fashionably tousled, and he looks directly at the viewer with the hint of a smile playing around his lips. It's actually a very sensual official portrait, to use two adjectives that rarely appear together in the same sentence. Anderson was one

Rolvaag

of the great liberals of the Watergate era, and this portrayal captures that youthful energy and wide-lapeled idealism splendidly—the sort of photogenic progressiveness that landed him on the cover of *Time* magazine in 1973.

Now here's where the negative correlations come in: Anderson's portraitist, Richard Lack, was an intensely conservative figure on the Twin Cities art scene

ANDY STURDEVANT

in the seventies and eighties. Not politically conservative, necessarily, but aesthetically conservative. Lack was the founder of the Lack Atelier, a painting studio in Minneapolis that continues to teach rigorously academic painting, in the tradition of David and Delaroche. It is remembered in some circles for one of the more bizarre footnotes in recent Twin Cities art history: a raucous confrontation in November 1989 between Atelier members and their peers in the contemporary art scene, at a meeting of the Minnesota Artist Exhibition Program (MAEP). The MAEP shows work by Minnesota artists, selected by Minnesota artists, and has had its own space in the Minneapolis Institute of Arts since the seventies. At the time, the Atelier artists felt their more traditional work was getting a short shrift in favor of more conceptually driven work, and forced an angry, brawling confrontation at the group's annual meeting. In art, as in politics, conservatism and progressivism vie continuously for the upper hand.

As masterful as the portrait of Anderson is, it's certainly a step back formally from its immediate predecessors. Anderson was a forward-thinking modernist and reformer, but you'd never guess that by looking at this stately portrait; it ignores the twentieth century completely, drawing exclusively on nineteenth-century academic genres. And yet, the two ideas coexist.

At the time, much was made of the fact that **Rudy Perpich**'s portrait also included his wife, Lola—no other governors had included first ladies in their portraits. That minor controversy aside, I don't have much to say about this one, other than it's remarkably pedestrian. It looks as if it was painted from a photograph, and in fact serves as a sort of inadvertent argument against official painted portraits at all—why bother with the trouble of going through with a painting if a photograph will do?

Al Quie is also painted by Richard Lack. Quie is portrayed in a suit, with cowboy hat in hand, standing in a green field under wide, blue prairie skies. This portrait represents the precise moment when regionalism metastasized into kitsch. The Minnesota landscape has turned up in previous portraits—Swift, Olson, Thye—but never in such a self-consciously revisionist way. The city is nowhere to be seen. In fact, the only manmade feature is a church, far off in the background. Minnesota, portrayed in portraits of Govs. Olson and Thye as a mighty, sprawling landscape that encompassed both vast, productive farmlands and towering skyscrapers, has mystically transformed into a sleepy, conservative agrarian backwater, tended to by a benevolent Reaganesque rancher.

Arne Carlson is painted by Stephen Gjerston, a student of Lack's. At first glance, this enormous portrait of Carlson, decked out in his University of Minnesota letterman jacket, registers as tasteless bordering on vulgar. After painting after painting of men in formal suits, enveloped in an aura of power, it's almost a shock to see Carlson smiling affably in his maroon and gold, hanging

out near Northrop Auditorium. Can you imagine any of his predecessors dressed in this way? But it's so good-natured, it really overwhelms my critical facilities. It's actually a fairly smart move. Carlson clearly wanted to be thought of as an affable, regular guy, and here he is, being just that. You tell 'em, Arne.

Speaking of overwhelming critical facilities, **Jesse Ventura**'s portrayal by Stephen Cepello, a wrestler turned fine artist, is legendarily over-the-top. Sure, it's absurd—it depicts Ventura against a stormy black background, resting one hand on *The Thinker* and the other holding a lit cigar, wearing what Twin Cities writer Steve Marsh once referred to as "a Jerry Garcia tie." Cepello wasn't ignorant of his predecessors' work, however. The background actually calls to mind the portraits of Floyd Olson and Edward Thye, with the Twin Cities humming away productively in a background landscape; in a weird, comic book sort of way, the portrait actually places Ventura in the broader context of Minnesota's governors. Ventura was an outlier, to be sure, and this portrait is sui generis. It positions the governor as a sort of superhero, an ass-kicking Navy SEAL who got lightrail built—there is a train running through the landscape—even as the stormclouds approached. But even in its bold, operatic weirdness, it doesn't ignore precedent or tradition. In its own bizarre, flamboyant way, it works well as an official piece of portraiture.

Until Mark Dayton has his portrait made, that leaves us with **Tim Pawlenty**. Before the painting was unveiled last year, I imagined that Pawlenty was going to go the Carlson route; the "hey, I'm just a regular guy" schtick, except cranked up to overdrive. I expected a snowy south metro landscape, with a figure dismounting a kickass snowmobile in a full jumpsuit. The figure is removing his helmet, only to reveal—wait a minute!—it's Tim Pawently, shaking his mullet in the breeze!

Any other year, he might have done just that. But this painting was created in 2011, during the earliest parts of the Republican primaries, and Pawlenty's eyes were on the prize. This is clearly the painting of a man who thought he'd be the forty-fifth president—it's safe, bland, and wasn't even painted by one of those Pawlenty-hating Minnesota artists, but a guy from Atlanta. Straight-on, fishy half smile, one hand in his pocket. It's forgettable in every way, much like its subject.

Next time you're at the capitol, take a few minutes to walk through and look at these paintings up close. Many of them—most of them, even—are quite amazing. Collectively, they're a poignant group portrait of who we as Minnesotans have been, could be, and would like to be, as embodied by these thirty-nine individuals.

ANDY STURDEVANT

Ventura

On Alec Soth's *Lester's Broken Manual*

ALEC SOTH, NATIONALLY RECOGNIZED PHOTOGRAPHER and subject of a midcareer retrospective at the Walker Art Center in Minneapolis, sells zines on his website. That's exactly what he calls them. Not "art publications," not "self-published books," but *zines*—like a nineties-era punk band, or a kid behind the merch table at an all-ages rock show. In most circles, that particular word fell out of use sometime around the end of the Clinton administration. If we are to believe the arguments of anonymous Wikipedia contributors, here is how the story of zines comes to an end: "It can be argued that the sudden growth of the Internet, and the ability of private web pages to fulfill much the same role of personal expression as zines, was a strong contributor to their pop culture expiration." To claim (or reclaim) the word is to take on the mantle of low-tech, lo-fi righteousness most often associated with defunct subcultural groups of the late twentieth century.

Of course, these zines are not Soth's work, in the strictest sense. They're the work of one Lester B. Morrison, a pseudonymous writer who collaborated with Soth on his 2011 publication, *Lester's Broken Manual*. The various titles—*Library for Broken Men, Lonely Boy Mountain, Lonely Bearded Men, Lester Becomes Me*—are printed and stapled 5.5″ x 8.5″ booklets of drawings, collages, found material, and graphite smudges, dealing explicitly with concepts related to survivalism, and more abstract, underlying themes of escape, and loneliness; collectively, they form a sort of first draft of the *Broken Manual*. "As many of you know, we published Lester's first zine, *Lost Boy Mountain,* last December," Soth writes on his blog, *Little Brown Mushroom.* He adds, with what one senses to be a certain sense of bemusement: "It went on to be named one of the best books of 2009."

The new work, *Broken Manual,* is itself very zinelike in its most basic format: it's a paperback, tape-bound at the spine with the title that appears to be crudely lettered on with a Sharpie. The text throughout—supplied by Morrison, and covering the "Steps to Disappearing" utilized by "hermits and hippies, monks and survivalists"—is typeset in uniform, twelve-point Times New Roman and it looks very much like something printed off a laserjet at Kinko's. The text portions appear on stock green and pink, 8 ½″ x 11″ paper. With the exception of the high-quality reproductions of Soth's photos of shacks, mountain vistas, and survivalist ephemera throughout (and the imprint of Steidl, a well-regarded German photography and fashion publisher), *Broken Manual* looks much like the sort of thing you might see for sale on a folding table at

ANDY STURDEVANT

a gun show next to titles like *Nuclear War Survival Skills* and *Patriots: Surviving the Coming Collapse*.

Beyond the basic formatting, the full edition of *Broken Manual* comes placed inside an inconspicuous larger book, one of those sixties *Time-Life Treasures of the Vatican* kinds of coffee-table books, hollowed out by hand; the paperback fits snugly inside the larger volume, hidden from view. I heard about certain stoner kids in my high school that supposedly kept their glass pipes and stashes in such custom-made books. I have also heard of gun show–types stowing their firearms in similar volumes, placing them on bookshelves, hidden from home invaders or ATF agents but ready to be withdrawn at a moment's notice.

Much of this is reminiscent of the sort of low-tech, lo-fi righteousness most often associated with *another* subcultural group of the late twentieth century, on the opposite end of the sociocultural spectrum from where most punk rock zines situated themselves—the survivalists. You may recall the various quasi-libertarian fringe dwellers who seemed to be a favorite topic of the national news media in the period falling roughly between the 1992 raid on Ruby Ridge and the Y2K panic—frequently lone, often violent separatists like Randy Weaver, David Koresh, Ted Kaczynski, Timothy McVeigh, and Eric Rudolph. Violence and ideology aside, both the zine and the survivalist movements share some common ground in their embrace of a DIY ethos that rejected a broken-beyond-repair mass culture, and proposed to create its alternative.

Around the time of the book's publication, Alec Soth invited me to come by his St. Paul studio and have a look at *Lester's Broken Manual*. His studio is in a nondescript, one-story building in the Midway neighborhood, just over the Minneapolis border. If political power broker Archbishop John Ireland of St. Paul had had his way in the 1890s, this area would have been the site of the Minnesota state capitol, uniting the Twin Cities into a single conjoined metropolis. Instead, the capitol lies five miles east, and downtown Minneapolis five miles west, with the Midway area between them an oddly featureless, unglamorous stretch of the cities that often feels neither here nor there.

One whole wall of Soth's in-studio library was covered with used, oversized coffee-table books, hollowed out and awaiting the placement of a copy of the *Manual* inside. He grabbed one from the top of a stack and opened it up. "Each one has to be glued by hand," he explained, "and it's an ordeal." The pages are glued together on the sides, then the guts are removed with a router. He had an associate doing this for him on dozens and dozens of these books, all of which were purchased used. Apparently, it was more difficult than expected to find coffee-table books large enough to accommodate the *Manual,* so once he found a winner, he bought as many copies of it as he could find. Preparing each of these oversized volumes for final publication was a slow process.

There's a physical gravity to these books, as objects, that seems to be at odds with the direction mass-market books are going. "Yeah," Soth agreed. "The future of photo and art books is going to be online only, or you're going to have to have some physicality. The print-on-demand thing is ridiculous."

It's true. The idea of millions of individual books that only fifteen people buy each seems bleak. The *Manual* offers one way to escape such ephemerality and ghettoization, perhaps. It's an art object, and a lovingly crafted one at that. However, the object is quite crudely formatted too—an imperfect artifact. "The book was never intended to be thorough. It's fragmentary," Soth says. "It's a broken manual; it doesn't work."

The idea of such a document came to Soth several years ago, while traveling around the South on assignment for the High Museum in Atlanta, shooting for a series called *Picturing the South*. He was perhaps thinking in broadly romantic terms, as one does while spending time in the South, about Flannery O'Connor's writings on crossing behind the "black line of woods," and about Eric Rudolph, the Olympic Park bomber and fugitive who evaded capture for years in the South, living behind a grocery store and stealing food from dumpsters. It obviously wasn't Rudolph's politics that attracted him, but the idea of his evading capture for so long. After that, other fringe figures began to come to his attention—the Kentucky monk Thomas Merton, for example—all of them figures notable for their repudiation of culture, for finding escape routes, and for generally withdrawing from the mainstream of contemporary life. More and more, the project, the subjects he shot, had less to do with a sense of place, the South in particular, and instead focused on tearing the notion of "place" out of the pictures. In its place was a weird, desperately lonely, shadow America. In fact, as he worked on it, the project became more and more about tearing things apart entirely. "At a certain point," he said, "it's not about photography."

Escaping from the demands of contemporary existence may sometimes seem like an appealing fantasy, but it's still just a fantasy. Not even an autobiographical fantasy, necessarily. Soth has a family and a career: "I mean, I'm not going to leave my children." Even if one is to enter the margins, as many of his subjects have, what then? There's rarely a total rejection of society by these volunteer outcasts, and especially not a rejection of others' attention. "There's always a need for other people," Soth says flatly. "Running away doesn't work."

And, here, we come to his collaboration with the mysterious Lester B. Morrison, Soth's pseudonymous collaborator, who provides the text of the *Manual*. It is Morrison's voice that preaches, in the book's introduction, "if you want to be free, you need to make THE BREAK." I say Lester B. Morrison is pseudonymous because "Lester B. Morrison" is a pseudonym. Lester says so right in the book: "When things get official, you can use my full name: Leslie B.

Morrison," he writes. "That way the paper pushers don't know if I'm a man or a woman."

Soth told me Morrison hadn't quite "made the break" himself yet, actually; rather, he'd been caught in a sort of suspended state, between polite society and the wilderness. Of course, there are those who suggest "Lester B. Morrison" is a pseudonym not for an unseen collaborator, but for Alec Soth himself—something Soth politely but firmly denies. "The Lester thing," Soth says when the subject comes up as we talk, chuckling to himself under his breath. "I'm not sure what to do about that. There's so much different information out there . . ."

Soth smiles. "There's a lot of layers," he says resolutely. "For example, no one ever seems to point out that Lester had a poem in *The Last Days of W.*," a book Soth published in 2009.

He smiles again. "And that was some time ago."

Painting Falls to Tavern Walls:
The Life of Minneapolis's Most Beloved Artwork

Hanging on the north wall of the 331 Club, a bar on University Avenue in Northeast Minneapolis, there is a painting by John Bowman from 1986 entitled *Crossings*. It's a landscape painting, a few feet wide and maybe two feet tall, primarily black, orange, and iridescent silver. It depicts a few deer standing atop what looks like a bluff or canyon, overlooking a group of high-rise buildings. It sounds like a pretty pedestrian piece, to hear it described—just another landscape painting with deer in it, hanging in a midwestern bar. It's the execution that sets it apart. It's a night scene, and the buildings' windows shimmer with light reflected from either stars or streetlights. The painting appears to have been made using stencils and possibly spray paint. In fact, upon closer examination, you realize it's painted on a wooden bedroom door, turned on its side.

Ask anyone about this piece, and if they know it—and this is a piece a lot of people know, because the 331 is a very popular bar—you'll get a different description from each person. All sorts of imagery is proffered: some insist there are hunters in there too, or, at the very least, other *human* figures, possibly making their way across a postapocalyptic landscape. Some say the animals pictured are elk, not deer. Others describe the setting not as urban, but as a "suburban office park." Some people are sure the area pictured is San Francisco—*those hills, it's got to be!*—while others says they're certain it is the 3M corporate complex in suburban Maplewood. Some claim the landscape is "definitely Los Angeles," with clearly visible brushfires burning in the distance. "I have stared at the painting for hours," says one friend, "but I can never recreate the details outside those walls."

People talk about it in a way they rarely talk about other notable pieces of art. In fact, I would say *Crossings* may be the most beloved piece of artwork in the city of Minneapolis.

The 331, where the painting lives, is a beloved bar, well known to anyone who lives in Northeast. It consistently draws people from other parts of the Twin Cities as well. It's located on what may be the best commercial intersection in the state: Thirteenth Avenue Northeast and University, home to numerous fine shops, art studios, restaurants, and other businesses, the sort of place you can spend a whole afternoon walking around. The 331 is a place that encourages return trips. A lot of Minnesotans have made that return trip, and have spent a lot of hours sitting underneath that painting.

The metrics for determining how "beloved" something is are pretty subjective, but there are a number of ways to consider the idea: What piece of art, were it to disappear or be otherwise deaccessioned tomorrow, would provoke the greatest outcry from the widest cross-section of people? What piece, if brought up in conversation, would prompt a person to say, "Oh, yes. I *love* that piece," or to tell you about the times they've spent in its company? What work of art encourages the most speculation about the artist, or about its origins? What piece of artwork sets the most hearts aflutter?

I will stop you before you give the obvious answer: if you know anything at all about public art in Minneapolis, you may be thinking it's Claes Oldenberg and Coosje van Broogen's *Spoonbridge and Cherry* in the Minneapolis Sculpture Garden near the Walker Art Center. It's not. Certainly that's the most *recognizable* piece of art in the city, but *recognizable* and *beloved* aren't the same thing. I suspect people like the *Spoonbridge* in a purely abstract way; if you were to apply an emotional electrocardiograph to the city's collective heart, measuring its warmth in reference to the work, I think the slow and steady *boop boop boop* you'd hear would indicate that more people *like* the sculpture as an important local landmark or photo backdrop. That's still no small feat, mind you, and as an emblem of Minneapolis, it nicely fits the city's image of itself as a place that likes big art, and likes it a little self-consciously wacky. But while the work is consistently popular with both natives and visitors, I think you'd be hard pressed to find someone passionately discussing the artists' motivations for creating it, or what kind of cherry it depicted, or where the idea came from, or what the original renderings must have looked like. Most discussions around the *Spoonbridge* are related to where a person should be standing in the camera frame when they have their photo taken by it.

What else then? Rembrandt's portrait of *Lucretia* at the Minneapolis Institute of Arts comes to mind. It's a beautiful painting for sure, and historically important. But it seems like a stretch to judge it the most *beloved*.

Let's not bring the Mary Tyler Moore sculpture on the Nicollet Mall that TV Land plunked down a few years ago into this, either.

Unlikely as it may seem, I'd once again posit that *Crossings* is actually the most beloved piece of artwork in the city of Minneapolis. Few people know the painting's name or the artist who created it, but a lot of people know the painting itself.

I first thought about this particular painting's potential "most beloved" status while talking to a gallery director at an art event in south Minneapolis one night. In the course of a conversation, someone asked him what his favorite piece of art in town was, and his answer was *Crossings*. Like most people, though, he didn't know the name or the title. He just knew where it was located. "It's the one at the 331," he said. No more explanation needed.

The other people in the group immediately realized what painting he was talking about and they all quietly and unanimously murmured their approval. I remember thinking to myself, "Oh, shit, *that* painting! Yeah, I love that one."

I spend a lot of time talking to people about artwork, and I can honestly attest to the fact that there are very few pieces in town that inspire such a wide range of discussion and speculation as this one.

It is, in some respects, the anti-*Spoonbridge.* Perhaps you might say it's *anti-iconic*; the painting is small, it's dark, and it defies easy description. People know exactly what the Spoonbridge looks like. They stop for a moment to consider it, perhaps photograph it, and then they leave. No one takes a photo of this particular painting. But people camp out underneath of it for hours, nursing drinks, watching bands, talking to their friends, playing bar games. One grows, over time, familiar with the work. And if regulars at the 331 don't come to love it, I'm willing to bet they spend a little bit of time thinking about it.

The setting plays a large part in all this. In a bar, there are no didactics. There's no panel on the wall providing the name of the artist, date, and medium for the work. In fact, very few people know the painting is called *Crossings*— I didn't know myself until writing this piece. Rather, the story of the painting's subject matter and its provenance is one that you provide, based on nothing other than your powers of observation.

In fact, I once talked to a guy who had heard that 331 co-owner Jon Oulman found it in a dumpster in an alley in Northeast. He said he'd also heard it was painted on an old bathroom door, and not a canvas. He thought the artist must be unknown—some anonymous Northeast-area crackpot, maybe someone like Henry Darger or the Philadelphia Wireman, whose work was found after being discarded when he or she died.

Turns out, some of that is true—the part about the bathroom door, at least. Of course, Jon Oulman knows the whole story. Oulman is the proprietor of the 331 Club, as well as what he describes as its "aesthetic director." That means the bar is his, and so are the paintings.

As noted above, the painting is not by some anonymous Northeast Minneapolitan, but by an American painter named John Bowman. Oulman showed Bowman's work several times at the eponymous gallery he ran at the Wyman Building in the eighties ("while the conservatives were running things," he notes dryly, "the liberals were buying art"). Bowman, a native of eastern Pennsylvania and graduate of Rutgers, is an associate professor of art in the department of drawing and painting at Penn State. Since the early eighties, he has exhibited work all over the world.

"I showed some of his early stencil work," Oulman says. "That's what was showing in New York at the time—mechanical work. Kids are doing that now." The painting in question is indeed on a bathroom door. Oulman points out, "It's an important work in his repertoire. It's his first piece on a door panel." In fact, Oulman has a few other Bowmans in his collection, including some hanging at his other bar, Amsterdam Bar and Hall, in downtown St. Paul. Like the painting at the 331, they too depict what Oulman calls "imagined landscapes": collections of skyscrapers off in the distance, usually massed against roiling nighttime skies, the whole scene appearing as if viewed through orange or blue gauze. Bowman spent some time in Prague, and some of the scenes do look vaguely Eastern European ("he always puts the proletariat in his work," explains Oulman, somewhat mysteriously). Taken with the rest of Bowman's body of work from the mideighties, the 331 piece feels right at home.

I ask Oulman if it does in fact depict a particular city. I tell him I'd often heard people say it was San Francisco.

"O.K.," says Oulman. He smiles enigmatically.

Oulman has been in the art business for decades, making the decision to exit the gallery scene in the early nineties. "I was tired of trying to find new contemporary art I was interested in: romantic, introspective, and beautiful," he explains. His entrée into the world of tavern-keeping came as a result of some real estate deals. He'd acquired some property over the course of a few years, and traded it for a run-down biker bar in Northeast: the 331. Describing the clientele at the time: "If ZZ Top was to do a Civil War reenactment on Harleys, they'd have done it there," he says. He thinks for a moment. "Actually, that's giving the bar more credit than it deserves, bringing ZZ Top into it." There's still a biker gang–styled screaming eagle on the floor of the entrance to the bar when you walk in, remaining as a reminder of the venue's heritage.

Under the circumstances, it seems natural that the artwork in Oulman's collection found a home here. "A lot of it was having something for people to look at," he says. "People like to see something when they're at their watering hole." A bar, he explains, is a place where people can choose to come or go. The conversations you end up having are with people who have made the commitment to be there. Everyone is gathered because they want to come to a public house, to talk, to argue, and to be social.

In that context, a bar is indeed a great place for a painting, and has been so historically. Painting, as a discipline, didn't get marquee billing, right up there with sculptural mediums, until the Renaissance. As a form, it was less rarified, much dumpier. Of all the so-called "plastic arts," writes *Cabinet* magazine contributor Yara Flores on art in ancient Greece, "painting falls to tavern walls."

Most writing about early Western painting tends to dismissively associate it with public houses and the sort of unwashed, tasteless slobs who hang out there. Woltmann and Woermann's 1880 *History of Painting* has this to say about early Roman efforts in the field: "Most of them are roughly painted and with direct reference to the spaces they are practically intended to fill. . . . Thus we find scenes of tavern jollity, fullers at work in their factories, and grossnesses of the brothel."

Indeed, one could write a whole book on the works currently in semipermanent rotation in the Twin Cities' bars and taverns. In fact, I have written about many of them: the W. C. Fields print at the Red Stag; the bizarre athletic mural at 1029 (now sadly replaced with a PBR mural); the now-vanished humanoid otters that once cavorted outside the U Otter Stop Inn; the reclining nude at Barbette: the drawings by Charles Schulz on the wall at O'Gara's; Michael Bahl's griffin skeleton at the Black Dog. You had the portraits of longtime local artist Scott Seekins at the former Nick & Eddie; the black-velvet conquistador

collection at the Kitty Kat Club. And of course, there's the signed, wall-sized print, from 1970, of Richard Avedon's 1963 photograph of the Daughters of the American Revolution hanging at the Black Forest Inn. Avedon donated it to the restaurant, next to the Minneapolis Institute of Art, when he was in town installing a show there. The piece is most notable, however, for featuring two bullet holes, added by a disgruntled, gun-toting patron in the mideighties.

Bars are, like anywhere that people gather, a place where stories are told, and ideas exchanged. Artwork shown in this context fuels that conversation, freed from the formal strictures of a gallery setting. Oulman likens the typical didactics to an order: "this is what you should think—obey!" Informal displays open up avenues for more freewheeling considerations of the work. I don't believe I'd have spent half as much time thinking about the deer overlooking the office buildings in that painting if I'd seen it once or twice in a gallery.

And I am certainly not the only one. When Oulman first opened the 331, the Bowman piece was one of the first on the wall. Of all the work he showed, it was the one that seemed to consistently attract the most interest. "I'd rotate it out, and people would ask about it —'it's, like, at night . . . there's deer.' So I said fuck it, I'll leave it up." People seem to respond to it. Oulman recounts the story of a blogger who wrote about the 331 when it first opened: "He said some nice things, and he said some nasty things." One of the nasty things the blogger said: complaining about the décor, he spat that the worst part about the place was "that *poster* of the Minneapolis skyline."

Oulman smiles again, and waits a moment for me to figure out the piece of artwork to which that blogger might be referring.

I chuckle. "It's *obviously* not the Minneapolis skyline. San Francisco makes a lot more sense."

Oulman just shrugs with a smile. "O.K.," he says.

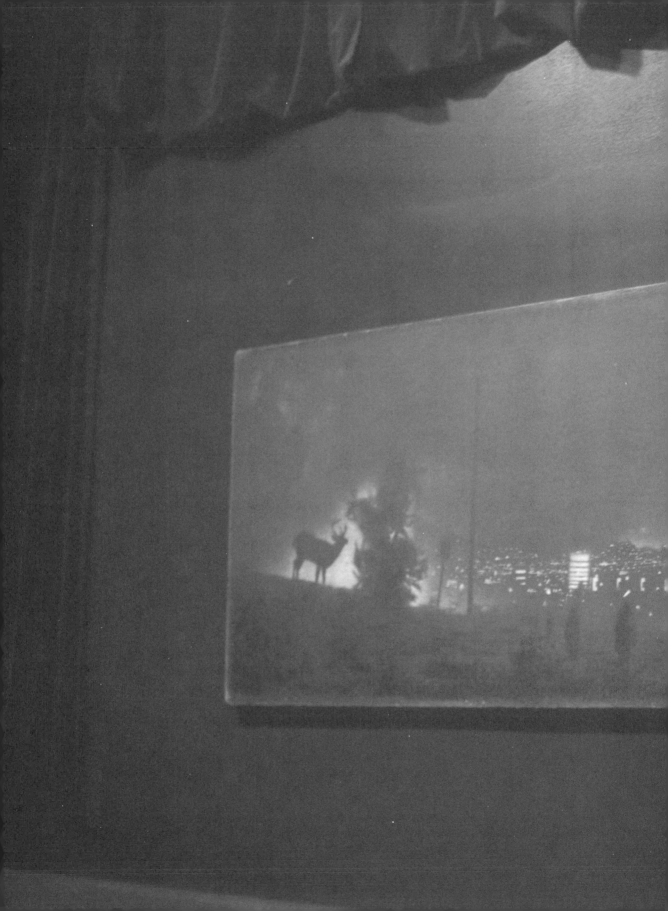

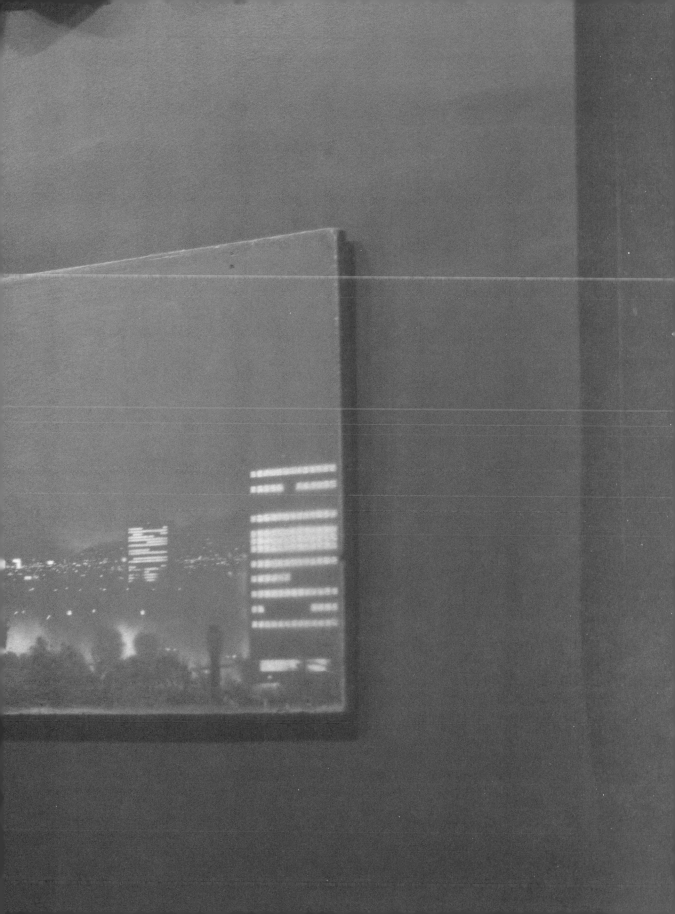

PUT UP DRYWALL, SEW, COOK, PLAY KEYBOARDS, MIX DRINKS, WRITE GRANTS

*How to make it as an artist,
using only Xerox machines, abandoned Taco Bells,
pictures of Cretan antiquities,
fluorescent copier paper, and trick sandwiches;
also: how to kiss a curator*

·

Scotch Tape, Letraset, White-Out, Rubber Cement, and Xeroxes

·

A Field Guide to the Vacant Storefronts of East Lake Street

·

The User of This Material: In the Library Picture Files

·

"First with mannequins, then with live models"

·

Ghost Crawl: Twenty-One Shows, Twenty Years Later

·

"What have we done during the time we lived?"
Death Letters from Twin Cities Print Media, 1943–2010

·

Scotch Tape, Letraset, White-Out, Rubber Cement, and Xeroxes

Sᴏᴍᴇᴡʜᴇʀᴇ ɪɴ ᴍʏ sᴛᴜᴅɪᴏ is a very handsome monograph of the work of designer Art Chantry, signed by the author when I saw him give a lecture in 2002. Chantry is not a household name exactly, but he's in that class of designers like Frank Kozik whose work is relatively well known outside the graphic design world. Chantry's medium is primarily poster art, largely done for rock bands and independent regional record labels. The fact that his work has been collected in this nicely packaged anthology speaks to his prominence as a designer. Rightfully so, too: Chantry's work has been extremely influential, and even if you don't know the name, you'd almost certainly recognize the sort of handmade fusion of low-culture/high-culture imagery in his work—it's a distinctive style that has been widely imitated since he first achieved prominence in the eighties.

You will find no real equivalent to Chantry in the world of contemporary art. There is not a graphic designer in the world—and certainly not in Minnesota—that I know of who has made creating poster or promotional art for galleries and art exhibitions the primary focus of their work. While it's true there have been a great many artists and designers who have concerned themselves with creating poster art as standalone art objects, the work that they create is very rarely about art itself. While you can easily find mass-produced posters for major museum shows in dorm rooms and dentists' offices across the world, anything made on a smaller scale is considerably more difficult to come by. Even during the high-water marks in poster art history—the Art Deco era, the Situationists, the Works Progress Administration, the Fillmore West years—there are very few art-world versions of flyers or promotional artwork akin to those beautiful Chantry posters for punk shows in dive bars and vғw halls. There are no anthologies of poster art created for the benefit of the types of smaller, independent galleries that are usually in the same neighborhoods as those dive bars and vғw halls.

Flyers for art shows are traditionally afterthoughts, designed in-house; the artist's name, the date of the show and the gallery, and an image from the show to pique the interest of the viewer. I get well-designed mailers and postcards for exhibitions all the time, but they rarely rise above the level of well-designed marketing item. Unlike the best rock show flyers, they're rarely standalone pieces of art.

In 2008, I curated a retrospective show for the twentieth anniversary of the Soap Factory, a Minneapolis contemporary art space. The exhibition drew from all the archival materials stored away, pieced together to tell the story of the organization's development—once called No Name Gallery, and later the Soap Factory, in honor of the derelict industrial building they moved into in 1995. Much of the material I drew from was promotional in nature, as this is the sort of work that tends to be created in bulk for events and then put into storage afterward. Among the wealth of ephemeral materials I was able to turn up—Polaroids, diagrams, handwritten notes, letters to landlords, exhibit maps—these promotional materials were what I found most fascinating. And I found them fascinating, I think, primarily because of how unassuming and practical they were. These materials also track the evolution of design during a critical period: the era following the advances in printing technology of the sixties (photocopying, for example), which extends right into the rise of desktop publishing as the preeminent method for creating printed materials. The world of art posters since the eighties is a microcosm where Macintoshes, screenprinting, Xeroxes, hand-lettering, the internet, rub-on transfer type, and photomontage ebb and flow, and all coexist together in strange, unanticipated ways. These leftover bits of design ephemera reflect a kind of resourceful, by-the-seat-of-the-pants sensibility that, in this age of universally available Illustrator and Photoshop programs, is largely forgotten.

Obviously artists had made a variety of simple exhibition posters for some time, using such techniques as serigraphy, photo-offset printing, and lithography. However, by the eighties, the tools at the disposal of an aspiring designer were considerably more varied and accessible: Macintosh introduced the first desktop computer publishing programs in 1984, and by the late eighties, the software for creating professional-looking promotional material was fairly accessible. In the decades after the first Kinko's opened up in the early seventies, most neighborhoods have had a corner copy center where one could make photocopies fast and cheap. Even on the low end, one could still find an abundance of Letraset, a tedious but effective dry-transfer lettering system that allowed the designer to rub individual letters one by one off a sheet of clear film onto paper.

Punk rock and the do-it-yourself philosophy happened to coincide with these small-scale technological innovations in design, innovations that made previously impossible reproduction techniques accessible to nearly anyone. (It was at this time and under these circumstances, in fact, that Chantry got his start.) In the eighties, any band, no matter how young, emerging, or amateurish, could simply find some striking imagery in a magazine, cut it out, glue it to a sheet of paper, scrawl some lettering over it, put some typewritten information at the

ANDY STURDEVANT

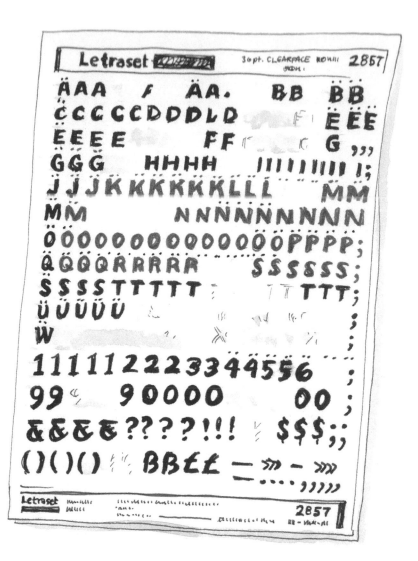

bottom, take it to a copy shop, and run off a hundred copies. Within a few hours, they could have bold, attention-grabbing flyers stapled to every phone pole in their hometown—a feat that would have been absolutely unimaginable only ten years earlier. "Computers were out of reach, rub-on letters were a luxury, so we improvised," wrote Dead Kennedys frontman Jello Biafra of punk rock poster art techniques of the time.

Any band could do it, as could an emerging artist. Looking through the pages of *Artpaper,* the Twin Cities' primary source for arts news in the eighties, one could come across any number of staid, typeset ads for shows in respectable downtown galleries. But smaller, more experimental spaces like

**PEIGNOT
Chicago
*Van Dijk***

Speedboat, Rifle Sport, and No Name Gallery were run primarily by younger artists who had grown up with punk rock. If a punk ethos was not explicitly a guiding principle for their designs, it was at least a significant cultural presence in the background. Early No Name flyers from this era echo Biafra's simple, back-to-basics philosophy. They are handmade, oftentimes by the artist whose work is being exhibited. There is an artistry to them, but there is also an appealingly rough-hewn, improvised quality that puts them closer, aesthetically, to punk rock flyers than to art prints: White-Out is painted overtop a photograph for light-on-dark lettering; photocopies of paintings are taped onto patterned paper, then reproduced on attention-grabbing fluorescent sheets of 8½″ x 11″ paper; strips of copy written in forgotten eighties-era typefaces like Peignot, Chicago, and Van Dijk are Scotch-taped over enlarged, Benday-dotted photographic reproductions. The subtlety-free impact of the fluorescent paper perfectly captures the transgressive, confrontational nature of the performance-oriented art of that time.

There is no attempt at visual uniformity or brand identity in any of these pieces—each show brings with it a different set of aesthetic priorities. It could be the work of a whole bevy of galleries, not just one. Some flyers make use of Letraset in very precise rows of neat, orderly text. Others are anarchic scrawls and drawings that refer directly to the work of the artist in the show. Still others make use of sophisticated desktop publishing techniques. The majority exist somewhere between these three approaches, making use of all of the available tools to one degree or another. A gallery logo is conspicuously absent from all of them; stapled anonymously to a telephone pole on First Avenue North next to flyers for Babes in Toyland or Run Westy Run, they must have looked right at home. These will never be exhibited side by side with posters from the Situationists or next to a retrospective of WPA artists, but they are perfect reflections of their specific time and place.

In the case of No Name Gallery, this anarchic approach to branding grew more mature through the early nineties. Jenny Carpenter came on as a designer for No Name as it became the Soap Factory in the nineties; and she was perhaps the first designer for the gallery to aim for a more unified look—her flyers all adopt a uniform size and feature consistent, sophisticated typography and graphics. Joseph del Pesco, who came on as lead curator in the early 2000s, continued in that vein, creating promotional materials that drew on a pool of themes, typefaces, and color palettes that were unmistakably made for the Soap Factory. Designer Matt Zaun made some of the best posters they ever distributed, before his death in 2007. Carpenter was herself a professional designer by trade and had after-hours access to her employers' printing technology. As a result, her work has an extremely polished look. But by the end of the decade,

extremely sophisticated professional-grade desktop publishing was essentially accessible to most anyone with a decent computer. The era of Xeroxes, masking tape, rubber glue, Letraset, and determined amateurism was over.

After the show, I sent out a call to six or seven of the best-connected Minneapolis artists and gallery owners I could think of to ask them if they had any archives from the late eighties I could have a look at. Most of them said the same thing: *I have some stuff, but I didn't really keep a whole lot of it.* The scarcity of these types of materials made the ten-year run of them all the more valuable; much of the collection is now archived at the Minnesota Historical Society.

About the time I was assembling these fliers, I'd been reading Thomas Frank's book *The Wrecking Crew,* his account of the far right's infiltration of government and their attempts to undermine it from within through privatization. I was struck by one passage in particular, in the chapter where he writes about the significant effect that direct mailings had in spurring a pre-internet conservative voting bloc to financial action. These solicitation letters, he writes, "have largely disappeared. No library that I know of made a comprehensive effort to keep up with the stuff. This form of prose changed the country, and yet it is today as obscure and inaccessible as the lost plays of Menander."

I hate to equate the promotional work of Minneapolis artists to form letters written by Reagan-era Ayn Rand disciples intended to scare widows into coughing up their cash, but there's a certain similarity. In the days before the internet, when information was not so easily disseminated, one had to spread word however one could, in ways that today may seem primitive. What's left of these ephemeral materials that aren't backed up on a hard drive somewhere? There are whole hidden histories of American culture out there that unfolded beneath the radar of libraries, museums, collectors, and the formal institutions of record, and are now mostly gone. These handmade flyers are a peek into that world that, though only twenty years old, seems, when measured in cultural time, like ages ago.

A Field Guide to the Vacant Storefronts of East Lake Street

HERE IS ONE OF MY FAVORITE NONDIRTY ART JOKES: A man walks into the studio of a celebrated sculptor in ancient Greece. He is amazed at how skillful and lifelike the sculptor's work is, so he asks him, "How is it you make these wonderful sculptures?" The sculptor answers, "Well, I start with a slab of marble, pick up a hammer and a chisel, and then I chip away everything that doesn't look like a naked guy with a spear."

I like this joke not because it's particularly funny, but because it does make an important point about the nature of art-making. Art is created when, through an artist's intention, *nothing* is transformed into *something*. You see a slab of marble, but you know there is a fully formed sculpture in there somewhere. This idea goes well beyond simple art objects too.

Every weekday, I take the 53 bus from my home in South Minneapolis to work in downtown St. Paul, and then back again. The route goes down East Lake Street, and staring out the window I notice how many attractive vacant storefronts there are between Minnehaha Avenue and the river. There's a surprising amount. The community in which this stretch of road sits, Longfellow, has always struck me as a good area for artists to live. Not ideal, mind you— it's probably not dense enough to be a truly great bohemian enclave. But all in all, Longfellow's got a lot going for it. It's not expensive, there's a lot of very attractive housing stock from the teens and twenties, it's halfway between Minneapolis and St. Paul and easy to get to from anywhere, and it's right off both the Greenway bicycle trail and the easiest to use bus line in town, the 21. There are already some artist-friendly businesses: Northwest Graphic Supply, Hymie's Records, Blue Moon Coffee, Merlin's Rest Pub. Most important, there are blocks and blocks of classic storefront retail space. If only five individual artists moved into five of these vacant spaces, devised ways to fund them, and did the most minimal coordination with each other, you'd be reading about East Lake art openings at least as often as in any other neighborhood in the city.

So in that spirit, the following is a field guide to the vacant storefronts of East Lake Street. There are many more, but these are the ones I find most appealing. Storefronts are venues for potential transformation. Art can't exist in a vacuum; it needs infrastructure to support it. And like the Greek sculptor in the unfunny joke, at least half of making art is recognizing where there is potential. There is

nothing in the urban landscape that speaks more to inchoate potential than a vacant storefront.

The problem with a field guide of this sort is that it's partially useless within a few months. Some of these buildings have been vacant for years, but in the time between assembling this list and the time you read it, the landscape of East Lake may have been altered completely—this list has one foot in the archive and one foot in the future. It barely matters, anyway. There's nothing special about East Lake Street; it's almost identical to a thousand other commercial strips in the United States that have weathered the changes in the urban environment over the past hundred years. You could take this list through your neighborhood's major thoroughfare, find similar examples to those described here, and think of them in the same way. You could, and you should.

2900 EAST LAKE STREET—FORMERLY ALL WHEELS
3800 EAST LAKE STREET—FORMERLY R.W. AUTO SALES

East Lake Street was, for some time in the postwar era, the center of automotive life in Minneapolis, second only to University Avenue in St. Paul. It was wide and long and lined with fluorescent lights, and perfect for cruising. To that end, it's still occupied by dozens of midcentury auto dealerships, many of which seem to be dead or dying, or at the very least on life support. In fact, with half of them you can't tell if they are abandoned, or if the few cars sitting on the lots are for sale. All Wheels (motto: "Your friendly neighborhood dealer since 1953") and R.W. Auto Sales (the less snappy "We buy cars") are good examples. I believe they're vacant, but every so often a few cars will show up on the lot, then disappear again. These buildings present an interesting challenge for any potential non–auto dealership afterlife: most of an auto dealership is obviously parking lots, with a tiny little building the car salesmen sit in. What can you do with that much asphalt, if not park cars on it? What can you do with that little indoor space, aside from crowd two or three car salesmen inside, and have them smoke cigars and wait for customers to wander in?

I don't have a great answer, but I will say I love these utilitarian, ramshackle little fifties structures, as well as the tacky oversized signage that surrounds them. What can go on these sites next? Maybe a drive-in theater for people in the neighborhood. Maybe a micro–sculpture park. The great Museum of Contemporary Art Detroit is built on the site of a former car dealership. If any city knows how to transform the ruins of postindustrial auto culture into art, it's Detroit. There's a reason Patti Smith said recently that if she were a young person today, she'd move not to New York City but to Detroit—because artists there are solving these sorts of problems better than anyone right now. I'm not

saying anyone needs to build a fullscale contemporary art center on East Lake, but I am saying that, as far as contemporary art is concerned, Detroit is a good place to look for ideas.

3328 EAST LAKE STREET—FORMERLY TROPICWORLD FOODS

This is a great, classic little storefront, halfway ruined by an ugly vinyl awning and some unattractive cinderblock brickwork covering up the space where the original big glass windows must have been. Tear those things away, and voila, you've got the gallery/project space/print shop of your dreams. This is everything you'd want in a storefront. It's light, accessible, and it even appears to be attached to a house. It appeared to be unoccupied, but there was no signage specifically indicating it wasn't.

I got so excited about this building, in fact, that I knocked on the door a few weeks after writing this to see what was going on. A man in there claimed to be running a business, although he wasn't clear on what kind and he appeared to be doing so without any sort of signage. So maybe I was mistaken. Or maybe he's looking for a good offer.

3533 EAST LAKE STREET

I have passed this place a thousand times, and I am convinced that it might actually be the most wholly perfect storefront in the city of Minneapolis. Everything about it is gorgeous: the scale, the wood, the coloring, the brick, the interior, even that great, empty circular neon sign, waiting for someone's circular neon logo to go inside of it. A friend who grew up nearby tells me it used to be a "health spa," which euphemistically means a brothel. If I had an extra couple thousand dollars in my savings account, I'd be writing this to you from inside there right now. I wish I'd acted sooner, because recently some of the decorative trappings like the neon sign bracket were stripped, and the front was covered by plywood. It appears to be getting a makeover, and one that, like many makeovers, will probably make it look superficially nicer, but somewhat blank.

3807 EAST LAKE STREET—FORMERLY RIVERSIDE CLUBHOUSE

Besides "health spas," East Lake Street used to be known for its neighborhood bars; over the past few decades, they've all seemed to disappear. I have no idea what the story is on this place, other than it used to be called the Zan-Z-Bar in the early eighties; it's been unoccupied for as long as I can remember. But what a classic façade! I can only imagine how great the interior must look. I imagine it's a lot of dark wood, tin ceilings, and nicotine-stained linoleum, probably covered with plywood, but waiting to be stripped down by some

ANDY STURDEVANT

enterprising young woman or man. Here, more than almost any of these store-fronts, is a commercial space begging for some attention. Keep the signage, including the one that boasts of there being a "phone inside." If you opened an artists' bar here, I'd be in every day and twice on Saturdays. Trust me on this one: in the right hands, the Riverside Clubhouse is the Max's Kansas City of the greater southside.

4020 EAST LAKE STREET—FORMERLY TACO BELL

O.K., so this place was obviously a Taco Bell at some point. No getting around that. So honestly, I'm a little unclear what the next step might be. But I guess it's got some value from a marketing perspective: "Oh, you know, it's the place on East Lake that looks like a Taco Bell." Across the street, a vacated building recently became a coffee shop and modern furniture store; the owner tells me he'd heard someone might be moving in on this space soon, though he was light on details. I'd want to keep it under wraps too, because the potential for failure is great with this one. It is perhaps the ultimate entrepreneurial challenge—I don't even know if the most brilliant artist in Detroit could think up a credible use for a former Taco Bell. But maybe this just demonstrates the limits of my own imagination.

The User of This Material:
In the Library Picture Files

UP ON THE THIRD FLOOR of the Minneapolis Central Library, past the racks of CDs and near the drawers of sheet music, there are several rows of file cabinets, each nearly five feet high, containing hundreds of thousands of black-and-white and color images of nearly every subject. It's the library's picture files.

If you're a designer, history nerd, artist looking for inspiration, amateur historian, or simply the sort of person who enjoys looking at dozens and dozens of photos of pinball machines in one sitting, it's one of the best resources around.

In the years before Google Image Search, librarians collected hundreds of thousands of images, from books, magazines, educational tools, and miscellaneous printed ephemera, and organized them by subject. Mostly these were outdated or remaindered books, or magazine duplicates, or local newspaper and newsletters that came through the library's circulation department. Journalists used to call them a "photo morgue." Isa Gagarin, a Minneapolis-based artist whose work draws extensively on anthropological field photography, first brought the picture files to my attention a few years ago. In an interview on the blog *Library as Incubator Project,* she described the process of using the picture files in this way: "It suited my appetite for visual culture because it was so random and dense: pulling open a drawer meant rifling through hundreds of pictures from all stretches of printed media and ephemera. It felt unorthodox to encounter an image uncoupled from the context from its source, in an institution so formal as a library."

The picture files are holdovers from a predigital era, which is why I'd imagine Isa was drawn to them (and certainly why I am). When an item of any kind outlives its previous usefulness in the physical world, it begins to make that long twilight journey into the expansive and mercifully forgiving realm of art.

Which is not to say these images have outlived their usefulness entirely. It's a great, extensive collection of all kinds of images, the vast majority of which have never been digitized. Which means, mostly likely, you've never seen them.

Here is a tiny sampling of the file folders in just a single row in one of dozens of drawers: *cotton, country stores, cowboys, cowgirls, crate labels, Crete, Cretan antiquities, cricket, crime and criminals, Croatia,* and *cross-dressing.* The cross-dressing category somewhat mysteriously contains a 1994 photograph of musician PJ Harvey I actually remember seeing in *Rolling Stone* at the time, possibly selected by a long-ago librarian whose critical faculties were temporarily overwhelmed

by Polly Jean's fur coat and garish makeup. Each of these categories contains dozens of photographs.

What's striking about the picture files is not merely the breadth, but also the way in which they're presented. As with going through pages of Google Image Search results, the best part about flipping through each subject folder is that the images are totally free of context. Beyond the subject heading, they're gloriously disorganized. The images have mostly been cut out of magazines, only sometimes with their captions preserved.

Sometimes a librarian has notated the source material, but other times there is no notation. It's not always clear where the photograph has come from. Some of the sources are recognizable. In fact, I see a few of the first photos cut from the pages of the first magazine I was ever published in, the late, great *Rake*. Others are not recognizable, shorn long ago of surrounding contextual information. Clearly ancient, yellowing prints sit side by side with glossy pictures that are only a few years old.

They're not in chronological order either. In keeping with some of the concerns of this book, I selected the "Minneapolis streets" folder to see what's in there. It's a treasure trove of photos of street scenes, jumbled out of order into a never-was downtown streetscape where the Pence Opera House, Shinders, a prepornographic Gopher Theater, the Hiawatha LRT, the Gateway District, and the skyways all exist in the same space.

Perhaps the most remarkable thing about the picture files is that you can actually check them out. Pick a few, pack them in an acid-free binder the library provides, and take them home with you. There's something wildly endearing about the open-ended public service quality of all this. There are no guidelines for what to do with the images. Do anything you want with them.

Or almost anything: A label on each folder points out that "this material may be protected by copyright law," and that "the user of the material assumes responsibility for copyright infringement, and agrees to hold the Minneapolis Public Library harmless for any misuse of such material." As we have learned from a decade or so of online intellectual property disputes, just because you have access to an image doesn't give you license to reprint it wherever you want. I've taken my chances here, and selected a few from the "Minneapolis streets" that caught my eye.

I'm particularly smitten with the strange little residential house that's covered with the type of signage one usually finds on the inside of a family restaurant. Judging from the attire of the young man walking by, I'd guess the seventies or eighties. But of course, a beard like that could come from almost any point in the last forty years. A woman who reads my weekly column later told me the house was located on Minneapolis's West Bank, and was torn down

to make way for the University of Minnesota's expansion. "An eccentric hippie named Fred lived there and collected signs," she said. "The fellow in the picture is named Jim, who now lives in Madison, Wisconsin." She added: "I know. I was there."

Several images seem to come from a Whittier-based guidebook of some kind, printed on a creamy, textured stock and typeset in the ne plus ultra of seventies typefaces, Souvenir. Since the pages are a little cut up, it's hard to tell exactly what's going on, but they seem to outline a public art plan, part of which seems to include drawings in wet cement on the sidewalks by MCAD students: typically addled, oddball Nixon-era stuff, like pointing fingers, Jesus fish, and a roller coaster.

The most interesting part is a proposal by the noted Minneapolis artist Hollis MacDonald for a mural on some blank walls at Twenty-Sixth and Nicollet. MacDonald is one of the most interesting Minneapolis artists of the past few decades, and I'd never heard of this mural before—to my knowledge, it's not there anymore, if it was even there to begin with. "The larger purpose is to enhance the aesthetic environment which is now dominated by parking lots," notes the accompanying text. That sentiment sounds just as at home now as it did whenever it was written.

A lovely photo essay of Hennepin Avenue in the sixties or so promises "bus stops, bistros, newsies, nudies, markets and movies." Some of those things you can still find on Hennepin, right? Hidden in there is a familiar face. Peeking past the neon signage is that wooden can-can dancer smoking the cigarette that now stretches horizontally over the top of the bar across the river at Whitey's Saloon in Northeast. She's one of the few remaining links to Hennepin Avenue's heyday as the region's premiere destination for lawless, alcohol-drenched mayhem. Hennepin Avenue, where the horizontal dancer once stood upright over an establishment called the Saddle Bar, one of the handful of nudie bars in the old Gateway District. The photo here alludes to the fact that whole district was so spectacularly, violently, and giddily out of control that one gets the sense that the Keilloresque reimagining of Minneapolis's civic identity as a repressed, polite, semirural Nordic enclave in the seventies and eighties was a conscious conspiracy on the part of terrified city fathers to whitewash this particularly rambunctious past out of existence. Somewhere along the line, the dancer found her way to an industrial surplus wholesaler, and then to Whitey's Bar, where she is today. No matter how much Minneapolis seems to have changed, it's good to know we can still find our friends if we look hard enough. The image is decoupled from the context, like Isa says, but it doesn't take much to begin to put them back together again, and get a little story out of it while doing so.

ANDY STURDEVANT

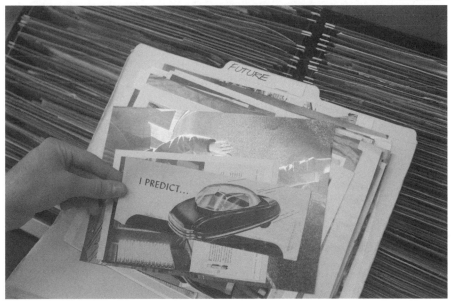

"First with mannequins, then with live models"

IF YOU'RE A PERSON ACTIVE IN THE WORLD OF VISUAL ART, you are often called upon to greet other art world acquaintances living and working in places like New York or Europe. This is usually great, because it means you're going to get to hear some important gossip about what's going on up in the big leagues, but there is often one minor difficulty you'll have to deal with first: most of the time, the New Yorkers/Europeans will want to kiss you on the cheek.

Now look: I like kissing people on the cheek. This has nothing to do with received notions of midwestern standoffishness. I have kissed lots and lots of midwesterners, both on the cheek and on the mouth, and I am a supporter of kissing in all of its many forms. But the fact is, greeting people by kissing them on each cheek involves specific maneuvering that one refines over the course of many years, and for whatever reason, people in the Midwest don't kiss each other on the cheeks very often. Even the art people. I don't why this is, exactly—maybe it *does* have something to do with standoffishness. But midwesterners do other things. Sometimes they hug, or half hug, or shake hands, or snap finger guns at each other, or pat each other on the back and say, "Good to see you, good to see you." There's a wide range of physical expression.

As great as all those forms of physical expression are, they're not the same as cheek kissing. Art people from New York and Europe have much more practice in this because they kiss each other on the cheek several times a day. As for myself, I am only in a situation a few times a year that calls for me to greet someone by kissing them. The will is there, but the technique is lacking.

It's not just me, either. For example, I was at the Minneapolis Institute of Arts once with an artist friend—a very smart, sophisticated native Minnesotan who studied in New York, lived there for years, and shows work nationally. While we were talking, an East Coast–born curator he knew walked by. He got up, and they greeted with the traditional hug and kissing on the cheek. It looked fine from where I was sitting, but he admitted to me afterward that this *still* makes him feel awkward. Not the kissing itself, but the stilted quality of his technique.

ANDY STURDEVANT

While it's hard to teach someone to not feel awkward, we realized, it's easy to teach technique. It was then we hit upon the idea of offering a workshop for midwestern art people on how to best kiss people from New York or Europe on the cheek when you meet them. It would cover need-to-know areas such as the best angle of approach, the precise amount of time the kiss should last, which cheek to do first, etc. Over the course of a few hours, with a little lunch in the middle, attendees would learn valuable techniques to this art form, first with mannequins, then with live models. By the time the workshop is over, attendees would be able to confidently greet art acquaintances by kissing them on the cheek as well as any native of the Upper West Side or East Berlin.

Here is a helpful outline, with diagrams:

Approach the right side. Cheek kissing is like reading Arabic or Hebrew: it goes right to left. The right side is always first. If you're the one being kissed, present your right cheek.

Lean in, don't step in. Grasp the other person lightly around their elbows. It's like a hug, but with a little more space between you. Don't grasp too tightly, and don't go in for a bear hug. Keep it light.

The kiss should land on the cheek for just a moment. Most the time, it doesn't touch at all. Make sure your lips aren't too wet. I mean, don't wipe your mouth with your sleeve before you go in or anything—you won't have time anyway—but do what you can. There should be very little moisture upon contact.

If the cheek is bearded, don't try to kiss around it. The kiss should land right about where the molars meet. A little lower is O.K. if you can't avoid it, but probably not any higher.

After you've made contact, pull your head back slowly in an elliptical motion. Don't make a beeline to the other side across the person's face. Don't make eye contact while you're going from one cheek to the other, unless you're trying to be weird.

Still grasping the other person's elbows, kiss the left cheek in the same place you kissed the right cheek.

Pull back, slowly disengaging your grip. Let your arms fall to your side. Stand back and make eye contact with the person you've just kissed. Smile.

All of this should take no more than about four seconds. Now go kiss some curators.

Ghost Crawl:
Twenty-One Shows, Twenty Years Later

IN THE SATURDAY, SEPTEMBER 9, 1989, ISSUE of the Minneapolis *Star Tribune*, art writer Mary Abbe wrote a column entitled "Lush growth of art blooms in 21 shows." In it, she previewed a few of the art openings going on that evening, mostly in and around the Warehouse District in downtown Minneapolis. "Nothing demonstrates the unprecedented expansion of the Twin Cities art scene better than the 21 galleries that will premiere new shows tonight," she wrote. "That's right, 21." The art calendar published on the same page confirms this with half a broadsheet-sized page packed full of gallery listings, many of them within a five-block radius around First Avenue North and Fourth Street North. It was near an area sometimes known, in a pique of nihilistic eighties art humor, as NoWare (North Warehouse, get it?), but then as now more generally familiar as the Warehouse District.

Twenty-two years later, the idea of so many shows opening at once is still pretty hard to imagine. Outside of the annual Art-A-Whirl weekend gallery crawl in Northeast Minneapolis, I can't recall the last time I went to even five shows in the same evening—especially on a regular September weekend night. It's also incredible that all of these exhibitions were within walking distance of each other; attending multiple openings in the span of one night generally means traversing large swaths of city by bike or car.

If you're an artist in Minneapolis, you likely know the broad outlines of the Warehouse District story: the artists and gallerists thrived for a while, until they were run out by stadiums, sports bars, strip clubs, economic downturns, and rising rents. Some galleries relocated, most shuttered. Artists moved elsewhere, dispersing throughout the city—into Northeast Minneapolis, Lowertown St. Paul, the Lake Street corridor. While I realized I knew barebones details of this story, reading Abbe's piece, I wondered what it would actually feel like to *be* in the area of all that many-years-ago arts activity. What are these buildings and spaces like now? How are they used? What do they look like? What do they feel like?

One Friday afternoon, before a Twins home game, I bicycled down to First Avenue with a photocopy of the newspaper article, a map, a sketchbook, and a camera to find out for myself—to undertake a Ghost Crawl, two decades later. I picked a Twins game day because I figured people would be out en masse, replicating to some extent the feel of a large weekend gallery crawl.

Most of the artists mentioned in this piece are still living and working locally. I debated whether I should e-mail some of them and invite them to

ANDY STURDEVANT

come with me. I decided against it, ultimately, as I wanted to make this walk by myself, and find out how it felt to be in these spaces, with no immediate links to their storied pasts.

Ten of these spaces were inside the Wyman Building, located at 400 North First Avenue in the Warehouse District, so that seemed like the place to begin. The Wyman was perhaps the flagship space of the Warehouse District art scene in the eighties. The exterior looks much the same as when it was built as a warehouse for dry goods sellers in 1901 (it's one of the most prominent features of the skyline visible from Target Field—the building with the rooftop water tower). The inside, however, was completely renovated in the mid-2000s, and now appears to be a totally different space than the one that housed those ten galleries in the eighties.

I start at the top. The seventh floor, where **Jon Oulman** and **Vaughan & Vaughan** were located in suites 706 and 712 respectively, is now a single open office space occupied by the advertising agency Colle + McVoy. The elevator opens right into the reception area, where I am instantly regarded with suspicion by the woman at the front desk (probably because I have my camera with me). I take a look around at the very polished, wildly well-appointed space, mumble a ridiculous lie about my dad once working there, and turn right around, back into the elevator. On this floor twenty-two years ago, Vaughan & Vaughan exhibited sculptures by noted New York artist Cara Perlman.

The openings on the third floor of the Wyman that long-ago evening were **Thomas Barry** in 304 (multimedia artist Bruce Charlesworth), **Georgean's** in 312 (four Israeli artists), **Sonia's** in 318 (wood sculptures by Glen Elvig), and **Textile Arts International** in 340 ("Brocade: Cranbrook Style"). Again, the individual suites are gone today, and this entire floor is now occupied by a publisher. They appear to have lovely offices, but the receptionists don't seem eager to have me wandering around with a sketchbook and camera.

The second floor of the Wyman was occupied by **Anderson & Anderson** (240), who were showing new work by sculptor Wayne Potratz, and **Peter M. David** (next door in 236), who was exhibiting prints by nationally known heavy-hitters Dine, Hockney, and Motherwell. This floor seems the most unchanged since the late eighties. Both 236 and 240 are still present and accounted for: the latter is occupied by the offices of Connect Retail Services ("where the customer meets your brand"), and the former is currently vacant, with drawn wooden slat shades. It's not hard to imagine a small gallery in either one.

The first floor of the Wyman—that once housed **Hastings Ruff, Flanders Contemporary Art,** and **Bockley Gallery**—is pretty empty now, consisting mostly of polished marble floors, light fixtures, and a large entry atrium. There seems to be only one office suite, occupied by Sight Marketing, and it doesn't match any

Wyman Building
400 1st Ave. N.

Anderson & Anderson
SUITE 240

Bockley Gallery
Peter M. David
SUITE 236

Flanders Contemporary
FIRST FLOOR

Georgean's
SUITE 312

Hastings Ruff
SUITE 134

Jon Oulman
SUITE 706

Sonia's
SUITE 318

Textile Arts Int'l.
SUITE 340

Vaughan & Vaughan
SUITE 712

of the suite numbers I have. Twenty years ago, painter Charles Thysell was at Hastings Ruff (in fact, that night was the gallery's premiere), painter Don Holzschuh was at Flanders, and Bockley was opening an exhibition of outsider art. Bockley is the only gallery still in business today and is now located in Kenwood, a few minutes drive southwest of the Warehouse District. The first floor of the Wyman is now home to two of those Warehouse District nightclubs

Peter M. David
Suite 236

with stupid one-word names: Aqua and Envy. Other nearby clubs: Elixir, Epic, Karma, Drink.

Exiting the Wyman, I head a block south to the one-time site of **Peterson Fine Art,** at 506 First Ave. North That night twenty-some years ago, the gallery featured oil paintings by MCAD alumnus Wayne Ensrud and prints by French Cubist Max Papart. The space is now the home of Pizza La Vista, a gyros-and-pizza joint catering to the late-night club crowd. Despite an obvious remodel, the interior still looks as if it could be a white-wall gallery space, with exposed brick and high ceilings. In the pizza joint, two TV sets play a country music satellite station. I buy a Coke and sit at one of the tables. The spot feels quite lively, with Twins fans crowded onto the sidewalks, heading for the ballgame.

The Forum Gallery, located in the Textile Building at 119 North Fourth Street, was exhibiting sculpture by Stewart Luckman that evening. The Textile Building is now the home of the downtown Pizza Luce on the first floor, and Public Radio International occupies much of the rest of the building. There is a cavernous unoccupied space located on the corner of Fourth Street and Second Avenue, visible through the window; it's easy to imagine that space filled with the sort of large-scale marble sculptures Luckman (who now lives in Washington state) appears to have made during that time.

Mhiripiri Gallery was located in the Butler Square Building at 100 North Fifth Street in Suite 268, where you'd have seen paintings by Ellen Eilers (who, at

The Forum Gallery
119 N. 4th St.

age ninety-four, still paints colorful landscapes of the Upper Midwest). When I walk into the Butler Square Building, I must look lost, as an overzealous security guard jumps up from his post and asks if he can help me. I ask for Suite 268, which he tells me no longer exists. At some point, 268 must have been renovated out of existence; it's now a ghost suite located between Fluid Interiors in 200, and the General Store in 275.

The Minnesota Center for Book Arts (in 1989, showing the work of recipients of the third biennial Jerome Book Arts fellowship) was located at 24 North Third Street. MCBA is now located in a beautiful, spacious building on Washington Avenue. The space on Third Street is now the home of Nami Sushi. The facilities at the current-day MCBA are so expansive and well appointed, it's hard to imagine the center fitting inside this lovely, intimate restaurant.

A bit farther up First Avenue, **No Name Gallery** (100 North First Street), then only in its second year, was debuting work by photographers Rik Sferra and Sara Belleau that night. A few years later, No Name was run out of the area by

Peterson Fine Art
506 1st Ave. N.

the u.s. Treasury, which built a high-tech, sprawling campus right behind it. They eventually relocated to the old National Purity soap factory across the river from downtown. There they became known as No Name Exhibitions at the Soap Factory, and then, simply, the Soap Factory. Their original building, known as the Foster House, is now the home of Hess Roise and Company, a historical consulting group that's worked on some notable projects around town, including the Foshay restoration. The exterior looks much the same as it must have in the late nineteenth century, or the late twentieth.

The Women's Art Registry of Minnesota at 414 First Avenue North was opening a group show of Native American artists that night. The building that housed

Mhiripiri Gallery
Butler Sq., Suite 268
100 N. 5th St.

them is one of those gorgeous red brick warehouses right next to the Wyman. WARM was one of the earliest arts groups to set up shop in the area. WARM is still active as an organization, but their original building is now vacant, its windows papered over. It was obviously the home of a restaurant or bar recently, but I can't for the life of me recall which one, and all identifying signage has been stripped away. I peek in the window, past the paper, and there are piles of dusty stools and cardboard boxes inside. A sign on the front door reads, "CLOSED UNTIL FURTHER NOTICE."

Below the Surface, at 27 North Fourth Street, billed themselves as a "printmakers' atelier," and September 9 was the space's opening night. A cooperative printmaking studio that operated until 1999 run by a printmaker named Denese Sanders, the space was an open studio for other printmakers. While

MCBA
24 N. 3rd St.

there, I reflect on some of the differences in the language of art practice then and now: a similar space opening today would likely never refer to itself as an "atelier," but as a "collective" or "collaborative." The word *atelier,* and its associations with classical realism and top-down instruction, are deeply unfashionable at the moment. The century-old building was, until recently, the home of an upscale Indian restaurant, but it closed a few years ago after the building was foreclosed on. The restaurateurs seem to have made a hasty departure; a shredded neon green sign glued to the front door notifies anyone who cares to read it that the locked-up building contains equipment belonging to Coca-Cola, and whoever's in there next better give it back.

Thomson Gallery, located at 321 Second Aveue North, is noted in the body of Abbe's article ("'This year has been one of our busiest ever,' said owner-director

WARM
414 1st Ave. N.

Robert Thomson"), but the calendar doesn't list an opening that evening. Presumably they were open—I mean, it was a big night, right? Despite featuring a graphic for an apparently defunct group of crafters and artisans on the window (the website listed is inactive), the building's windows are covered and the space appears to be vacant. It's in a slight state of disrepair—boarded windows, missing bricks.

The entire block seems deserted.

In fact, I am surprised at how many of these spaces are now vacant. New stadium and nightclubs aside, walking this route now is probably closer in some respects to what it must have been like in the early eighties than in the years immediately following 1989. Before coming out here for this "ghost crawl," I fully expected to encounter an advertising agency or sports bar in every one

ANDY STURDEVANT

of these sites, crouching inside the shell of an identifiable one-time gallery. Instead, I come across boarded windows, dust, and derelict signage as often as I do thriving upscale boutiques. Perhaps we're coming around to the end of the cycle that began when artists twenty-some years ago discovered the infrastructure of the Warehouse District was cheap and spacious enough to make for a good home, and which crested when the developers and opportunists started to price them out. Maybe the cycle is just waning, putting us back at some point that seems more like a beginning.

Obviously, the Warehouse District will never be what it once was; history doesn't work that way, and there just aren't many examples of city districts being adopted by artists, then abandoned, and then adopted again a generation later. However, in some of the spaces—the old Thomson space in particular, and the last I saw before heading off—I was surprised at how abused and cast aside they seemed. They also looked full of promise—exactly like the sort of space an enterprising young gallerist might want to move into.

Below the Surface
27 N. 4ᵗʰ St.

"What have we done during the time we lived?"
Death Letters from Twin Cities Print Media, 1943–2010

FROM 2007 THROUGH 2010, I wrote regularly for a semimonthly arts paper called *Art Review and Preview!*, or *ARP!*—always with the exclamation mark, and not to be confused with the official magazine of the American Association of Retired Persons. (The founders, Tiff Hockin and Ariel Pate, later told me that when they chose the name, they'd never heard of AARP.) For four years, Tiff, Ariel, and Troy Pieper provided a print venue for reviews, essays, interviews, and local art historical pieces that still hasn't been replaced. Eventually, the time came for the editors to move on to other ventures—graduate school, relocations, other jobs. The three editors released the final issue in fall 2010, republishing some favorite older pieces and commissioning some new ones. They asked me to contribute some notes on endings.

To prepare for my piece, I camped out for several days at the microfilm library in the Minnesota Historical Society, reading the final issues of other Twin Cities–based arts and culture publications from the past seventy years, in order to get a sense for how *ARP!*'s final issue might look. I was most interested in the letters from the editor that either introduced or concluded each issue. Many of the publications anticipated their own demise, although some clearly did not.

I collected about two dozen of them, and assembled the best for *ARP!*'s final issue. Some were shortened or minimally edited for readability, but they were presented basically as printed, in order for the reader to contrast the varied flavors of the publications. Typographical errors, inconsistencies, and eccentricities were preserved to that end.

In each of these letters, the editor tells a story about the circumstances under which his or her paper folded. Each set of circumstances is unique—war, illness, death, editorial infighting, geographic relocations, dwindling subscription bases, flagging interest—but there are common threads running throughout. Actually, there are only two common threads: there is always a lack of money, or there is always a lack of time. Regularly putting out a magazine is a difficult and all-consuming task. When the time came to end this task, there was a wide range of approaches the editors took: humor, candor, tact, anger, self-righteousness, resignation, or optimism, and sometimes many of these at the same time.

Here they are once again, including, in its rightful place, the final editorial letter from the final page of *ARP!* On the final page of the issue, contributor

Elbert Mueller quoted H. L. Mencken's famous epitaph: "If, after I depart this vale, you ever remember me and have thought to please my ghost, forgive some sinner and wink your eye at some homely girl."

CENTRE AISLE
FINAL ISSUE: FEBRUARY 3, 1943

Centre Aisle was a St. Paul–based "journal of the non-professional theatre," published monthly from February 1936 to the end of 1940 and weekly from January 1941 through this issue. The paper was affiliated with the Association of Communal Theatre (ACT), and this letter is signed by ACT's president, Albert Johnson. Despite the announcement of Centre Aisle's *relocation to Iowa, there is no record of the paper being published again after this issue.*

Our editor of Centre Aisle, William Merle, is off to the wars. A few ACT members and readers of Centre Aisle are aware of the singular work he has done in building this paper from scratch and in being a potent part of the impetus that became ACT. Not many know of the industry, patience, initiative, imagination and sacrifice that he has invested.

Some there may be who, spoon fed on slicks, couldn't see the real value of this sheet for fussing over occasional typographical errors and the carefree makeup of this paper. I know of no one who paid his dollar a year for Centre Aisle who doesn't feel that he is getting his money's worth in vital theatre news and spirited inspiration.

The theatres of America owe a debt to Private William Merle of the U.S. Army. Unfortunately, it is one of those debts that will probably not be paid until some student of theatre history a hundred years hence digs up the name of the founder and first editor of Centre Aisle and writes a book about it [. . .]

The business and editorial offices of Centre Aisle and ACT are moving to Mt. Vernon, Iowa. This issue (Feb. 3) of Centre Aisle will be the last published in St. Paul for the duration.

The next issue (Feb. 10) will be published at Mt. Vernon. Transportation difficulties and other war conditions may delay the next issue [. . .]

If there is a delay in getting out the next issue your subscriptions will be extended for the period of the suspension.

The Whoozit Sandwich
FINAL ISSUE: SEPTEMBER 1945

The Whoozit Sandwich *was a monthly bulletin for members of Minneapolis's Typographical Union No. 42 serving in the U.S. Armed Forces between 1944 and the end of World War II. This column was prefaced with news of V-J Day.*

THE WHOOZIT IS A 'WAR CASUALTY'!

WHOOZIT SURRENDERS UNCONDITIONALLY!

What an announcement! It will be welcome news to all youse guys and girls who have been pestered with our dribblings for a year-and-a-half. When the Whoozit Sandwich was resurrected in May, 1944, it was for the purpose of writing a letter to all the guys of No. 42 serving in Uncle Sam's armed forces . . . and now that the war is over and the guys are moving so rapidly that Secretary Brecht can't even keep a mailing list [. . .]

From now on, though, until you guys all get home, The Whoozit staff is going to indulge in a few dreams—the best of which, we hope, will be one that will find us all sitting down to a heaping platter of cheese sandwiches, a few bottles of cold beer and a lotta conversation. And we're going to pray that the dreams come true . . .

It's goombye for now . . . and if it happens that The Whoozit doesn't print an October issue—it's goombye from now on . . . until, well, let's get that dream above mentioned a reality.

FOLKEBLADET
FINAL ISSUE: JULY 30, 1952

Folkebladet *("People's Newspaper") was a weekly paper serving the Norwegian Lutheran "free church" community from 1877 through 1952, when it was absorbed by the* Lutheran Messenger. *It was one of many regular weekly papers published for the Norwegian immigrant community in its native language—there were a large number of Swedish, German, Finnish, Danish, and French papers, as well. As the first few generations of Scandinavian immigrants began to die, so too did these foreign-language papers. This editorial, written by editor Sverre Torgerson, appears in the final issue. He also includes, at the end, a note from one Albert A. Horvald of Grafton, North Dakota. Many thanks go to Evy Adamson for translating these words from the original Norwegian.*

It's not without sadness we write this, our last editor's article for *Folkebladet.* It's always sad to say goodbye for the last time to a good friend. *Folkebladet* has been one of these good friends the forty years we have known and read it.

It's been a long and hard, often contentious but fruitful life, and it has left a mark.

It's not important to have long "complaints" and point out in detail the service *Folkebladet* has conducted. During these many years, it's been vivacious

and liberating, meaningful work. It has tried to be true to its motto: "A paper for the church and the people." [. . .]

Truth can be hard to hear and troubling opposition, but it never dies. Where it takes a foothold in the heart, it liberates both the mind and will. We ought to believe that it has been the fruit of *Folkebladet*'s work these many years. [. . .]

God's riches will and must go forward. It's not dependant upon this person and this organization. This can be taken as a piece on the way. There will be other people and other organizations to send the matter further forward.

DEAR EDITORS!

It is with sadness I must say farewell to *Folkebladet*. I have had it for many years and have taken much pleasure from it. Many thanks to everyone who wrote and held out so long with many good reads. It will be sad when the paper doesn't come anymore. But so is life. We become old and must go, but then there is the question: What have we done during the time we lived?

MIDWEST SCANDINAVIAN
FINAL ISSUE: SEPTEMBER 1959

Midwest Scandinavian *was founded in Chicago in 1890 as* Ugebladet, *a Danish-language newsweekly.* Ugebladet *relocated to Minneapolis in 1929, where it was published weekly in Danish until 1945, when it became* Midwest Scandinavian. *Published monthly from 1945 in English, the masthead declared it "a monthly journal for American-Scandinavians everywhere." In early 1959, publisher Axel H. Andersen was hospitalized, and the paper missed several issues. A short, hastily assembled April 1959 issue announced a new editor and included a bizarre editorial accusing an unnamed rival paper of an attempted (presumably metaphoric) "assassination." Only three issues of* Midwest Scandinavian *appeared afterward. This is the "assassination" editorial from the April 1959 issue.*

ASSASSINATION ATTEMPTED

Now when it is all over, the thought of midwestern Scandinavian's funeral seems a big joke. Still, some twisted idea popped into a competitor's mind; and though flowers had not been ordered, the end was well foreseen.

Great pain was taken to mail notices of our funeral while the body was still warm, and sharp penpoints stabbed down a necrology that has no serious

consequence. Such a little fake funeral is rather amusing: It is like going to some gramp's funeral now and then, when some excuse is needed for a game of baseball.

As the funeral is cancelled, a good look at the beautiful sky above and all the wonderful people below the skies seems to be in season. Something hopeful about the sky throws a new light on the subject of the people. After all, we are still alive and for one great purpose: Others. And "others" are people that live here, that share the great heritage of the original little nest which our forefathers came from. The serfism of small thoughts shall have no consequence as to build a wall between the Scandinavian-American interests.

The Midwest Scandinavian is back to you, stronger than ever. Apparently, the much talk of being absorbed by another paper has boosted our subscribers' and other friends' interest. [. . . N]ew subscribers and a commendable number of renewals are added to the list every day of our blessed life. Also, this is no time to dream of 78 years of failure and neglect. So we are working hard on getting the paper out to our many friends, and some of our new salesmen are readying themselves for a new get-acquainted-job.

THE POTBOILER
FINAL ISSUE: SUMMER 1967

The Potboiler *was the regular newsletter of the Kilbride-Bradley Art Gallery in downtown Minneapolis, published between 1954 and 1967. The editor, Robert Kilbride, wrote an engaging mix of local art world gossip, reviews, non sequiturs, and previews of upcoming exhibitions. In the magazine's final issue, Kilbride makes the following baseball predictions. Though there is no indication that it is the final issue, his prediction (not reprinted here) that the Twins would finish third in the American League that year turned out to be very nearly correct—they tied for second with Detroit.*

Now after Harmon Killebrew hits 63 home runs and Detroit beats Pittsburgh (4-2) in the World Series, I'll reprint all this plus the dumb predictions by the dumb 15 or more in the fall issue of the Potboiler. Now . . . just for fun, lets say none of this happens . . . then nothing about baseball will appear in the fall Potboiler. Dull art talk will return with much yawning right behind.

My last prediction. I predict a great year for me and my ilk at the ball park what with the new 16 ounce draft beer and the new trick sandwiches.

TWIN CITIAN/NEW TWIN CITIAN
FINAL ISSUE: DECEMBER 1970

Twin Citian *was a glossy monthly magazine launched in 1961 that carried a sophisti-cated mixture of lifestyle features and straight journalism. At the beginning of 1970, pub-lisher Ron Bacigalupo relaunched the magazine as the more explicitly political* New Twin Citian: *"Bromides of past* Twin Citians—*articles having to do only with what is in good taste, with what is 'sophisticated'—are no longer enough." The new magazine consciously modeled itself after* New York *and* Esquire *("they 'tell it like it is,' from Buckley to Mailer"), but the quality declined sharply throughout the year; the Decem-ber issue contained only four articles and a handful of regular columns. There was no indi-cation it would be the final issue, with the possible exception of this fishy-sounding advertisement that appeared in the back:*

SKI AND SEE BRECKENRIDGE, COLORADO

JOIN A TWIN CITIAN TOUR TO ONE OF COLORADO'S FINEST SKI AREAS.

Fly with us for four days and three nights of skiing and fun. Stay in com-fortable family-sized condominiums and enjoy some of Colorado's best skiing.

While there, an opportunity will be offered to those interested to survey the housing and land investment opportunities of this fast developing recreation area.

For more information call or write TWIN CITIAN.

HUNDRED FLOWERS
FINAL ISSUE: JANUARY 28, 1972

Hundred Flowers *was a weekly New Left underground newspaper based on the West Bank and published from April 1970 through this issue. The newspaper's name was derived from a saying by Chairman Mao quoted in the paper's masthead: "Let a hun-dred flowers blossom, let a hundred schools of thought contend."*

Sales from the last issue aren't known, yet, so we'll have to wait and see whether we're solvent. POT LUCK SUPPER WEDNESDAY MAY 17, FOLLOWED BY A PAPER MEETING. Or, if it can't wait, stop by the office first at 20th and River-side, on the second floor of the People's Center. PHONE IS 338-1444. Lost Phil's reply to Frank's Community Media article. It's got to be somewhere around the office, and as soon as it's found, it will be printed.

METROPOLIS
FINAL ISSUE: SEPTEMBER 6, 1977

Metropolis *was an alt-weekly magazine that emerged just before* Twin Cites Reader *and* Sweet Potato (*later known as* City Pages). *It featured a well-written mix of investigative reporting, news analysis, cultural commentary, events listings, and arts reviews. It was published weekly from October 1976 through this issue. The letter is signed by editor Scott Kaufer and managing editor James Gleick and seems to allude to the free weeklies that would thrive throughout the eighties and nineties.*

We are sad to report that this will be the last issue of Metropolis. It has been nearly a year since our first issue, and during that time our revenue never caught up with our expenses. The money has simply run out.

From the first, expenses were high; they were necessary if we were to publish the sort of newspaper that we had in mind, one that would be a community resource, and alternative to the monopoly [of] daily newspapers in town. For what it's worth, we still believe a newspaper like this can succeed in the Twin Cities.

LINK
FINAL ISSUE: NOVEMBER 1977

LINK *was a newsletter for the Field-Regina neighborhood of South Minneapolis. It was published monthly from June 1975 through this issue. This editorial was unsigned, though presumably written by editor Elsa Canterbury.*

It is with regret that I announce this will be the last scheduled issue of the LINK. It is difficult to let go of something that you have worked so hard on and that you feel has been successful in its own way. But circumstances dictate that we cannot continue under present conditions.

As stated in the October issue, without a business manager and/or someone to sell ads, we cannot continue. Not one person responded to our request.

A few people responded to helping as editor but lost interest very quickly when they learned it was not a paying position . . .

Verbal support has been abundant. Unfortunately "that does not a paper make."

The LINK has always needed a commitment of time and talent. Many have given very generously, and we appreciate that. But there is always a need for new people to share the responsibility. Without that commitment it has been necessary for us to refrain from making future plans.

GOLDFLOWER
FINAL ISSUE: APRIL/MAY 1979

Goldflower *was a self-described anarcho-feminist magazine published monthly in Min-neapolis between 1971 and 1975, and then bimonthly from 1976 on. There seem to have been some dramatic shake-ups in the magazine's leadership in late 1978. Several months elapsed before the April/May 1979 issue appeared with "Goldflower lives" on the cover. This letter "from the new collective" appears on the second page. Despite the optimistic tone, it seems to have been the paper's last issue.*

Six months ago, the new collective of Goldflower was a group of strangers coming from diverse backgrounds, experiences and ages. Our goal was to build communication and trust among ourselves and the women's community at large. New members have been meeting since October and during this time we have experienced extremes of energies and commitments. In the process, we have questioned whether Goldflower is needed and wanted by the community. The encouraging letters from our readers, the growing number of subscribers, and the powerful articles and poems sent to us have convinced us to continue to form an embodiment of the woman's voice.

It is important for us to be actively involved sharing our own talents and learning new skills from other women, to provide a space for women to express themselves, and to be a nucleus of feminist communication. Goldflower is all of us; it is not only its collective members; it is the women's community at large [. . .]

The Goldflower Collective would like to extend our sincere thanks to all our advertisers. They have made this issue possible. Please let them know you saw their ad in Goldflower.

MACHETE
FINAL ISSUE: DECEMBER 1980

Machete *was a monthly news, culture, and arts paper published from 1978 to 1980. In the final issue (which featured a portfolio of photographs from noted Minneapolis pho-tographer Paul Shambroom, then only twenty-four years old), a small notice under the editorial masthead announced, "For the time being, this is the last issue of Machete." This cut-out "subscription" card also appeared:*

DO YOU THINK THE 1976 PINTO IS A SAFE CAR?

DO YOU WANT TO SUBSCRIBE TO MACHETE?

Don't think it over twice, friends, the answer is no. What would you get by sub-scribing to Machete? A cashed check and an empty mailbox. Don't do it! Don't send us money, don't send us checks, don't send us money orders! We couldn't resist the temptation to take the money and run. There won't be any more Machetes, unless unscrupulous operators fob off imitations. Don't be fooled!

No! I'm nobody's fool. I won't send you $5 for a year's subscription to Machete.

Don't subscribe!

Name

Address

City State Zip

ARTPAPER
FINAL ISSUE: OCTOBER 1993

Artpaper *was a monthly Minneapolis-based newspaper serving the area's visual arts community, published from 1981 through this issue. It featured reviews, essays, gallery listings, grant opportunities, calls for work, and other pieces of information that were difficult to come by in the pre-internet era. This excerpt was prefaced with the text from a press release by Board Cochair Don McNeil announcing* Artpaper's *end and recognizing "the heroic efforts of both board and staff."*

Artpaper was born to meet the information needs of a regional art community. As the magazine grew, it developed a more vital mission, one that addressed the essential issue facing the arts today—the separation between art and everyday life.

The inability of the majority of society to understand and accept the importance that the arts can and do play in all aspects of daily life contributed significantly to the situation that caused *Artpaper* to cease publication. Even though the need *Artpaper* addressed still exists, it was not embraced strongly or deeply enough to enable the magazine to survive. This is not at all unique to *Artpaper*. It is the unfortunate reality of the arts today [. . .]

The contributions made by the arts are constant, but the voices creating them are always changing. *Artpaper* was successful in creating a strong voice. It should be remembered for how far it took us.

ARTPOLICE
FINAL ISSUE: APRIL 1994

Artpolice *was published regularly by Minneapolis-based artist Frank Gaard, beginning in 1974. In the final issue, he lays out the magazine's history and philosophy, lists some of his early influences (Beuys, Deleuze, Phillip Glass), and then looks into the future and "The Final Chapter." Gaard had a career retrospective at the Walker Art Center in 2012, which included many issues of* Artpolice *and its successor,* Man Bag.

Artpolice ceases it's existence as a serial publication with this special twentieth Birthday issue; from this point onward the Artpolice shall produce material on an irregular basis and experiment. The Artpolice has appeared every year since 1974, the past 10 years we have produced 3 issues per year or in 1975 & 1976 only 1 issue but they were very cool [. . .] The exact number of zines produced is not known to this writer a Hungarian writer in Koln says around 70 Artpolice magazines are in print [. . .]

The crisis that engulfs contemporary arts today is not from the right wing zealots who see all modern praxis as threatening but from the general decline of institutions, collections and the loss of belief in art most esspecially the art of our times. The know-nothing philosophy so popular decades ago is back, anti-intellectual trends, antisemitism, racism all on the rise; the contemplative turn of mind seems to have vanished in the 500 channel high-definition-video numbscape, the future seems more bleak each day . . . By all accounts a tiny project such as the Artpolicecomics failed save one it exists, it has mutated before and apparently is taking yet another turn towards the subterranean regions to which all creatures seek out in times of change and storm. If we left art history to the Hilton Kramers of the world we'd soon have Rush Limbaugh celebrated as a performance artist—DEEPER LET'S GO DEEPER INTO THE DARKNESS OF LAUGHTER. Franky

RAG MAG
FINAL ISSUE: SUMMER 2001

Rag Mag *was a literary journal founded as the* Underground Rag Mag *in Minneapolis in 1982. It changed editorial hands several times, moving to northwestern Wisconsin and then to Goodhue, Minnesota, where it was published from 1989 to 2001. This letter is signed by editor Beverly Voldseth.*

To all of you who have waited so kindly and patiently for this issue, letting me hang onto your work until I could get it done, I am grateful.

I have loved almost all of the mail, and feel as if I know many of you personally from notes and letters and your work. I am indebted to you for all you have brought into my life in the way of your words. May you find publication in all the magazines that will spring up to replace *Rag Mag* [. . .]

Living in a small town, I have lived for my mail. Adjusting to an empty postbox will take some getting used to. Thank you, thank you, thank you for keeping it filled all of these years.

ART REVIEW AND PREVIEW!
FINAL ISSUE: FALL 2010

ARP! would like to thank our contributing writers, our wonderful subscribers, our advertisers, and all the folks that have simply expressed enthusiasm.

ARP! has always thought that localized culture should be granted a manifest, physical voice that grins as much as it reluctantly sighs. Though not to admit defeat—instead to egg us on.

Order a complete set of ARP! back issues (yes, ten issues, beginning with June 2007) for just $45. Not even remotely available in any stores. Or, pick and choose—only $5 each.

Send an e-mail with "back issues" in the subject line. Back issues are a "while supplies last" kind of thing.

ANDY STURDEVANT

INCREDIBLE TALES

Three improbable stories from the recent past

Dome Light:
The Life and Art of Martin Woodrich

IN THE EARLY MORNING HOURS of December 12, 2010, artist Martin Woodrich was asleep in his small, modestly furnished one-bedroom apartment in downtown Minneapolis. He'd been home all evening, working in his adjoining studio in preparation for an upcoming retrospective show. Like most Minneapolitans, he was glad to be indoors, sheltered from the blizzard that had dumped over three feet of snow on the city in only twenty-four hours. After a few hours of working on a new painting, Martin soaked his brushes in odorless thinner, hung up the battered old baby blue Twins T-shirt he often paints in, and went to sleep around eleven p.m. At around five in the morning, he was awakened suddenly by a thunderous noise overheard, from just outside his studio, which was quickly followed by what sounded like an avalanche.

"I had a sickening feeling," he says now, months later, from his temporary studio space across the river from downtown Minneapolis. "It's like I heard that sound, and I knew exactly what it was—like I'd been expecting it."

That sickening sound was the roof of the building Martin had lived in since 1982 collapsing.

The building Martin lived in is the Hubert H. Humphrey Metrodome.

Martin Woodrich has been artist in residence at the Metrodome since 1982, when it first opened. Although he's little known to the public, for nearly three decades Woodrich has maintained a living space as well as a small studio near Gate H, adjoining the terrace suites right above sections 138 and 139. In the twenty-nine years he has worked in the Metrodome, Woodrich has seen two World Series, one Super Bowl, nine NCAA tournaments, and many changes in the Downtown East area. He is primarily a painter, but apart from the thousands of paintings he has created in that time, he is also responsible for countless drawings, sculptures, prints, photographs, videos, installations, performances, and even a few poems. The Metrodome is one of only four stadiums in the United States that maintains a year-round artist-in-residence program, the other three being Dodger Stadium in Los Angeles, Candlestick Park in San Francisco, and the New Meadowlands in New Jersey. And Woodrich is the only artist in residence in America to have remained with a stadium since its inception.

He is now fifty-eight years old, and since the Twins' move to Target Field in 2010 and the Dome roof's collapse, his future as an artist is uncertain. Ironically, when the roof fell through, he was putting the finishing touches on the

first major retrospective of his work since the eighties, opening at the Minneapolis Institute of Arts at the end of 2011. By the time the retrospective opens in November, he may no longer be working in the building that has been his home and his muse for over a quarter century.

"Things change," he says, chuckling. "The last year has been so crazy. Who knows what might happen? That's the Dome. The Dome is a crazy place, so I guess that's part of the deal."

How did Woodrich come to make his career in this way? Before telling that story, it's useful to know a little bit about how the Metrodome came to be in the first place. The two stories are closely entwined.

The battle over the stadium was a contentious one. By the time Governor Al Quie signed the bill for a $55 million domed sports stadium in downtown Minneapolis in 1979, the battle over funding and site selection had gone on for ten years. As a condition of the facility's funding through a special tax district in the area, the Metropolitan Sports Facilities Commission insisted a small fund for an artist-in-residence program be built into the deal, in order to "facilitate and support the creation of a downtown-wide cultural district." Downtown revitalization proponents had lobbied tirelessly for this condition to be added to the bill, modeling it on a successful similar program in New York City in the sixties. When Shea Stadium opened in Queens in 1964, a few thousand dollars were drawn from the stadium's operating fund to support a small residency program on-site. The abstract expressionist painter Philip Guston lived and worked out of a studio at Shea in the midsixties, giving the new suburban facility a certain cosmopolitan air that investors and realtors found highly attractive. (In retrospect, Guston's abstract work during this period was perhaps the least distinguished of his career, and some art historians have suggested his now-famous return to representational painting in the late sixties was a direct result of his frustrating experiences in the Shea Stadium residency program.)

So, it was decided that the Metropolitan Sports Facilities Commission would adapt an artist residency program for the Metrodome. A yearly fee of $20,000—drawn from the stadium's general operating fund, ticket sales, and donations from local foundations—was arrived at as a reasonable accommodation for the selected artist. And it is that $20,000 annual stipend that Woodrich has lived on each year since 1982.

In 1982, Woodrich was a twenty-nine-year-old painter living in an illegal walkup in the Warehouse District, about a mile northwest of the Metrodome (and, ironically, now the home of Target Field). Born in Judson Township near Mankato in 1953, he had moved to the Cities to attend the Minneapolis College of Art and Design, where he graduated with a degree in painting in 1976. He was also awarded one of the first Jerome Fellowships, in 1981. It was possible for an

ANDY STURDEVANT

artist to eke out a meager living on private and corporate sales during that time, and Woodrich sold work to the likes of First Bank System (known for their daring contemporary art collection). He also exhibited in some of the most respected galleries of the time—Jon Oulman, Thomas Barry, Medium West. He had a reputation as a gregarious, witty personality in the art scene, able to charm patrons and his artist peers alike.

"You were always hustling in those days, always looking for new ways to get your work supported," he says now. "So when I read about the opportunity for the residency at the new stadium, I thought, Sure, what the hell? My girlfriend had kicked me out, and I didn't have anything going on, so it seemed like it might be a fun way to spend a couple of months."

Woodrich was a casual sports fan, but certainly not an obsessive. "My dad took me and my brothers up to the Met to see the Twins in the '65 playoffs," he remembers. "I think I've got Earl Battey's signature somewhere. It was fun, but it wasn't like, Shit, I wish I could spend all my time at the ballpark." He also remembers tailgating at the old Met with his father and some family friends before a Vikings game in the late sixties, though when pressed for details, he just shrugs. "I mean, it was fun, but it was just being with my brothers and my old man, you know? I was probably sitting somewhere drawing anyway." So why accept a residency in a stadium, where one assumes you'd be eating, sleeping, and breathing sports?

"Art comes from anywhere, you know?" he tells me. "You never know what is going to spur your next project. I mean, it's not like they were looking for [famed sports painter] LeRoy Neiman to sit around and make shitty portraits of [Minnesota quarterback] Fran Tarkenton. They were looking for an artist who could handle themselves and make some interesting work and not spook the bigwigs, or seem like a hack. You know, not seem like a rube when the Yankees were in town or whatever."

Woodrich applied for the position, and after a few interviews and showing stadium officials his studio above Moby Dick's bar on Hennepin Avenue ("they weren't real impressed with the place," he deadpans, "because some wino tried to stab them on the way up"), he was named the facility's artist in resident in March 1982, a month before the Metrodome opened. By the first Twins game in April, he had moved in. He'd unwittingly entered a phase of his career that, more than two decades later, he would still find himself in the thick of. "I never planned to stay this long," he says. "After six months, it was going well, and I asked, Well, do you guys mind if I reapply? I like the light in here. They said, Be our guest. And I just kept turning out a lot of work, a ton of work. And I just reapplied every six months until, I think, 1985 or so." At that time, Woodrich met with the leadership of the Facilities Commission, and all parties

agreed they were happy with the results to date, and it would be best to extend the residency through the end of 1990. Eventually, it was extended to 2005, when the Twins' lease was up. Since then, like the building's other tenants, he's renegotiated year to year.

I tell Woodrich I still don't get it. Why the Dome? Why commit to so much time in this place? He thinks for a second, and then asks me if I've ever been to the Dome myself. I say of course, many times. "O.K. then," he clarifies. "So you know it's not just sports, right? You know it's the people who are in there. It's the way the doors suck you out when the vacuum is broken as they open, right? It's those little details. Plus, it's empty half the year anyway—all that space. I'd just wander around during the off-season, or when the teams were on the road, looking at the ceiling. Plus all those old folks roller-skating and mall-walking. Or the Monster Jams. Or the Hmong New Year. Always something interesting happening. To me, it's like Gaugin in Tahiti, or the abstract expressionists in the East Village—it's the surroundings that make the work. It's the place I experience my life. It just so happens that, for me, that place is a stadium with a fiberglass roof. It's so unlike anywhere else in the world."

Woodrich's work is in storage now. It was moved after the roof collapsed—fortunately, none of it was damaged. We drive from his studio in southeast Minneapolis to a storage facility on Lake Street, not far from the Institute of Arts. Walking through the rows of his paintings and drawings, one is struck by how little his work seems to do with football or baseball, or even the Dome itself. Not one sports-related image appears in the lot of them. Much of the work is huge, atmospheric abstract paintings—neutral tones, with a static quality that seems oddly familiar to anyone who's spent an evening under the fluorescent lights at the Dome, looking down at the artificial turf. There is something unreal about this work, just as there is about the Dome. Some of the pieces incorporate an odd plasticized fabric, and even neon lighting elements. Much of the work puts one in the mind of a bizarre mash-up of Dan Flavin and Agnes Martin. Woodrich is a formalist; his interest is in light, form, and texture. These interests were clearly forged, at least in part, by spending the last twenty-five years living underneath the Dome. One thinks back to Woodrich's darkly humorous explanation for his attachment to the place: *I like the light*. To spend time with a Woodrich painting is to feel surrounded by forced air, strange angles, and a pervasive artificial glow. It is unsettling and yet somehow deeply nostalgic for the very recent past.

"These won't be in the show, probably," he smiles wryly, showing me a portfolio of life drawings. It's a ream of beautiful charcoal sketches of nude men, some with very familiar faces. "Let's just say that after twenty years, I was able to convince the guys to let me use their locker-room showers as a life drawing

ANDY STURDEVANT

master class." A noted Gold Glove–winning Twins outfielder of several years ago, totally naked, stares back at me with a serene expression on his face.

The only other work that seems to explicitly reference the building itself is a book of gouache paintings. It's what he calls a "portrait series" of every seat in the Metrodome. Thousands of blue seats, almost all 64,111 of them, are painted quickly but meticulously. Each seat number is written underneath in a clean, precise hand. The variations between them are subtle to the point of being indistinguishable.

Since the Dome's collapse, Woodrich has been living and working off-site as the stadium is renovated. The studio in the Metrodome stands empty. Fortunately, it is undamaged, but not suitable to live in for the time being ("which," he notes, "is completely absurd—the roof got torn up in '81, '82, and '86, and they got it together again in no time"). He says the Facilities Commission is offering to pay for his temporary lodgings through the end of 2011, but, he claims, "They say I should be prepared 'to look at the arrangement a little more closely, going forward,' whatever that means." He knows his time is almost up. "I think that in five years, there won't be a Metrodome anymore. The Twins are gone, and the Vikings will be too at some point in the near future. I can't imagine another artist-in-residence program. I'm not sure what's next."

A spokesperson for the Metropolitan Sports Facilities Commission wouldn't comment on the future of the residency program, other than to say this: "Woodrich has been a valuable voice in Minnesota arts for the past twenty-five years, and we're proud of the work we've done together."

The retrospective at the MIA in November will certainly help spur interest in Woodrich's expansive body of work, and he says he'll certainly be appreciative. He claims he'd spoken to "a majordomo" at Target, and the possibility of an artist-in-residence program for each individual Target retail location is something that may be in the works. "It wouldn't be the same, of course," he says. "And it might not even be for me. There are younger artists out there who could use the leg up. The scale isn't there, for me, with a Target store. I mean, sure, it's big. But it just doesn't have the . . . *grandeur* of the inside of the Dome, if that's the right word. The Dome was the last of its kind. People just don't really appreciate that kind of experience anymore."

What he will do away from the sterile otherworldliness of the Metrodome is not yet apparent to him. He looks out the window of his studio where we're sitting, out onto the street. He squints as the glare of the sunlight hits the white piles of snow on the street corners, reflecting back through his window.

Woodrich smiles ruefully. "This sounds crazy, but it feels weird to be outside. The sunlight, the air, the dirt—just doesn't feel right. I just feel *assaulted,* you know?"

Farm Accident on the Forty-Sixth Floor

"**I**T WAS SLUMMING IN REVERSE," says Rachel Haselbauer over e-mail, recounting her days as a gallerist in the art space she ran with her husband for four years between 1979 and 1983. "By day, we were living in a tiny walk-up in Stevens Square, sharing a bathroom with three other families. By night, though, we'd be forty stories above downtown Minneapolis, right in the middle of the financial district. You could see out the windows—they faced east—and the whole city was laid out in front of you, the capitol, the cathedral. It felt like we owned all of it. That was how Farm Accident felt."

Farm Accident was an alternative art space, improbably (and illegally) located in an abandoned suite of offices on the forty-sixth floor of the IDS

Center between 1979 and 1983. If you were a well-connected artist in Minneapolis in the early eighties, this may sound vaguely familiar. Jenny Holzer, Robert Mapplethorpe, and David Byrne all made appearances in the space while visiting Minneapolis, as did New York journalist Glenn O'Brien, who featured it on his infamous *TV Party* talk show in 1981. More importantly, Farm Accident also exhibited the work of at least two dozen other very ambitious Twin Cities artists in those years. The space was intentionally flooded on at least two occasions and filled with sand on one other.

ANDY STURDEVANT

Many other art spaces during this period existed on the margins of legality, but Farm Accident's situation was unique. As Haselbauer suggested, theirs was a reversal of the usual formula by which underground galleries operated: by necessity, the space did its business in secret from the poshest address in the city. Openings were rarely publicized and even less frequently written about; exhibitions were known only to a handful of artists, Walker employees, MCAD faculty, musicians, and hangers-on.

I first heard about Farm Accident a few years ago, when I began researching the history of the Minneapolis art scene in the eighties for a show I was curating. People spoke of it in mythical terms, like an outpost of the Lower East Side, floating up in the sky: Farm Accident, the no-holds-barred art space where the openings began at one a.m. or later, and you could only enter through a service elevator. And in the IDS Tower, no less.

In piecing together the story of the early Warehouse District art scene, the name always came up. My interviewees would invariably lean forward and ask, "Have you heard about Farm Accident yet?" I'd say yes, I'd *heard* about it, but no one seems to have been there personally. This was always the case: "Oh, I never went personally—I'd always *hear* about the shows later. But I have a friend who showed there; see if you can track him/her down . . ." Eventually, I just lumped Farm Accident in with venues like E. Floyd Paranoid, other local galleries and spaces seemingly lost to history.

I abandoned the effort to find out more, despite fantastic rumors of A-listers, raucous openings, and other hazy, grandiose reminiscences. I didn't have anything to go on. People had heard of the Haselbauers, but no one claimed anything like a friendship with them. Plus, besides a few passing mentions in the Twin Cities' most faithful chronicler of the eighties art scene, *Artpaper,* the only substantial print reference to Farm Accident that I can find anywhere isn't even from a local paper: it's just a few sentences in a profile on our local art scene by Grace Glueck, entitled "ART: In the Heartland, New Voices Emerge," published in the March 3, 1982, issue of the *New York Times.* "Over forty stories up in the Phillip Johnson–designed IDS Tower, the elite of the Minneapolis art scene gather in a suite of abandoned law offices where they will revel until morning . . ." And that's it. Glueck doesn't say if she visited it herself, but there it is. And other than that, there's complete media silence on the issue. Nothing in the Minneapolis *Star Tribune,* nothing in the *Pioneer-Press,* nothing in the *Twin Cities Reader* or *City Pages* or anywhere else.

It wasn't until after the show I'd been curating had closed that I was able to take some time to put the pieces together. I finally managed to shake the names of "Rachel and Eric Haselbauer" out of a noted Minneapolis painter who'd been neighbors with them in Stevens at the time, but had since lost touch.

Eric Haselbauer and Rachel Saliterman met as students at MCAD in 1974, the year they graduated. She had grown up in St. Louis Park and earned a BFA in painting; he was raised in St. Paul and studied sculpture. The two of them got married after a quick courtship and lit off for New York City to live "in the cliché hovel" on Manhattan's Lower East Side. There they spent a few years working on art, socializing, making friends with the denizens of the New York scene. In late 1977, Eric's mother fell ill and, being out of money anyway, the couple returned to Minneapolis to take care of her.

"We wanted to do something big," says Rachel. "It was disheartening to be back home after being in New York, so we had lots of grand ideas about what we could do." The ideal project became apparent over the course of a few meals with Rachel's family.

Rachel's uncle was an affable commercial real estate broker named Bill Christensen; he was in charge of several properties downtown, including some spaces in the IDS. He had prospered in the building boom of the sixties and was a lover of the arts—he collected work by contemporary artists (reputedly, he was the first Minnesotan to own a Basquiat painting), and had, in fact, helped his niece through MCAD. The IDS space had gone through a few tenants in the early seventies, most notably serving as the offices of Petersen, Brenner, and Kaplan, LLC, a law firm specializing in class-action lawsuits against manufacturers of farm equipment. When the law firm moved their offices to a less expensive address in the western suburbs in 1977, the space sat vacant for a year.

"We'd been talking to Bill about how we'd wanted to open a space, and knew he had a great line on the real estate market," says Eric. "Bill was always very supportive; he'd always asked us when we were in New York what art we'd seen. So, he was sympathetic."

Rachel continues: "This one night—and this would be early in 1978—we're out at this dumpy Italian place in Richfield, Anzevino's, and we're all talking about real estate and where might be a good place for a gallery. And Bill gets a sort of gleam in his eye, and says 'You know, there *is* a space that just opened up that might be interesting . . .' And of course, he was talking about the IDS."

Things moved quickly from there. Eric and Rachel saw the space and thought it was perfect. "We loved the hubris of operating in the IDS. It seemed so ridiculous," says Eric. The space would be available after hours only, and accessible only through a freight elevator.

"Bill was just about to retire, I think," says Rachel. "And he was always kind of a punchy guy, punchy old Uncle Bill. Working out of a vacant office suite, illegally, was just the kind of thing he thought would be a great laugh, a great joke."

Dubbing the space Farm Accident in honor of its previous tenants, Rachel and Eric began working out the logistics. The only means of entry was a freight

ANDY STURDEVANT

elevator, since the main elevators were closed down overnight; and the elevator was only accessible from the adjacent parking garage. On nights when there was to be an opening, Eric would have to stake out the garage, wearing a custodial outfit so as to move through the building unnoticed. After dark, he would shuttle in Rachel and any artists, and after midnight he paid off a regular coterie of custodians "with cigarettes and twenty-dollar bills" to guide partygoers in through the freight elevator, three or four at a time, in total silence. "It was like *Man on Wire,*" laughs Rachel, referring to the 2008 documentary on Phillipe Petit, the French aerialist who snuck into the World Trade Center to perform his own art. "I saw that film and it took me right back." In the morning, the revelers would have to be snuck back down. Unconscious or sleeping gallerygoers were often carried out in tarps or crates by Eric and an accomplice, dressed in custodial gear, to avoid suspicion. One prominent New York sculptor was carried out in this way and dumped near Moby Dick's on Block E until he woke up several hours later.

The logistics of this arrangement dictated, of course, that Farm Accident only show work in three or four exhibitions a year—but the ones they opted for were remarkable for their sense of derring-do. Rachel and Eric were careful to always choose regional artists they thought could handle such a unique space and whose work lent itself to easy, ephemeral, high-concept installation.

The names of the artists who showed at Farm Accident are faintly familiar to most Minnesota art lovers: Russ Kaudy, Sandra Dwyer, Diane Sheehy, Bruce Boulger. Boulger paid tribute to the unusual gallery space with a 1979 piece called *Presence,* wherein he filled the rooms with helium and Christmas lights composed of bulbs hand-painted with purple watercolors—"the story was you could see this purple glow from anywhere downtown or in the Warehouse District, kind of like a Bat Signal for artists." For his show, Kaudy procured a collection of Minneapolis Police Department uniforms and Minnesota North Stars jerseys and stitched them into a long fabric roll with which he wrapped the entire room, in a piece entitled *Thin Green Line/Thin Blue Line.* Sheehy's exhibition, *crisiscrisiscrisiscrisis,* consisted of tiny figurines made from plasticized petroleum, buried in mountains of sands for gallerygoers to sift through and find. The sand was painstakingly brought up to the space, over the course of two weeks, in wooden crates by Eric and Sheehy. Dwyer's show consisted of some of her Super-8 short films projected on each wall—one of these, *May I Borrow Your Husband?,* was shown in the Whitney Biennial in 1984. Each of these exhibitions was documented on 35mm film and with Polaroids, dismounted immediately, and that was the end of it.

The parties they told me about were fascinating—a who's-who of the Carter-era Minneapolis art scene, with an odd splash of out-of-town visitors,

bleary-eyed late-night revelers, and anyone else who was able to talk their way in. "We never had fewer than a hundred people up there," says Eric, "but never more than a hundred and fifty. We had to keep it kind of exclusive, otherwise it would get out of hand."

In 1981, the gallery had the distinction of showing what is possibly the very first piece of anti–George W. Bush art in America: a drawing by Michael Brandt, from a larger series of defaced images of the children of Reagan's cabinet members. This one in particular was a crude mimeograph of then–Vice President Bush's two sons with silver paint scribbled over their faces, "silver spoons" scrawled presciently across the bottom. At another memorable opening, performance artist Jim Schober assembled, over the course of a night and to the cheering of the crowd, much of an actual John Deere tractor from parts he'd smuggled up piece by piece, using only a high-powered drill and some bolts as his tools. The piece was called *Lifter Puller*—a title that a young, hard-partying teenager in attendance named Craig Finn made note of.

There were other highlights through the early eighties, but by 1982 the fun was wearing off. "We were kind of tired of having our life's work be this thing we could never talk about," says Rachel. "We were proud of what we did up there, but the silence was corrosive."

Bill Christensen died in 1982 and, after four years of secret exhibitions, it seemed to be a good time to hang it up. "It was a tough time," says Eric. "Bill passed, then my mother a short while later; both of Rachel's parents passed away soon after that." Rachel agrees: "We had no money, no savings. We were definitely having a crisis of spirit. We'd been out of school for almost ten years, and suddenly we seemed very alone."

One night in 1982, after a miserable month of unexpected deaths, Eric and Rachel were cleaning up from one of the final openings, looking out the window of the IDS from Farm Accident. Both thought they saw a shape in the western sky. "It was the Angel Moroni," Eric writes simply. "I can't tell you how I know that—the only contact I'd had with Mormonism was our heroin dealer, who was a lapsed LDS. But I knew it was him."

They both understood that it was a sign—they were being called out west to become Mormons. "We didn't even think twice," says Rachel.

Eric and Rachel may have been great contributors to the Minneapolis scene, but they were never deeply a part of it. When they moved on, they left few friends behind. By then, the Warehouse District scene was coming into its own, and the focus was shifting to commercial spaces in that part of town, where there was no need to sneak around via freight elevators. Minneapolis was enjoying a cultural resurgence with a cultural elite all its own in such figures as Prince; there seemed little need to import luminaries from the couple's New York days.

ANDY STURDEVANT

Quietly, in early 1983, Rachel and Eric left Minneapolis for Salt Lake City, where in the fall they enrolled in Brigham Young University's MFA program. They still live and work in Salt Lake City today—Eric is currently assistant curator of sculpture and new media at the Salt Lake City Museum of Contemporary Art, and Rachel earned her PhD and now teaches printmaking and church doctrine at BYU. It was in Salt Lake City that I was able to contact them via e-mail, and piece together the stories and quotes you're reading today.

"It was raucous, it was amazing. The view from the forty-sixth floor when the sun is rising is unlike anything else," writes Rachel. "It seems like a lifetime ago."

Maximum Bohemian

THE FRENCH PAINTER ODILON REDON never visited the state of Minnesota in his lifetime. He was born in Bordeaux in 1840 and spent most of his life in Paris, where he died in 1916. During his career, he was responsible for some of the best-known Symbolist paintings of the late nineteenth and early twentieth centuries—*The Cyclops,* most famously, but dozens of others as well. His work was not exhibited in America until the famed Armory Show of 1913, and, even today, few prominent American museums own much of his major work. Most of those that do are on the East Coast; few are here in the Midwest, although Chicago has several at the Art Institute.

There is one Odilon Redon painting, however, totally unknown to most of the museum-going public, hanging in St. Paul. It's a portrait of Governor John Lind, painted in 1903.

Perhaps you're thinking the same thing now that I was when I began the research for this piece: "Odilon Redon painted a portrait of a Minnesota governor, and it's hanging in plain view at the state capitol in St. Paul? Why have I never heard of this before?"

It's a simple question, but the answer is complex. The painting's relative obscurity has to do with a whole host of enormously complicated turn-of-the-century political and artistic issues—free silver, prairie populism, Symbolism, European immigration, American exceptionalism, and fin de siècle decadence, among other things.

We should begin this story at the beginning, in rural Småland, Sweden. John Lind was born there, in 1854, to a farming family that immigrated to Goodhue County, Minnesota, in 1867, two years after the Civil War had ended and only nine years after Minnesota had been granted statehood. When he was thirteen, young Lind lost his left hand in a farm accident, and consequently retreated into solitude and study. Lind eventually went into the field of education, becoming a superintendent; he later earned a law degree from the University of Minnesota and was elected to Congress, representing Minnesota's Second District. In 1899, he was elected to be the governor of Minnesota as a Democrat, becoming the first in forty years from that party to hold the seat. During his two-year tenure, Lind was one of the most radical governors in Minnesota history. Populist positions such as progressive taxation, civil service reform, direct election of state officials, free coinage of silver, and the eight-hour workday were all causes he consistently fought for during his time in the governor's office; these were the very positions that Republican governors of

ANDY STURDEVANT

the past—mostly Eastern-born lumber barons and businessmen—had aligned themselves against.

Lind was an intellectual, fluent not only in Swedish and English, but also, like many educated men of the time, in French. In particular, he was an admirer of the French writer and social critic Émile Zola, whose naturalist writings on poverty and class struggle struck a chord with the reformist Lind. Zola was widely read in American populist circles, and as a congressman in 1891, Lind had apparently toyed with the idea of bringing Zola to Burnsville—then the Second District's largest community—to speak at a gathering of populist Democrats and Silver Republicans. The plan, of course, never came to fruition, though there was some correspondence between Lind's and Zola's respective offices.

Zola never came to America, but on his recommendation, young French writers traveling abroad were consistently encouraged to visit Minnesota throughout the 1890s and 1900s, to see the populist experiment in action. These writers—mostly journalists, but also poets, novelists, and essayists—left our state impressed, not only with the social movements at work here, but also with the landscape itself. So much was written about Minnesota in Paris throughout the 1890s that the body of work practically constituted a distinct school of French letters, dismissively referred to by some as "les Minnesotains." Counting themselves among this group were naturalist writers in the Zola vein, certainly, but also Symbolists, fascinated with the state's physical makeup: hallucinatory cold and dreamlike barrenness. So goes one description of the state's topography, written by one such writer in 1890: "... over there stretched dry and arid landscapes, calcinated plains, heaving and quaking ground . . . monstrous flora bloomed on the rocks; everywhere, in among the erratic blocks and glacial mud." Minnesota, with its unforgiving ruggedness and vast social divides, presented to French writers "not only a model for modern social reform, but also a deeper, more troubled metaphor for the vast, unknowable expanses of the human psyche," according to one historian.

Among these Symbolist artists and writers whose fascination with the state coincided with Lind's administration was Odilon Redon. Redon found himself, in fact, in a precarious position over a rift that was forming in French letters among les Minnesotains. Those more inclined to populism, liberalism, and naturalism viewed the state and its various reform movements as a beacon for how a society could transform itself (les Minnesotains sociale); those more inclined to Symbolism, decadence, and pure aesthetics saw the state and its harsh, rugged, featureless landscape as a metaphor for the human experience at large (l'Minnesotains symboliste). Redon, a Symbolist painter whose background also included a stint as a liberal, anti-Imperialist journalist, felt torn between these two approaches. He had friends and admirers in both camps.

During the 1899–1900 season, of all the arguments raging in the coffee shops and cabarets of Paris, perhaps none were more heated than the sociale/symboliste split.

What happened next is one of the great untold stories in Minnesota art. Lind's administration ended in 1902. As governor, he had been instrumental in focusing the interest of these small groups of influential French artists on Minnesota, on broadening the debate between naturalism and Symbolism, and there was much discussion at the end of his term about how he might be remembered. Passions continued to run high: "It was a period of unimaginable bitterness, worse in some respects than 1871," notes art historian Steven F. Eisenmann in the 1992 book, *The Temptation of Saint Redon.*

Meanwhile, in Minnesota, Lind had made few friends in the urban elite, in spite of some support from the burgeoning cultural community. A small cadre of Francophiles, noblesse oblige–crazed heiresses, arts supporters, and wealthy liberals decided, as soon as his administration ended, that they would endeavor to raise the appropriate funds in order to see that Lind received the finest portrait in the state's relatively brief history—a painting that would stand out from the grim, chiaroscuro-choked oil representations of his predecessors. One of them had the idea to contact Zola's offices to find an appropriately modern, progressive artist in Paris who might be up to the task. Zola's secretary referred them to Redon.

Redon, once hearing the offer from the Minnesotans, agreed to make the painting. Primarily, he liked the idea of creating a work that would speak equally to the contending factions of les Minnesotains, which would address both aspects of Paris's current intellectual fascination with the faraway, almost mythical state. Redon accepted the commission happily. The funds Lind's benefactors in Minnesota raised were too meager to allow for transatlantic travel, but Redon was provided with numerous photographic sources from which to work. He began the painting immediately, in mid-1903.

Of course, there was one problem. As is often the case with well-meaning, wealthy patrons, no one seemed to have carefully considered the practical and legislative barriers of such an endeavor. The Minnesota legislature that year was controlled by conservative Republicans, and when word reached them that the radical governor's portrait was being painted by a European decadent, the outcry was forceful. "It will not stand," declared the Republican speaker of the house. Having already put the money up front, and not wanting to appear provincial in the eyes of the Parisians by canceling the commission partway through, Lind's supporters made a crucial decision: they would hide the identity of the portrait's artist from the legislature, bringing the painting into the country, but concealing its origins with an obvious pseudonym—"Max Bohm,"

ANDY STURDEVANT

a pun on the phrase "maximale de bohème": maximum Bohemian; they planned to pass it off as the work of a domestic painter. "A terrible idea," wrote one patron of the decision, "but perhaps the only course of action available to us." Redon's painting arrived via rail in late 1903, the bill of goods deliberately falsified, unbeknownst to the artist; crucial journalists and politicians were paid to remain silent. There is a sad irony in the fact that the portrait of this reformist crusader was brought into Minnesota under such dubious circumstances.

Redon went to his grave never knowing that the painting was displayed under the name "Max Bohm." In fact, Lind's portrait is *still* attributed to this obvious pseudonym in official state records. The listing of the work, according to the Minnesota Historical Society's records, is "Max Bohm," as is the physical plaque in the capitol. Thanks to the deception, the legislature was appeased; Lind was disgruntled at being the subject of such a ruse, but he kept quiet on the matter until his death in 1930. "That French painting . . ." he was rumored to grumble from time to time, in his lilting Swedish accent, "So silly what they've done." The portrait hangs in the capitol today, obviously the work of a French Symbolist, but even now attributed to Max Bohm.

The French mania for les Minnesotains turned out to be short-lived, and died down shortly after Lind left office. As the United States expanded westward, new states captured the imaginations of continental artists: Utah, Oklahoma, Montana. (Many authoritative accounts have already been penned of les Montaniens.)

The painting itself is perhaps a minor work in Redon's career, but it is beautiful nonetheless. Lind stands, facing the west, the "stretched dry and arid landscapes, calcinated plains, heaving and quaking ground" rolling behind him—it all looks fantastical, those "monstrous flora bloomed on the rocks," and the air charged with Edenic possibility. His hands are behind his back, hiding his missing limb. As an official portrait, it certainly *does* stand out from its predecessors. It suggests untapped possibility: not only in the social and political realms, but also aesthetic and, perhaps, even spiritual potential. The way the clouds roil overhead, and the way the landscape unfolds, excites the imagination in a way that other official gubernatorial portraits hanging nearby do not.

Fast forward to the year 2010. Much of the information in this piece is gleaned from an unpublished 2006 paper on the Lind portrait, written by University of Minnesota art history graduate student Marisha Ferguson. Though the paper hasn't yet been published, the true story of the painting's incredible provenance clearly made its way, somehow, to the capitol. A 2007 audit of the state's financial holdings, commissioned by future Republican Party candidate for president and then–Governor Tim Pawlenty, lists the work quite high on the list, where it is valued at around 1.6 million dollars; it's a surprisingly high

figure for a Redon piece, and quite a bit more valuable than any other work of art currently in the state's possession. In Pawlenty's budget for 2010, a short item in the appendix suggests selling the portrait off to private buyers and applying the assets toward the deficit.

It seemed as if this move to liquidate the artwork's value is more than simply standard, conservative notions of "common sense" or "fiscal responsibility" at work; it felt like a crude form of belated vengeance against an embattled but genuine reformer, enacted by just the sort of conservative Republican Lind fought in his time, albeit a century later. Fortunately, the item was discovered by an executive at an arts advocacy group in St. Paul, and brought to the media's attention; the Governor's office backpedaled quickly, denying the suggestion was ever seriously considered and its inclusion in the budget had been the result of an intern's error. The painting remains on view at the capitol. Who knows what might have happened, though?

It is true that the painting's provenance is murky, barely believable, and as fantastical as the painted oil landscape itself. It's quite a tale, to think that French Symbolists sat in outdoor cafés of Paris a hundred years ago, debating the merits of Minnesota; even more, to imagine that one of the greatest of their number was enlisted to create a portrait of that state's inspiring young governor, only to be betrayed by bigotry, shortsightedness, and misplaced noblesse oblige—first in the early years of the last century, and yet again in the early years of this present century.

ANDY STURDEVANT

UNDER THE BANNER OF THE MICROSCOPE

*Flags: of local, regional, and national interest,
with a primer on which flags not to use*

·

America's Historic Flags: Which Have Been Co-opted?

·

Public Buildings, Parades, and Protests:
A Field Guide to the Vexillological Highlights of Minneapolis and St. Paul

·

America's Historic Flags:
Which Have Been Co-opted?

THERE USED TO BE A STORE AT THE MALL OF AMERICA, on the third floor, that sold nothing but flags. Eventually, they had to downsize to a kiosk, but for a while, business seemed to be humming along. They sold the flags of all fifty states and many nations, and seemed to do a healthy trade in historic American flags. It's where I bought my Bennington flag—that's the one with the 76 in the canton—apparently thinking I was going to begin a collection of historic American flags for my apartment. This was in 2009 or so, and I noticed at the time they had an unusually comprehensive selection of historic American flags. It dawned on me why this might be: because local Tea Party aficionados were buying them to take to rallies.

I became a lot more careful about which historic flags I bought after that. Many of the same flags turned up time and time again in photos of Tea Party rallies. Though the influence of that faction has waned in recent years (perhaps this is why the flag store moved into a kiosk), it's still worth knowing what your historic American flag may or may not say about you. If you, the reader, consider yourself sympathetic to the Tea Party or related ideological movements, you may invert the status assessment.

THE GADSDEN / MINUTEMEN FLAG
Liberals lost this one fair and square. Somehow this classic underdog icon has been completely co-opted by the most privileged bunch of knuckleheads in the annals of Western civilization as a rallying cry to abolish the last lingering vestiges of the New Deal and reinstitute the Gilded Age, except without the jaunty mustaches this time around.

This is a real shame, since the Gadsden banner is certainly one of the all-time greats in our nation's iconographic hall of fame. It goes all the way back

to Benjamin Franklin, who first conceived of the American colonies as a scrappy rattlesnake biting through the shiny black leather of a colonial oppressor's boot heel looming overhead. It's had real resonance since then too. Apparently *Saturday Night Live* alum Mike O'Donoghue—known in the early days of the show for his "Mr. Mike" character—wrote an incoherent-sounding but probably excellent sequel to *Easy Rider* in the eighties where Dennis Hopper and Peter Fonda's characters come back from the dead as biker zombies to battle the sinister forces of Nixonian America in a postnuclear wasteland. They apparently planned to accomplish this by locating the original Gadsden flag in the wreckage of the Smithsonian, and invoking its ancient totemic powers to destroy the Fascist usurpers of the American way.

Apparently supporters of the United States' national soccer team use this banner regularly, and in the context of international soccer, its underdog qualities make a certain amount of sense. But if you saw two zombie bikers heading toward Washington flying the "Don't Tread on Me" banner, your first thought would definitely not be that they're drug-addled hippie anarchists off to battle Nixon on behalf of the freaks. It would be, "Damn, those zombies sure do hate estate taxes and public broadcasting."

STATUS: COMPLETELY CO-OPTED

THE BENNINGTON FLAG

Tea Party people have dragged out this flag on some occasions, but all in all, I don't think this one can be completely co-opted. This is for a few reasons: first of all, it originated in Vermont, one of the pinkest of the blue states, and the home to America's only socialist senator. Second of all, it most likely wasn't a Revolutionary War flag at all; most likely it was created during the War of 1812, so it doesn't fully align with the Tea Party's playacting obsession with the Revolutionary War (Tea Partiers don't care about the War of 1812—almost no one does). Thirdly, it's primarily associated with America's Centennial and (especially) Bicentennial. The wacky handmade quality of the 76, the six-sided stars, the oversized canton: it smacks of the sort of zany playfulness that dominated American culture during one of the least Tea Party–oriented periods in our

history, the seventies. It looks like it should be on someone's belt buckle—a person at a Jimmy Carter campaign rally, or a person sitting in the back of a Chevy van with bubble-tinted windows and looking like one of the two patriotic stoners in that *Freedom Rock* four-CD box set commercial they used to show on late-night television. The Bennington flag's loopy, discoish qualities ensure that it will always belong to the loopiest, most discoish Americans.

STATUS: NOT CO-OPTED

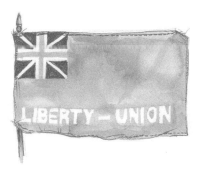

TAUNTON LIBERTY FLAG

Despite its central place in the lexicon of American democracy, *liberty* is becoming, unfortunately, one of those weasel words that tends more and more to mean "cut social services for poor people." *Union,* however, is a completely O.K. word. It's in no danger of being co-opted by the right wing, and is a word I don't mind hearing in political discourse in its broadest sense: togetherness through adversity.

Well, actually, it's not a word completely devoid of other associations. *Union* in this specific context actually means union with England. That, plus the presence of the Union Jack, is what makes this one a tough call—this flag was originally flown by Tories who still maintained loyalty to the Crown and rejected American independence, instead wanting to petition for full rights as Englishmen. Flying this flag today might be read as either a form of conservatism so atavistic it seeks to return America to a pre-1776 state, or a case of Anglophilia so extreme it renders all other symbolic judgment completely impaired.

This is, unfortunately, sort of the flag equivalent of the kid in your hometown who spoke with a British accent starting his sophomore year, scrawled lyrics to Adverts and Paul Weller songs on his Trapper Keeper, and wore a trench coat with a World War II RAF fighter plane target on the back to your high school's graduation ceremony. Which is to say: aesthetically laudable, conceptually suspect.

I've never understood why America doesn't still have a tiny but vocal minority faction of Tory royalists who believe the British Crown remains the sole

source of legitimate political authority on the North American continent and that all actions undertaken by the American revolutionaries after 1776 were illegal and thereby historically null and void. Aren't there still French monarchists, all these centuries later, waiting patiently for the House of Bourbon to be restored? I'm not saying we *need* a Tory party in America advocating for reunification with the UK (although it'd be more fun to get in an argument with those people than it would a gang of Michele Bachmannites). But it does seems a little odd that such a viewpoint vanished completely after the Revolution, considering how many Americans supported the British Crown prior to Independence. Where did they all go? Canada? If any of them were in fact left, they'd probably fly this flag.

STATUS: PROCEED WITH EXTREME CAUTION

ROGER WILLIAMS'S FLAG

Roger Williams, that great Rhode Island separator of church and state, liked the red ensign used by American colonists just fine, but he didn't like the Cross of St. George in the canton. So he removed the cross, and there you go: a red field and a white canton. It's a strange reductionist vision of what a flag should be. It's defined primarily by what it's not: basically, it's *not British.* You can fill in the blanks yourself, inserting symbols of whatever ideology or viewpoint you most identify America with. That makes this the most open-ended of historic American flags.

STATUS: COMPLETELY SAFE!

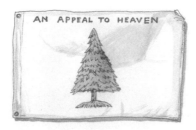

WASHINGTON'S CRUISERS FLAGS /
MISC. FLAGS WITH PINE TREES ON THEM

The pine tree is a fairly old symbol for America, and New England specifically. The idea was that some early allies of the settlers were a band of Native Americans known to the Algonquins as the Penacook, or "children of the pine tree." Personally, I like the idea of the pine tree a lot: it's independent and it stands alone, hence fulfilling the need to symbolically express that individualist strain inherent in American self-identity. However, it is *also* part of a broader interrelated root organism that's out of sight, a complex ecosystem in which it must play a small part. I'd say the "appeal to heaven" business is more a rhetorical underdog device than a theocratic statement of purpose, but you may take that as you will. This one turns up at Tea Party functions occasionally, but I think it's too subtle and too restrained to fit into that universe entirely.

STATUS: SAFE / NOT CO-OPTED

GREEN MOUNTAIN BOYS FLAG

A good-looking flag with a great history, but the GMB is the flag adopted by the Second Vermont Republic secessionist movement, which seeks Vermont's nonviolent secession from the union. How you feel about that depends on a whole host of messy issues we can go into some other time, but I think it's fair to say that this particular historic flag has been pretty thoroughly co-opted by Vermont secessionists, and it really couldn't be used for any other purposes at this time.

STATUS: CO-OPTED BY VERMONT SECESSIONISTS

Public Buildings, Parades, and Protests:
A Field Guide to the Vexillological Highlights
of Minneapolis and St. Paul

WHEN YOU CROSS THE MISSISSIPPI RIVER on the Hennepin Avenue bridge, heading into downtown Minneapolis, you come across a very elegant, very old flagpole that looks strangely out of place amid the typically desolate, half-heartedly modernist public plaza that surrounds it. It has a marble base, topped by a leafy bronze sculptural element bearing a green patina. On the front there is a relief portrait of George Washington, looking very much as he does on the front of the quarter.

The surrounding area looks like someone dropped a tacky, sixties-era city on top of an older city, and like Buster Keaton in his most famous cinematic scene, the flagpole managed to be standing in the one spot where it wouldn't be crushed. Actually, if you read the history of downtown development, that's just about what actually happened. You can see the same flagpole in a photo of the Gateway District, as this part of town was once called, circa 1918: it's literally the *only* thing in the photo still standing, less than a hundred years later.

The flagpole was designed by Daniel Chester French, the same sculptor responsible for the Lincoln Memorial, and was a gift to the city from the local chapter of the Daughters of the American Revolution on July 4, 1917. "He built his monument in our hearts," reads one of the inscriptions, an apparently original bit of verse penned by a long-forgotten DAR member. "He united us under one flag."

There are three flags one primarily encounters downtown (well, besides those of businesses that fly their own flags too, if you're willing to stretch your definition of the word *flag* to mean "a piece of fabric that has the company's logo printed on it"). The first is obviously the American flag; the Stars and Stripes outnumbers all others three to one. Second most common behind that is the flag of the state of Minnesota.

Then, there are a few locations—outside U.S. Bank Plaza on Sixth Street, and Butler Square in the Warehouse District—flying a flag with a white pennant on a blue background. This is the flag of the city of Minneapolis.

You probably didn't know that Minneapolis even had a flag, whether you live here or not. Most city flags aren't well known, with the possible exceptions of Chicago, New York City, and Washington, DC, and maybe a handful of others. The Minneapolis flag is obscure even for a city flag. It was designed by a

student named Louise Sundin in 1955, selected by a blue-ribbon panel in a citywide contest, and adopted by the city council that year. As noted, it's a white pennant on a blue field. In the pennant is a circle, split into quarters, bearing four symbols in each quadrant: a cogged wheel and square; a pilot wheel; a microscope; and a neoclassical building.

From a purely aesthetic perspective, I do not find the flag very appealing. It's certainly not awful: the color scheme is agreeable, and the pennant shape is a really nice touch. But it's no coincidence you rarely see the Minneapolis flag displayed in public, or on T-shirts and tattoos and local craft beer bottle labels, and that's probably because it's just not very inspiring.

For one, it's absurdly literal. The pilot's wheel is fine, but a *microscope?* Surely Minneapolis is the only political entity in the world that has a microscope on its flag. There's nothing wrong with microscopes of course, but there are less obvious ways to convey "we value progress" without throwing in a drawing of a microscope. The neoclassical building depicted rubs me the wrong way too— it doesn't seem appropriate for a city that, around 1955, seemed determined to raze as many old buildings as possible. Lots of American cities were determined to turn their downtowns into suburban-style corporate campuses after World War II, but few did so with the aplomb of Minneapolis's city fathers.

This flag isn't like Chicago's, for example, which you see everywhere. Those pale blue bands and four red six-sided stars are on the arm of every public servant in a uniform, seem to fly from nearly every building, and are generally found in all forms of Chicago-centric design: the aforementioned T-shirts and tattoos and local craft beer bottle labels. I'd fly it too if I were a Chicagoan—it's a wonderful flag. It embodies each of the five criteria outlined by the North American Vexillological Society (NAVA): It's simple enough that a child could draw it from memory, it has meaningful symbolism (each star represents a notable event in the city's history), it uses only three colors, it has no lettering or seals on it, and it is distinctive. It succeeds where Minneapolis's flag fails. Minneapolis could probably do better. Write your city councilperson and call for a new contest, and a new blue-ribbon panel made up of microbrewery beer label designers, textile artists, poets, aesthetically sensitive police officers, public servants, a DAR chapter president, and some Target Corporation executives. This is a new era. If we did it in the fifties, we can do it again.

Of the two cities, St. Paul is actually the much better one for seeing a wider assortment of flags than Minneapolis, for one reason: It's a capital city and a seat of government. When looking for flags, keep in mind what I will call "the three Ps." These are the three types of venues where you are most likely to encounter flags:

1) Public buildings
2) Parades
3) Protests

St. Paul, being the capital city, has a much higher all-around percentage of these things than Minneapolis. Public buildings, parades, and protests accumulate around seats of political power, and St. Paul is where this power resides in Minnesota. Not just political parades either. In terms of the second P, St. Paul is also home to the state's most active and vocal Irish American community, so the annual St. Patrick's Day parade fills downtown St. Paul with all sorts of banners, of Ireland as well as some excellent police and fire department flags.

Irish tricolors aside, there are all types of flags to be seen in downtown St. Paul, many more than you might expect. Even on a nonparade, nonprotest day, one finds a healthy assortment of banners proclaiming allegiance to various ecclesiastical, international military, and civic concerns. In fact, you find almost every type of flag in downtown St. Paul but one.

The one flag you never see, oddly, is the flag of the city of St. Paul.

Or perhaps I just don't see it. But I've biked from Lowertown to the edge of Frogtown dozens and dozens of times, and I've never found a single one flying anywhere. Not at city hall, not at the capitol, not outside the old government center, or the post office, or any of the courthouses, or the local newspaper's headquarters, or anywhere else closely affiliated with the city where you might expect to see its flag.

This is a shame. I like the St. Paul flag much more than its Minneapolis counterpart. Sure, it's a little silly and overliteral. But it looks more or less like a flag should: It's three primary colors, there's a north star, and there's a shield. The log

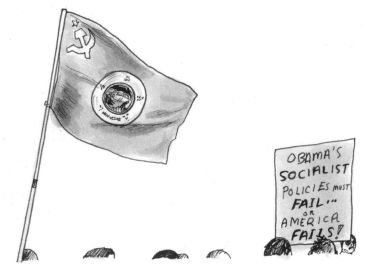

ANDY STURDEVANT

cabin is a nice, meaningful touch. I'm not sure what the story is with the winged wheel—is it a steamboat wheel? A nod to the city's surprisingly robust early automotive industry?—but at least it's not a microscope. It has the same problem that any flag with text on it has, which is that it reads backwards half the time. But even then, at least the text is written in the Windsor typeface, which is what Woody Allen uses in the opening credits of his films. It's not a bad flag. I'm really surprised you never see it in downtown St. Paul. Even the relatively obscure Minneapolis city flag turns up in at least three locations in that city's downtown.

Aside from the puzzling absence of St. Paul's flag flying from any of her flagpoles, there are a number of other interesting banners to be seen downtown.

As a reminder of the city's strong French Catholic heritage, the Church of St. Louis, King of France, at Cedar and Tenth, flies both the French tricolor and the yellow-and-white flag of the Vatican. On the white field is the papal tiara, and two keys connected by a red cord.

The Wells Fargo building at Seventh and Wabasha flies a battery of international flags, including those of Canada, Japan, the UK, Thailand, and Sweden. Nothing too out of the ordinary about this, though it does seem peculiar that the Minnesota state flag flies at equal footing with the national banners.

In the realm of third P, you often see some fascinating flags at protests around the capitol building. My favorite example of this is regrettably not one I saw in person, but that I came across on a local Flickr stream devoted to documenting protests in Minnesota, both on the left and right. It's a flag that was flown as part of a Tea Party–oriented Tax Day protest outside the capitol last year, and it has to be one of the greatest examples of vexillological folk art I've ever encountered. It's the flag of the Soviet Union, with Minnesota's state seal sewn into the center.

Regardless of what you think of this object politically—and I personally think it's completely ridiculous—you must admit it's an astonishingly striking piece of political hyperbole. It is a perfect distillation of the essence of the contemporary far right-wing narrative elegantly expressed in one simple visual idea: the great state of Minnesota is being slowly turned, from the inside out, into a repressive, Soviet-style socialist republic. This was even in 2011, when the Republicans controlled the legislature. To me and perhaps to you, this idea is, absurd, *at best*—after all, if Minnesota were indeed a secretly hardcore socialist nation-state in 2011, it was surely the only one in the world that was considering "right to work" legislation. As inflammatory and ridiculous as it is, it's hard to deny that the flag packs a visual punch. It's far more effective than a hand-lettered sign, or a historical curiosity like the Gadsden flag.

Wherever you go, however, the flag you see the most is the one that represents the great state of Minnesota: a blue field with the state's seal in the center. Unfortunately, it too is a troubled icon.

Looking back at NAVA's guidelines, it passes on fewer counts than Minneapolis's: only a bizarrely gifted child could get the details of the extremely complicated seal right. It looks an awful lot like the blue-field-and-a-seal flag of a dozen other states (Idaho, Kansas, Kentucky, Maine, Vermont . . .). It has the word *MINNESOTA* printed on it, unless you view it from the reverse while flying, in which case it reads ᴬᵀOꙄƎИИIИ. Still, it's a step up from the original 1893 design, which was blue on one side and white on the other. The flag had to be redesigned for cost-effectiveness, since manufacturing the original design essentially involved sewing two flags together.

The greatest problem with the Minnesota state flag, of course, is the seal, and its depiction of a white settler plowing a field, his rifle nearby and a Native American on horseback galloping off into the sunset. The two figures seem to be glaring at each other. At best, it says, "Well, the era of the Indian is over. Thanks, we'll take it from here!" At worst, it's an endorsement of ethnic cleansing.

The continued use of this flag is a problem many Minnesotans have been trying to solve since the sixties. In 1968, the human rights commissioner proposed that the legislature authorize a new state seal, and in 1989, a citizens' coalition put forth a proposal for a new flag design that got rid of the seal entirely. The proposed flag is a really lovely design: a north star on a blue field, over a white wave suggesting snow or water, with a verdant green on the bottom. It's elegant, simple, and meaningful. Its adoption has been proposed in the legislature a few times, most recently in 2007. It's never gone anywhere, though. It never seems to get the traction it needs.

It's a shame the flag situation in Minnesota is so dismal. Flags can be powerful symbols, which is perhaps why the DAR flagpole and its solemn invocation of the "one flag" has endured for decades while everything around it has vanished.

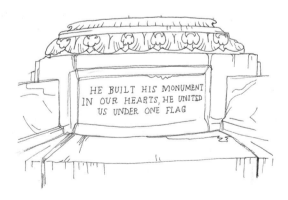

HE BUILT HIS MONUMENT
IN OUR HEARTS, HE UNITED
US UNDER ONE FLAG

ANDY STURDEVANT

MORE OF A MISQUOTE
THAN AN OUTRIGHT HALLUCINATION

Disposable cameras, Christmas lights,
mumblecore, and the invention of the trust-fund kid

•

The Blackout Years

•

"Retiree from birth": A Short Personal History of the Trust-Fund Kid

•

Put That, Put That, Put That on Your Wall

•

Fictitious Times

•

The Blackout Years

A FEW YEARS AGO, my friend Tom unexpectedly sent me a photo he took of me while we were living in Pittsburgh. In it, I'm on the roof of his apartment in front of the city's skyline. He lives in California now, and I'd gone to visit him a few weeks earlier, an event that we commemorated by taking a lot of photos of each other and our adventures around San Francisco, and uploading them all to Facebook. Me eating my first In-N-Out burger. Us in the backyard of a punk rock compound in Oakland. He must have been thinking of me, and dug up this particular photo from his archive after my visit.

I'd never seen this photo before.

There aren't many photos of me from the period between 1998 and 2004. I'm guessing there's probably less than two dozen. In the period after high school and before the advent of digital photography, I didn't own a camera; I used a disposable camera if I used one at all. Future biographers will undoubtedly refer to this era as "the blackout years."

I wonder if this is something that sounds familiar to you if you were born before, say, 1982. The obsessive need to document every aspect of one's life doesn't seem like it was a part of the cultural landscape until the mid-2000s, with the advent of Flickr, Friendster, and cellphone cameras. I thought of this kind of constant photographic documentation as something that my parents did, or perhaps something limited to the group of college friends I had who were studying photography and always carrying around Polaroid and Pentax cameras. There are rolls and rolls of images from my childhood and teenage years, mostly snapped by my parents. My life since 2004 or so has been documented more than adequately; Facebook probably contains more photos of me from the past six months than from all my entire undergraduate years combined. But on my own for the first time after high school, out in the world, skinny and unbearded, it's comparatively sparse. What few there are tend to be Polaroids, art projects roommates were working on, or packets of blurry Walgreens-developed four-by-sixes.

There is almost no record of any apartment I've lived in until very recently—not that place on Bardstown and Highland with the Roy Lichtenstein mural I and some friends painted on the bedroom wall, not the party house on Birchwood Avenue we ironically dubbed "the Palace," not the third-floor Old Louisville apartment where I lived first with Jackie and then with Kelly. Until fairly recently, I did not have a *single* photo of me with any girl I dated through that entire time, as hard to believe as that is. Not even my college girlfriend,

whom I was with for two years. I have a few lone snapshots, but nothing that would ever indicate we were ever in the same room together. It wasn't until a friend uploaded scans of some time-stamped print photos in 2004 of a rock show back in Louisville, years later, that I noticed in a few of them, the two of us were sitting together in the background—me and the college girlfriend in question. And as far as I know, that's it. I just don't remember there being many cameras around then.

It makes it so easy to mythologize that time, because unlike now, there's not much of an electronic paper trail. I didn't have a blog or keep a journal. I don't have the password for the Yahoo e-mail account I used during that time. The art I made in that era has been dispersed throughout a series of apartments of people I'm not in touch with anymore. Any writing I did was pretty limited to undergraduate academic papers or saved to 3.5″ floppy disks somewhere. There are a couple sketchbooks and some paper archives—but compared to the massive quantity of documentation that exists on my post–social media exploits, it's pretty thin.

Perhaps there were many more that I'm simply not recalling, and they're either in friends' possessions in boxes somewhere, or lost between moves, or still somewhere in my parents' basement. But I'm pretty sure that is, as much as I'd like it to be, not the case. I'm pretty sure it's almost a complete media black-out, and when the photographic record is pieced together for whatever all-encompassing online storage unit Google or Facebook has in store for us in years to come, future generations will have to savor what little they have of that skinny, stubbly, shock-haired naïf with the thrift-store glasses and girlfriends who never seemed to appear with him in the same photograph.

ANDY STURDEVANT

"Retiree from birth":
A Short Personal History of the Trust-Fund Kid

"Many of these protestors are bored trust-fund kids, obsessed with being something, being somebody, meaningless lives, they want to matter."

**—RUSH LIMBAUGH ON THE OCCUPY WALL STREET PROTESTORS,
OCTOBER 10, 2011**

I RECALL READING THIS STATEMENT at the time and thinking, so it's come to this: the right wing is finally stealing talking points from art school kids. Substitute the phrase "those guys in that one noise rock band that moved to Brooklyn" for "these protestors," and I remember hearing that exact argument from some stoned undergraduate sculpture major in a Pretty Girls Make Graves T-shirt drinking a Miller High Life and sitting next to me on a rotting brown couch on the porch of a collapsing Victorian party house where twelve people lived sometime in the spring of 2002. I mean, the *exact* argument, expressed in precisely the same language. Bored trust-fund kids, those eternal bogeymen and bogeywomen of pure, noble self-expression.

This is the sort of cheap class-warfare rhetoric that gets tossed around art schools, rock clubs, and other places where youth come together to take drugs and collectively sort out questions of privilege and authenticity among themselves.

It was a phrase I heard a lot by the time I'd got to college, and I knew by the time I was twenty it was essentially meaningless, because none of the artists, musicians, or scene people I knew socially had a "trust fund" in the formal sense. It was a term used to refer to "kids"—that is, people younger than twenty-four or so—who may have had well-to-do parents paying for their Orange amplifiers or their private education. But that's not quite the same as having access to the enormous amount of family money implied by "trust fund."

I am sure it was different in New York. Louisville is certainly a town with pockets of great wealth, and I knew some well-to-do families growing up, but the vast majority of "rich kids" in Louisville were not rich to the degree that their peers on the East Coast are rich. The richest families were certainly not sending their dumb kids to college in Louisville, where I'd have been hanging out with them. Louisville is a city with only two major universities, perfectly fine for their size and endowment, but neither of which is particularly distinguished academically. Any kid with an actual trust fund was surely being sent

off to Harvard or Stanford or Oberlin or one of the Seven Sisters. "Trust-fund kid" was just a blanket term meaning "mom and dad pay their rent and the costs relating to upkeep of their Jeep Cherokee." It's effective as an insult because it suggests sinister machinations of old money and hidden bank accounts and secrecy. In addition to that, it's agreeably infantilizing: "kid." But in the way I'd heard it used, it never meant someone literally had an actual trust fund. I don't think anyone I went to college with was deluded enough to think the ranks of our local universities were swelling with men and women with access to that sort of wealth. If that had been so, the fine arts buildings where I spent most of my time would have been much nicer.

My suspicion is that this term began gaining currency in the flyover states with the advent of the internet, and the ability of people to read about "scenes" of various kinds in New York City, and then project the class conflicts of that arena onto their own local class conflicts. Louisville, like a lot of American cities, is *intensely* class conscious—if you meet anyone out in the world who also grew up in Louisville, the first thing they'll demand to know is where you grew up and what high school you went to, and then mentally assign you to a certain socioeconomic bracket based on your answer. Friends who grew up in the suburbs of Minneapolis and St. Paul tell me it was the same here, and unless you grew up in an exceptionally homogenous community—uniformly very wealthy or very poor—it's probably true of where you grew up too. So any language that can be used to talk about class and privilege, whether it's accurate or not, is easily co-opted. I imagine a bunch of pretty canny scene kids across the U.S. reading whatever NYC-based blogs people read in 1999–2000 (I don't even remember myself) and coming across some griping about "trust-fund kids" fucking up the music or art or lit scenes there, and thinking, "ah ha!" and then sneering in public the next evening that what does so-and-so know anyway, he/she is just a *trust-fund kid*.

It's a term that's been drained of any literal meaning it may have once had. It was ridiculous when I was twenty-one and used it to describe upper-middle-class peers, and it's even more ridiculous when used to describe the vastly heterogeneous mass of people involved in the Occupy movement. I've known Rush Limbaugh was stupid since I was thirteen years old, but I didn't realize he was stupid enough to co-opt the language of art school students from the early 2000s. I didn't think *anyone* was that stupid.

Where did the term come from? Searching libraries and databases of print publications, you'll find a smattering of references from the late eighties, and quite a few from the nineties, mostly in reference to rock bands and in articles in magazines like *New York*. It didn't turn up in the *New York Times*—a signifier of mainstream lexiconcial acceptance if there is one—until the late nineties.

ANDY STURDEVANT

The very earliest reference to the exact phrase "trust-fund kid" that I turned up dates from 1985. It's used a few times in a novel by Abby Robinson called *The Dick and Jane*, published in February of that year by Doubleday. Robinson is a New York–based photographer, and writes that the book was "loosely based on my experiences working for a private detective." From the novel:

Parker was a tall, skinny, horsefaced trust-fund kid. He had so much dough, he was a retiree from birth.

Abby Robinson is the sort of career polymath I dream of being. Her work is primarily as a photographer, though she wrote this semiautobiographical novel in the mideighties, and has also written extensively on photography in Southeast Asia, and has contributed to the *New York Times* and *Ms.* She teaches in the graphic design program at the School of Visual Arts in New York, and has traveled extensively all over the world.

All of this information is on her website, as is her e-mail address. So I wrote her, asking as delicately as I could where she might have heard the term or, if there was maybe a chance she'd invented it. She was kind of enough to send a nice response, saying in part:

Alas, I don't think that the term's earliest use was in The Dick and Jane, *though it's fun to think that it was. I think it was already common parlance by then. The term I like even better is "trustafarians."*

Clearly, it was already out there in the mideighties ("trustafarian," incidentally, seems to have been a Clinton-era coinage). It's unsurprising to me that the earliest usage comes out of the New York City of that time period.

Trust funds, I should mention here, work in this way: a parent or relative, such as a great aunt or grandfather, places a certain amount of money in a secure account on behalf of a child, either before their birth or shortly thereafter. It can be for a small amount of money, but in this context, it's generally a fairly large sum. The money accrues interest over the course of the trustee's childhood, and is not accessible until the trustee reaches a certain age. Usually it's eighteen, or twenty-one, or another age when childhood is thought to have ended. Upon reaching that age, the trustee can access the money. They then use it to start an adult life by buying a condo or going to law school, or, per the stereotype, waste it on cars, booze, designer clothing, and hard drugs. It's then used in certain circles to explain how a peer can seem to live an extravagant lifestyle without visible means of income (that is, what's usually called *a real job*).

It wasn't always "trust-fund kid." The designation "trust-fund baby" is a bit older, dating from the 1984–1986 period. "Places like Woodstock, NY, Taos, NM, and the Hotel Chelsea were filled with these Trust-Fund Babies," reports New York–based writer Carole Berge in her 1984 novel *Secrets, Gossip and Slander.* Between 1984 and 1987, there are almost twice as many references to "babies"

in print as there are to "kids." It seems to be in more mainstream use in the early to mideighties, turning up in everything from nonfiction sociology books to *Mademoiselle* articles, and even in an awful-sounding relic of a book entitled *Fringe Benefits: The Fifty Best Career Opportunities for Meeting Men*. (In case you are wondering, and I am sure you are, women are advised to become travel agents or optometrists.)

All of this would lead me to believe that "trust-fund baby" is the older of the two phrases, and the one from which the now more common "trust-fund kid" is derived.

As mentioned earlier, I believe credit for this innovation goes to Abby Robinson for coining the actual phrase "trust-fund kid" in *The Dick and Jane*. After reading the book, it confirms my suspicions that Robinson may have been the coiner, for one specific reason. The book is a funny, thoughtful combination of the old, mythical world of the seedy, pre–World War II New York City and the then-contemporary world of seedy, pre-Giuliani New York City—a New York City that is now just as mythical as the old hardboiled New York City of Raymond Chandler. So it's myth doubling back on myth, a fact reflected in the language in the book, which is a really inventive blend of eighties downtown artspeak and forties hardboiled pulp fiction. One of the hallmarks of this hardboiled-style writing is taking common phrases and punching them up a little bit; making them a little more colorful, a little more splashy. Robinson may have taken the then-current phrase "trust-und baby," and roughed it up, Bogart-style, into "trust-fund *kid*." Because "kid" is more hardboiled than "baby," right?

If Robinson did indeed coin the phrase—and until I see otherwise, that is what I am going to choose to believe—it's comforting to know that the phrase comes from the art world, where it has found its greatest use historically. It's in the art world where the dream of *being somebody* often takes the form of a drama pitting idle, diletanteish privilege against meritocratic, up-by-the-bootstraps achievement. It's in the art world where this conflict was perfected. It's often said the art world is a breeding ground for ideas that will gain currency in mainstream society in later decades, and here again we see this is the case. Rush Limbaugh is, when casting aspersions on the activist class in this way, enacting the role of art school bully and fake arbiter of socioeconomic authenticity, twenty years after the role was perfected by some anonymous scene jerk in Lower Manhattan, drunk on free white wine and whispering angrily in someone's ear about whatever hot young up-and-comer was the subject of that week's gossip.

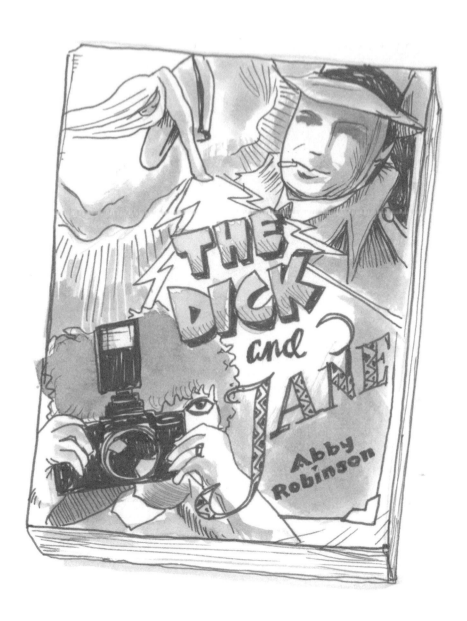

Put That, Put That, Put That on Your Wall

IN THE EARLIER PART OF THIS PAST DECADE, in 2003 or so, I saw a VHS documentary on the Athens, Georgia, music scene in the eighties called *Athens, GA: Inside/Out.* It was a very good film and I remember quite a bit about it—there was a great, boisterous scene of outsider artist Howard Finster playing guitar with Flat Duo Jets front man Dexter Romweber, shouting the lyrics to old gospel songs together in touching, imperfect harmony. Much of the film was like that, depicting semilegendary figures in the Athens music scene that produced the B-52s and R.E.M., among others, in casual, everyday settings, all of them charming as can be.

Most memorable of all was one scene in particular I thought about for years and years after I saw it. In this scene, I recalled R.E.M. singer Michael Stipe looking directly into the camera and claiming that he was the first person to ever use Christmas lights as everyday indoor decoration. Before that, Christmas lights had only been strung up during the month of December, and only in celebration of the Christmas season. I couldn't remember the exact wording of Stipe's assertion, but that was the overall effect. This struck me as a stunningly specific cultural achievement that, if true, was probably one of the great domestic innovations of the late twentieth century. To have it tied to such a legendary figure made it all the more of a triumph.

In the years after, I'd mention this tidbit, Cliff Clavin–style, to anyone I was talking to whenever the topic of Christmas lights came up. "Interesting thing about Christmas lights," I'd say. "I understand the first person to put them up in a bedroom for everyday, non-Christmas decoration was"—here I'd pause for effect—"none other than Michael Stipe." It was probably an irritating tic, but most people at least pretended to find it interesting, if difficult to verify. A few times, I'd even meet people who'd also seen *Athens, GA: Inside/Out,* and I'd ask if they remembered that scene. "Hmm, no," they'd say. "It was definitely in there," I'd tell them. They'd frown and nod their head.

The reason I thought I remembered this scene so clearly is because I remember the setting so well. I watched *Athens* on a tiny TV–VCR I had in my bedroom in an old apartment back in Louisville—a bedroom that was itself lit and decorated with Christmas lights. I remembered looking at Michael Stipe onscreen, and then looking up at the Christmas lights, and then thinking, *Wow, it's like Michael Stipe decorated my bedroom. His bedroom in Athens in 1979 probably looked just like this.*

ANDY STURDEVANT

Over time, the more skepticism I'd encounter, the more I realized it was possible I was misremembering this scene entirely, or maybe confusing it with another movie I'd seen—I watched a lot of documentaries about eighties rock music in college. When I first saw *Athens, GA: Inside/Out,* it was during that interstitial period after the decline of VHS, but before many obscure titles from that era had made their way to DVD, and before instant streaming made so much of film history so easily accessible. Today, Netflix Watch Instantly is a treasure trove of arcane, half-forgotten films that came out on VHS, skipped DVDs altogether, and are available again for the first time in decades right now.

But *Athens, GA: Inside/Out* has been available on DVD and streaming for several years now, so there was no excuse for me to not go back and corroborate the quote directly from the source. I was hesitant to do so. I liked believing this seemingly unverifiable fact was true.

If indeed Michael Stipe did make this statement, is it true? I had Christmas lights up in every apartment I lived in between 2000 and 2005. Around the windows, strung across the ceiling, over doors, around the perimeters of the room. White ones, mostly, but I had a few blinking ones at various points, as well as the tube-style lights. I even once had purple Halloween-themed Christmas lights (I guess they would be called "Halloween lights") that cast a ghostly purple light over the tiny one-bedroom apartments I had. It made everything that happened in that space seem as if it were important and cinematic and a little bit surreal, like being the protagonist in a low-budget, poorly lit student film.

Fifteen years after Michael Stipe first strung up Christmas lights in his Athens, Georgia, art-punk house, it was still de rigeur to decorate your art-punk house with Christmas lights. As far as I know, it still is, ten years after that. Whenever I happen to visit the apartment or studio of a young art-punk, most of the time there'll be Christmas lights strung up.

In my usual way, I made a half-hearted effort to verify the facts using the internet, but it wasn't very helpful. There were no references I could find to Michael Stipe making such a claim in any of the regular places, and anyway, I didn't want to look too carefully, as I suspected careful examination would wreck the whole deal. You can go for years and years using the internet to only halfcheck your facts, using just credible enough sources like Google Books and Wikipedia, and getting just enough information to justify whatever dumb notion you already believed was true anyway. Who wants to let a good story go?

I did learn a thing or two about Christmas lights over the years, and that very basic history led me to assemble a sloppy syllogism confirming my belief. Christmas lights were first adapted for use in average households in the fifties, first to decorate Christmas trees, and then eventually the rooms in which those Christmas trees sat. Didn't it make some sense, then, that it would take about

two decades for someone to figure out that they could be used to adorn mantles and doorways during the off-season too? And doesn't it makes sense that the person to figure that out might be a young, twenty-year-old Michael Stipe, in Athens, Georgia? After all, Christmas lights strung up in a room create an abstract *sense* of that room, not fully illuminated but filtered through a blur, in a similar way to how Stipe mumbles the lyrics to his songs, how he abstracts and blurs the words.

Are you buying that? It's a stretch. Clearly it's very faulty reasoning.

This house of cards had to come crashing down eventually. A few years later, my Facebook news feed dropped another documentary about Michael Stipe into my lap, this one made in 2011 by director Lance Bangs. I watched the first minute or so of it, and the very first words out of Michael Stipe's mouth are these: "The enduring legacy of punk rock is Christmas lights year-round."

It's a perfect line—succinct, funny, dismissive, and credible. He must have perfected this line in interviews and conversation over the course of years. He doesn't claim to have been the actual person who first strung up Christmas lights year-round. He simply claims punk rock created it, collectively.

In the past, in some other magazine interview or documentary he must have made similar assertions to the one I claimed to have seen him make. If I did misremember the unlikely assertion in question—and most likely I did—it's more of a misquote than an outright hallucination. Which is fine with me. Maybe Stipe didn't invent Christmas lights year-round, but at least he was there when it was invented.

In fact, he probably borrowed that line from someone he knew in Athens, and then refined it over time. Maybe one night he and Peter Buck and their friends were sitting in a living room somewhere near Prince Avenue with Christmas lights tacked to the ceiling moulding and listening to the first Television record, and one of Michael Stipe's older punk rock friends whispered to everyone, "You know, man, the true legacy of punk rock is . . ." Then he pauses and grins. "Christmas lights year-round." Everyone cracks up, and Stipe took the line and ran with it. I don't blame him. I'd have done the same thing. It's a great line.

ANDY STURDEVANT

Fictitious Times

IT WAS IN 2003 that Michael Moore stood onstage at the Oscars, shaking the statuette awarded to him for *Fahrenheit 9/11* like a movie Viking waving around a leg of lamb and bellowing about the increasingly apparent disconnect between reality and unreality: "We like nonfiction," he shouted, "and we live in fictitious times." It seemed true at the time, and it seemed truer and truer as the decade went on.

Here are ten films from that decade. I've absorbed vignettes from some of the following films to the point where they felt more like real life to me than real life felt.

9 Songs (2004)—Michael Winterbottom's mostly improvised exploration of a romance between an English scientist and an American student over the course of a summer in London doesn't have a plot in almost the exact same way your last romance didn't have a plot. At the time, *Rolling Stone* crowed that it was "the most sexually extreme rock and roll movie ever made," but that's kind of ridiculous; though it *is* very sexually explicit, there's nothing that happens in it that probably didn't happen to you in the last year or two.

Also, even though this film is only a few years old, there's already an endearing time-capsule quality to some of the musical performances. One of the featured bands is the Von Bondies, for example. Remember them? From Detroit? They were going to be huge. I thought that myself at the time.

Mutual Appreciation (2005)—One of the most telling anecdotes of the decade is one that's already been mostly forgotten. In 2009, a six-year-old boy in Colorado was reported to have gotten trapped in the basket of a helium balloon, and ascended into the sky, resulting in a media frenzy that dominated the news cycle for a few days. Eventually it was revealed that he had been hiding in a garage the whole time, and the whole thing had been some sort of bizarre hoax orchestrated by his parents. When the kid went on national TV and was asked whether he'd been hiding or not, he proceeded to puke all over the set.

He puked due to stress, because he had no idea if he was a real person, or if he was a person acting out a plot point in a fictional narrative that had spun completely out of his control. He's not the only person in American life stressed out about this either—TV is full of people who can't tell if they're living or on TV. I can't scientifically prove that people on the bus or in supermarket aisles act differently than they did twenty years ago, but it seems to me that there are

an awful lot of people carrying on in public as if they were auditioning for invisible cameras.

Andrew Bujalski's second film focuses on aimless, inarticulate twenty-somethings in New York, some of whom play in rock bands. Those two dangerous adjectives, "aimless" and "inarticulate," are often secret indie-film code for "cute" and "quirky." Not here, though. You've been to the parties in this movie, you know the people that are there, and you recognize them immediately. Bujalski makes most movies about aimless people in their twenties seem like crudely scripted burlesque. No one onscreen seems to be auditioning for invisible cameras, despite the fact that at least half the cast members were nonprofessionals.

Police Beat (2005)——Many of these movies I saw by myself, alone in my apartment. Sometimes, you miss out on a great experience by not seeing a film on a 35mm print in a crowded theater (*Lawrence of Arabia,* say), but with so many of these films, shot in grainy 16mm or on digital video, seeing them by yourself on a small screen can be such an almost overpoweringly intimate experience that viewing them any other way seems uncomfortable. Such a film is director Robinson Devor's episodic account of a West African immigrant (simply called "Z," and played by Pape Sidy Niang) and his experiences as a bicycle cop in Seattle. The viewer is so frequently alone with the character's thoughts, spoken in voice-overs in Z's native Wolof tongue, that our identification with him is almost complete by the film's end.

The Puffy Chair (2005)——I believe Rhett Wilkin's (possibly autobiographical?) performance as Rhett in this two-brothers-on-a-road-trip film is hands-down the greatest-ever portrayal of a hippie in cinematic history. I've known a lot of hippies, as one does growing up in Kentucky marijuana country, and I've never seen an actor so perfectly strike the right notes of self-righteousness and gentle self-pity endemic to the hippie population at large.

Old Joy (2006)——Kelly Reichert's beautiful film centers on two longtime friends in their thirties, rootless, hippieish Kurt (Will Oldham) and newly married father-to-be Mark (Daniel London) catching up during a hiking trip in the Oregon wilderness. Mark has settled down; Kurt can't seem to. Delayed-onset adulthood is a fairly recent generational phenomenon, and few films have explored the ramifications as well or as movingly as this one. Really, few films have explored the topic in much depth *at all,* which makes this one all the more valuable. The early scenes of Mark driving around Portland in a hybrid listening to Air America are time capsule–worthy for how they knowingly capture the feeling of living inside a left-liberal bubble during the Bush Administration.

Hannah Takes the Stairs (2007)—Hollywood has been behind the times in telling stories that reflect the technological advances of the early 2000s; even today, watching characters use e-mail or the internet onscreen often seems forced. There is a beautiful scene in Joe Swanberg's *Hannah Takes the Stairs,* in which Mike (Mark Duplass) has shown up at the workplace of his girlfriend (Hannah, played by Greta Gerwig), and tries to surprise her with a call on his cell phone as he watches through a window. She hears her phone ring, looks at the caller information on the screen, makes a face, and then ignores the call. Mike watches the whole scene play out unbeknownst to Hannah. That's such a simple idea, but happens in such a matter-of-fact way that suggests it's not a novel or unusual use of cell phones. It's just an extension of the characters' personalities and the way they interact with everyday technology. And yet, when I saw it, I slapped myself on the head and thought, "Why have I never seen anything like this onscreen before?" Most twenty-somethings on film and TV seemed to still have landlines and answering machines in their spotless *Friends* apartments well into the 2000s.

Quiet City (2007)—Another interesting quality of many of the films on this list is that they don't take place in New York City. They take place in second-tier regional centers like Seattle and San Francisco and Boston and Portland, cities that have their own quirks and charms not as easily shorthanded cinematically. Aaron Katz's *Quiet City* is an exception, in that it takes place in New York, but it isn't another indie-film example of Gotham exceptionalism. Onscreen, it's just a city, a blank canvas for the two characters, Jamie and Charlie (first-time actors Erin Fisher and Cris Lankenau), to explore over the course of twenty-four hours. By the end, we feel like we only know it as well as the visiting Jamie, despite having seen every inch of it portrayed on film thousands and thousands of times before. It's probably the weakest film on this list, but it captures with unusual clarity the experience of visiting an unfamiliar city for the first time.

Rachel Getting Married (2008)—I saw this at a large one-screen theater, with a hundred other people for a sellout showing. Jonathan Demme's portrayal of a large Connecticut family in the days leading up to daughter Rachel's wedding is so crowded with people on the peripheries—houseguests and wedding party members and in-laws-to-be—that one never really feels alone with the characters while watching it. Someone is always off-frame, in the next room over, and sitting with so many other viewers in a theater amplified the sense of being present for a large, boisterous event. Demme is of an older generation than any other director on this list, but he draws a line between John Cassavetes, Mike Leigh, and Robert Altman, and younger filmmakers who are also telling stories

using improvised dialogue, off-the-cuff cinematography, and nonactors. In fact, one of the most moving performances in *Rachel* is by the musician Tunde Adebimpe, appearing in his first film role as the groom.

Humpday (2009)—Exploring similar territory to *Old Joy,* Lynn Shelton's film plays the one-friend-grew-up-the-other-didn't scenario as a comedy. As any comic will tell you though, nothing can be funny without also being a little sad. There are moments that directly address the complexity of male friendships where I cringed in recognition, in a way that I did not during mainstream pictures that purportedly addressed the same issue (*I Love You, Man,* for example, or any Judd Apatow).

Medicine for Melancholy (2009)—Director and writer Barry Jenkins's film follows a young man and woman through an awkward, morning-after date through San Francisco over the course of a day. Both characters are, for lack of a better term, black hipsters, moving in largely white Bay Area, fixed-gear-bicycle, indie-rock circles. The dialogue—about their personal experiences living in the area, their previous relationships, their thoughts on the city and the rapid gentrification it's undergoing—feels so right that it's hard to figure out how much of it is scripted and how much is improvised, until you reach a certain point where you no longer care. The film even drops into what seems to be a real-life community meeting about rent control, with no harm to the continuity. It also ducks into museums, public plazas, dance clubs, galleries, coffee shops, grocery stores, one-bedroom apartments—all places familiar to you, places you know and spend time in, even if you've never been to San Francisco.

I LOVE *LOVE POWER*

On the road and in the streets: billboards, highways, murals, futuristic birdhouses, stadia, liquor store signage, and the legend of the United Crushers

Making Diagonals:
The City by Bus, Bike, and Foot

L AST YEAR, I DROVE AN IRISH ARTIST I KNOW—formerly living in New York and then temporarily residing in Minneapolis—around town to scout for a location for a public art piece he was working on. Specifically, he was looking for abandoned billboard support structures, and a mutual friend had told him that of all the people in town, I'd be best able to help him navigate the landscape.

I picked him up at the University of Minnesota, and we drove down Cedar Avenue, then Minnehaha Avenue to East Lake Street, where I thought we'd find forests of billboards. I take the bus down East Lake into St. Paul every day, and I seemed to recall seeing plenty of billboards from my seat.

Actually, it turned out there weren't as many as I remember. There are a few, on top of commercial buildings, but all appear to be in use. Most depict local TV weather people, sleazy bilingual attorneys, or gurgling babies mouthing platitudes about their dreams. There is one billboard near Cedar of a corpulent local conservative talk radio host, wearing a billowing white shirt so massive it looks like it was draped over him by Christo.

The artist tells me that in New York, billboards are a bigger part of the visual landscape. He thinks it's because of the aboveground trains. Most Minneapolitans see the city from a car. A billboard is really too high up and too fleeting to be effectively seen from that space. On city streets, anyway.

I'd forgotten how unattractive Minneapolis is, as seen from a car. Unattractive, even ugly. At forty miles per hour, behind glass, most of the city is a bland, indistinguishable blur of one- and two-story buildings, on a flat, unending grid that stretches off to the horizon in all four directions, broken up only by massive parking lots. There are few curves or diagonals. There is little variety in the elevation. And for half the year, it's covered in snow.

Minneapolis wasn't built for the automobile, which is something I didn't understand until I started seeing the city from bus, bike, and foot. The city was laid out for streetcars, starting mostly in the 1890s, with most of the layout done by the 1920s. On public transit, you see that Minneapolis is really a thousand classic small-town Main Streets, low-rise strips of brick buildings sewn together in a tiled pattern stretching over sixty square miles centered around St. Anthony Falls on the Mississippi.

The start-and-stop rhythms of mass transit mirror the way the city blocks are organized: each suite of blocks begins with a cluster of brick commer-

cial buildings and storefronts, where the streetcar or bus stops to collect passengers. Here, during this pause, the eye rests on the commercial signage and the window displays and people entering and exiting the shops. Then, as you begin to move again, a short collection of quiet brick and stucco houses on small lots, of all colors, pass by with increasing speed, then decreasing speed, and drawing to a close at the next intersection. Then another cluster of brick buildings and storefronts, and then back to the activity and color and visuals of the street corner.

Think of it in musical terms: the four or five blocks between stops are a bar of music; each little structure you pass—a house, a church, a storefront—comprises a note, all working as a melody, and then at the end of the bar, a rest.

Really, the only things that look truly great from a car are the neon liquor store signs—Franklin Nicollet, Minnehaha, Skol, Zipps. The one feature of the landscape a visiting friend was consistently bowled over by was this neon signage. "There's that one liquor store sign I liked again," she'd say when we passed one on the street. "No, that's a different one—the one you liked before was Hum's. That's Lowry Hill." I'd say. "Another one!" she'd exclaim. The liquor store neons were meant to be seen from a car, which is why half of those stores have drive-in windows. They're absurdly garish, and they're one of my favorite things about the city.

This gridcentricity is one of the reasons, I think, so many people bike around the city, and why even committed automobile users will usually snowshoe or cross-country ski in the city parks as a winter hobby—they just need to be able to move *diagonally*. When you see the city from bicycle or foot (or snowshoe), it's a richer, more self-directed experience. You are freed from the grid, and you can move through parks and past rivers and lakeshores and through alleys and side streets and plazas and parking lots in more rambling, discursive ways.

Back to my friend the artist. I felt as if I'd let him down; I'd disappointed him and made a poor case for the city. I'd wanted to help him find what he was looking for, though what he was looking for possibly doesn't exist in the way he wanted it. Minneapolis isn't a city that gives up what you're looking for easily. It's not always eager to help you, nor does it wear its eccentricities on its sleeve. You really have to get out and look around.

As it happens, we did find a potential site for him—not a billboard support, but a railroad bridge. A beautiful, wrought-iron industrial design that lifts a segment of Washington Avenue over a series of rail lines that meander through the grid below grade. Minneapolis can often seem stubborn and unwilling to help. But if you're willing to look on its terms, you can usually find what you're looking for.

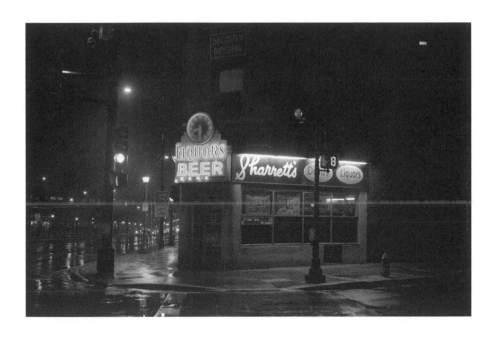

Metrodomeland

IN 2012, it was announced that the Minnesota Vikings football team will get a new stadium built in downtown Minneapolis, on or near the current site of the Metrodome, where they've played since 1982. Of all the commentary I've read on the topic, very few people seem willing to address the aesthetic concerns that go hand in hand with any large-scale construction project of this sort. My greatest worry is this: How badly will any new stadium developments disrupt the charming urban enclave that surrounds the Metrodome?

I'm joking, of course. The area surrounding the Metrodome might be the most utterly charmless chunk of real estate in the entire city. It's a desertlike expanse of surface parking lots surrounding a cavernous cement-and-teflon building that almost everyone hates. Only chain-link fences, train tracks, and a tangle of high-speed interstate on- and off-ramps break up the endless sprawl of crumbling asphalt. Walking around on nongame days (which is to say, most of the year), you can traverse the entire square mile around the Metrodome on foot, and besides a handful of light-rail riders, you'll encounter almost no one.

Writer Dara Moskowitz Grumdahl once referred to the area as a "futuristic nowhere," which sums it up pretty well. It's a nowhere all right, practically posthuman in its complete sense of abandonment. "The idea is to get the fans in, let 'em see a game, and get them out again," a Metrodome spokesperson famously explained when the facility opened in 1983. The site is indeed a monument to grim efficiency. It doesn't encourage lingering or reflection. It's a place to get in and then get the hell out of, as quickly as possible.

This is not to say, however, that there is nothing to see in the neighborhood. Far from it! Art is anywhere you're willing to look for it, even in the bleakest stretches of the city, and there are few stretches of the city bleaker than around the Dome on a late winter afternoon.

I once told a local arts administrator, half-seriously, that some of my favorite pieces of public art in Minneapolis were those brightly colored metal silhouettes of the athletes in Metrodome Plaza, off Chicago Avenue. They were added to the site in 1996 by Ellerbe Beckett (now AECOM), the architecture firm responsible for the design of the plaza. The idea was—and here I quote the *Star Tribune*—"to lessen the Dome's sterile feel." You can see these pieces as soon as you get off the light rail.

The arts administrator wrinkled her nose and told me, "Those aren't really *sculptures*. Those are just *fabrications*."

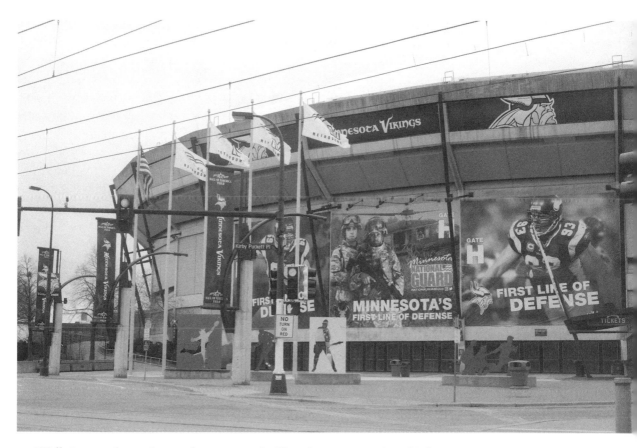

Well, it may depend on whom you ask. If art is any arena in which aesthetic decisions are made, these pieces qualify as art for me personally, for one reason alone.

Along with the basketball and football and baseball players, there is a figure of a guitarist. In addition to a sports facility, the Metrodome was also built to be a venue for large-scale concerts, though there are more memories of terrible shows than good ones at the Metrodome—the worst is generally regarded to be a June 1986 show by Bob Dylan and the Grateful Dead plagued by awful sound, muggy indoor air, and the Dome's no-smoking policy. The guitarist sculpture is, I suppose, meant to be a reminder of the arena's wide variety of potential uses. But if you look at a short list of acts that have played the Dome, it's all pretty standard arena rock—the Stones, Pink Floyd, Genesis, Van Halen. You'll notice that this guitarist doesn't look *anything* like a typical arena rocker. No flapping hair or tight pants or windmilling. He's got close-cropped hair and a T-shirt and is wearing his guitar really low. He looks much more like a member of Minor Threat than the E Street Band.

Here's the really weird part though: If you count the tuning pegs, you'll notice he's playing a seven-string guitar. Who plays a *seven-string guitar?* I can think of a few bands: Steve Vai, Dream Theater, Korn, Limp Bizkit, the Deftones, Suicide Silence, Behemoth, Periphery, Nevermore, TesseracT, and Mucc. I could go on. If these names are not sounding familiar to you, it's basically a who's-who of weird, difficult, unpleasant, obscure, and/or confrontational prog and metal bands of the past twenty years. Those are the only types of bands you ever see utilize seven-string guitars.

Some artist or designer made a very conscious decision here. He or she decided that this sculpture, to be placed outside what was then the largest arena rock venue in town, was secretly going to depict some crazy, experimental seven-string guitar–playing, Dream Theater–loving, alternate-tuning weirdo. If that's the case, this is by far one of the best sculptural gags in the entire city. It does indeed, in the words of the *Star Tribune,* "lessen the Dome's sterile feel," in a very sneaky sort of way. Enjoy this quiet joke while you can—I doubt this guitarist is going to survive once the Dome is imploded.

Next, cross those parking lots to the east of the Dome, and stand overlooking the junction where Third and Fourth Streets come zooming on and off of I-35w. There you can see a piece of art that truly captures the essence of the local mindset responsible for projects like the Metrodome.

Peter Busa was an American abstract painter, born in Pittsburgh in 1914, and later based in New York City and Provincetown, Massachusetts. He studied with pioneering proto-pop artist Stuart Davis, and like many artists of his generation, worked on Works Progress Administration murals in the thirties. In the sixties and seventies, he was living in Minneapolis, and working as a studio art professor at the University of Minnesota. In 1973, the house-paint manufacturer Valspar commissioned him to create a piece called *Demolition* on the side of its downtown Minneapolis headquarters. It's that colorful, geometric mural, on the side of the brick building, right by Interstate 35w.

The Dome wasn't the first project to alter the landscape of the area. Nineteen seventy-three was the year that 35w was built through downtown, connecting the portions to the north and south built a few years earlier. *Demolition,* painted that same year, is probably the first piece of artwork in the Cities created for the sole purpose of being seen from the highway. It's meant to be seen from the inside of your car as you zoom north. In that sense, it's a perfect reflection of the times. It's a lovely piece, more playful and fun than a work on that scale should be.

But think about what a radically different way to observe a mural this is than what tradition has dictated. A mural, historically, belongs to a public space, and is something to be contemplated—imagine the murals Busa probably

ANDY STURDEVANT

made for the WPA, in post offices and high schools. They're full of details and symbols. There are small pockets of activity that, when taken as a whole, create a larger narrative. *Demolition* is much simpler than that. It's created to draw attention to itself, quickly and efficiently, as you pass. It imparts a brief moment of grace as you pass over an ugly part of the city on your way to somewhere else. Echoing the words of that long-ago Metrodome spokesperson, the idea here is to get the fans in, let 'em see a mural, and get them out again.

Despite how dismissive I may sound, I have a lot of love for the Dome, even from a purely aesthetic angle. There was something perversely appealing about how noisy and temperate and inhumanly plastic it all was. Visually, seeing a baseball game there was more like *THX-1138* than *Pride of the Yankees,* but it was still great to be able to roll up ten minutes before the first at-bat, slap down a ten-dollar bill for a seat up under the enormous vinyl banner of Tony Oliva's face, and get enough change back to buy a beer. I loved the Baggie, the blue plastic fence that made up the right-field wall. I loved the primitive "WALKS WILL HAUNT" ghost animation that sometimes showed up on the scoreboard when a pitcher walked a batter to first base. I loved the almost psychedelic visual effect of a few thousand people waving tiny white "Homer Hankies" all at once, a tradition dating back to the eighties. The Metrodome could be a lot of fun, because you often encountered the unexpected, and as a whole, the place could be really *weird.* Of course it was built to be a huge, unfeeling machine meant to deliver maximum sports-related entertainment as cheaply and efficiently as possible, and the awfulness of the area around it reflects that philosophy. But even then, those appealing oddball qualities seeped through. Even in the blandest, most unlikely spaces—and no space is blander or less likely than around the Dome—you can find those qualities.

Dome Souvenirs Plus and Baseball Museum, located at 910 South Third Street, is a perfect reflection of this idea, and probably one of the great hidden treasures of downtown. It's greatness lies in its idiosyncrasies, and how much it is seemingly a pure vision of its owner, Ray Crump. Crump had been a batboy for the Washington Senators, and became the Twins' equipment manager when the franchise moved to Minneapolis in 1961. Over a decades-long career, he accumulated a vast collection of completely one-of-a-kind items. The store and museum opened a few years after his retirement from the club, in 1986.

Dome Plus is not simply a standard Twins and Vikings sports merchandise shop, with jerseys and beer cozies and things like that for sale. Half of it is, but the other half is a free baseball museum, which looks very much like what you'd expect a museum singlehandedly assembled by a major-league equipment manager to look like. It's almost overwhelming in its sheer quantity. The room (you often have to flip a light switch yourself when you walk in) is jam-

packed with all manner of bats, jerseys, programs, and helmets under glass. Not only big-ticket items, but smaller things like shot glasses, calendars, promotional materials from local car dealerships, just about anything that could have had a Twins logo printed on it between 1961 and 1991. Most of the museum's contents are Twins-related, but not exclusively. Aside from his involvement in baseball, Crump had also been a stage manager at the old Metropolitan Stadium, so there is a wall's worth of signed portraits of country music stars he'd come into contact with when they played Minnesota. There is, of course, the inevitable Elvis-themed kiosk. It all feels much like the work of a single person's vision, assembled over the course of a lifetime.

The museum is open during the week, and for a few hours on Saturday. The last time I dropped by hoping to take some photos, on a Sunday, I missed museum hours. But even if you make the same mistake, the many hand-painted murals outside are worth seeing up close. Seeing the enthusiastic exhortation to "VISIT OUR WALL OF CELEBRITIES!" (with the little portrait of Elvis silently nodding his assent) is a great experience by itself.

To get to Dome Plus from the Dome itself, you must cross three separate barriers, each one presenting an increasing level of danger from the last: Fourth Street, where cars are accelerating to enter onto 35W southbound; the light-rail tracks, where trains are speeding in and out of the LRT station; and finally, Third Street, where cars are exiting 35W, slowing down from seventy miles per hour as they make their approach into the city. Crossing Third and being extra careful to not be plowed over, you may come across the remains of a work by the Minneapolis artist Eric Rieger, known professionally as HOT TEA. He's best known for using colorful yarn to thread the phrase "HOTTEA" through chain-link fences, in boxy, digital watch–styled lettering.

Last time I saw one his pieces there, it looked like it was a few months old; the yellow yarn was faded, segments were missing, and it was just barely legible. I e-mailed Rieger to ask, and he reports this "font," as he calls them, was about two months old. That's quite long-lived for one of his pieces. "In Uptown, where I usually put my work," he writes, "I am lucky if they last a week."

Unlike many of Rieger's pieces, the words on this font are rendered in excitable italics, sloping at forty-five degrees, as if the letters themselves are racing onto the highway. The italics seem to be a sly joke, a way of saying, "Hey! Stop long enough to read this, and you're going to be run over by a fast-moving automobile!" It seems as if it's meant solely for pedestrians, in one of the least pedestrian-friendly parts of the city.

It's fitting this piece should be decaying in the way it is. Rieger told me he was moving into a new phase of his work, and that he was starting to move away from these sorts of fonts: "You may begin to see less and less of the actual

ANDY STURDEVANT

italicized font and more experimental typography and installations that react to a specific space." In the months since, they've grown increasingly elaborate.

Make it across all those parking lots, roads, on-ramps, and train tracks, and you will find one of the most amazing private residences in the Twin Cities. On one of the nearby north-south avenues, off Third Street, there is a two-story former blacksmith's shop. The entire building has been retrofitted to look like a fantasy medieval castle, complete with metal dragon gargoyles, a wrought-iron gate (behind which sits a brick courtyard), and turrets flying mysterious pennant-like banners. The metalwork is the work of sculptor Paul Tierney, and commissioned by the home's owner, musician Jeff Arundel. It's located well off the area's main drag of Washington Avenue, hidden in a relatively quiet cul-de-sac right on the border of Metrodomeland and the Washington Avenue commercial district. Despite being located in the middle of downtown, you'd miss it—unless you lived there, or were cutting through backstreets on foot.

Peeking out of a second-floor window as you walk down the avenue, cobblestones beneath your feet, there is the highlight of the whole experience: a bearded metal wizard, highlighted in an oxidized green patina, looking down at you. His mouth is agape.

"Congratulations," he seems to bellow. "You have traversed vast asphalt wastelands, and you have beheld many wondrous sights—a man with seven strings on his guitar, and a photo of the man who is called the King.

"You have passed through this godforsaken borderland, and have arrived back in your homeland—back in the *real* Minneapolis. A land where there are sidewalks, and old buildings, and sit-down restaurants. Your journey has come to an end. Go have a plate of tater tots and a tumbler of Scotch at Grumpy's Bar."

And so you do.

I Love Power

ON THE SUBJECT OF METRODOMELAND and the sprawling monument to the apocalyptic posthuman landscape that surrounds it, there are two more pieces of automotive-centric artworks in the area besides Peter Busa's *Demolition* mural. For better or worse, the interstates radically changed the visual landscape of the Twin Cities in the sixties and seventies, and Busa was a sort of pioneer in exploring how non- or semicommercial art could take advantage of these new transitways. (By "non- or semicommercial art," I mean "things that are interesting to look at that aren't billboards.")

In this approach, Busa had at least two acolytes I'd like to examine, both of whom we might call folk art practitioners, and both of whom remain mostly anonymous. Both created large-scale noncommercial public artworks meant first and foremost to be seen and experienced from a car traveling down the highway. These two visual monuments dominate interstate travel through Minneapolis, and, to me, have always seemed of a piece.

The first is the so-called *Love Power* mural that decorates the side of a building on Washington Avenue at I-35W, right before the highway crosses the Mississippi River. "Love Power," proclaims a smiling Jesus, standing before a rainbow with his arms wide open. There is a phone number (it still works) and the descriptor "music & miracles ministry." Near Jesus in a neat script is the phrase, "Whosoever will may come." One would assume this phrase comes from the Bible, but in fact it does not. Or not exactly. It's similar to a verse in the King James version of Revelation, but the exact phrase seems to have been coined by Protestant hymnists in the eighteenth or nineteenth century: "Send the proclamation over vale and hill / 'Tis a loving Father calls the wand'rer home / Whosoever will may come."

Love Power has been a shelter and food kitchen, is home to an active evangelical congregation, and for a few years, played host to a quasilegal art and music venue noted for some of the more raucous parties of the social season for a few summers in a row. All three entities were branded Love Power—the shelter, the congregation, and the venue—because the mural is such a recognizable icon around town. Such was the power of this love that it could compel an evangelical congregation and all-night art-kid dance party to share not only the same building, but also the same name and same branding.

Because there are no registries for vernacular public art, I can't seem to find a specific date for the mural's creation, though it's reputed to have gone through a number of iterations over the years. People living around the West

ANDY STURDEVANT

Bank claim to be able to mark the history of the neighborhood through the changing expressions on the Lord's face: there was the older, even weirder *Love Power* Jesus, who apparently bore a stormier, more inscrutable countenance, reproduced below. A newer, more accessible *Love Power* Jesus, blue eyes sparkling, has been there since at least 2000.

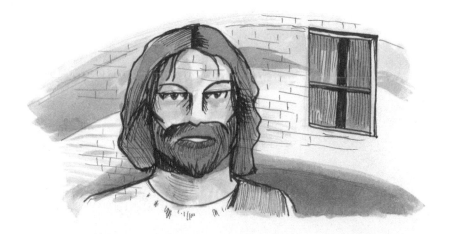

The most notable alteration, however, was when unknown graffitists added an *I* to the front of the marquee sentence fragment, giving the depiction of Jesus a more sinister political spin: "I LOVE POWER." The *I* is long painted over, but you can still make out its general outline below the new layers of paint. About a quarter of people around town referring to the mural will still call it the "I love power" mural.

It was an easy target; the temptation to make the "Love" in "Love Power" a verb instead of a noun was too great. The mural is not at all badly painted—despite some dubious modeling in his robes, Jesus's face is pretty capably rendered. It appears to be the work of a semiprofessional. But Jesus, for all the inviting sparkle in his eye, wears a truly bizarre expression that seems too gleeful to be completely innocent. He seems completely at ease recast as a trippy, power-mad theocrat proclaiming his love of subjugating nonbelievers. There is something very aggressive about the gesture of painting a three-story Jesus making direct eye contact with every one of the thousands of motorists whosoever would glance over at him while speeding down the most heavily used interstate in Minnesota.

I asked a few prominent local sign painters and muralists if they knew who was responsible for the mural. Most of them dismissed the idea that it was a well-known professional, believing instead that it was an inspired amateur whose name is lost to history. It doesn't appear to be signed, so we may never know.

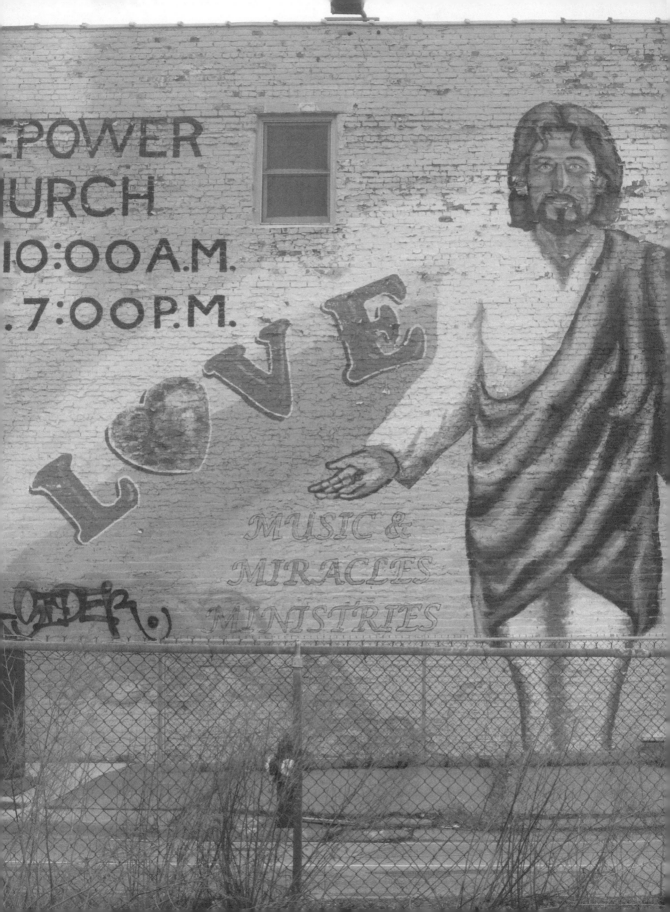

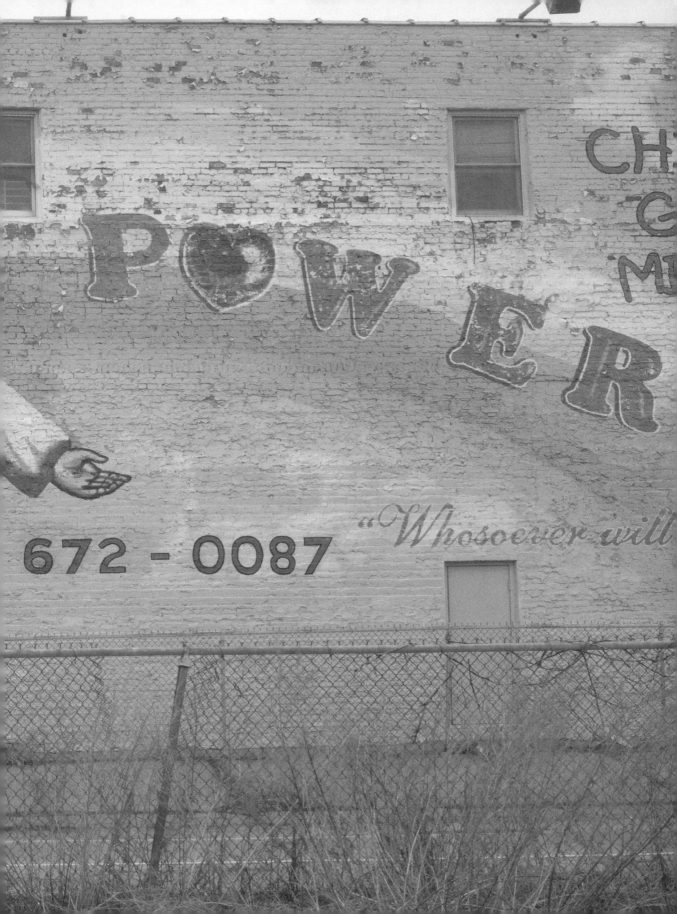

Which brings us to another bold hand-painted gesture, two miles east. On some of the old Archer-Daniels-Midland grain elevators that have sat empty for decades and have miraculously escaped demolition for all those years, an audacious bunch of graffitists wrote the eponymous phrase "UNITED CRUSHERS" across the top, in a bold, black-and-white sans serif, one letter per tower. It's hard to gauge how high the letters are, but they're extremely visible from Interstate 94 West as you approach the Witch's Hat water tower in Prospect Park, so they must be several feet high, at least. The piece has been there for as long as I've lived in Minneapolis, and doesn't appear to be going anywhere soon.

A piece of that size and ambition, painted in such a hard-to-reach place on a prominent local landmark, involves significant coordination and effort. In its own way, it also says, "I Love Power." Not necessarily the absolutist Puritan variety darkly hinted at in the altered *Love Power* mural, but perhaps the power to defy the laws of gravity and of the state, and the power to command attention and respect.

I suspect the United Crushers made their move at a time when it looked likely that those grain elevators would fall to the University of Minnesota's expansion plans. That process has moved along so slowly, however, that it's now been around long enough to serve as a minor local antilandmark. Like its freeway-anchored cousins *Demolition* and *Love Power,* it too is posed for maximum visual effect at sixty miles per hour, and a perfect piece of renegade public art for the post–Robert Moses era: oddly aggressive, larger than life, and inspiring a kind of casual awe in the thousands of commuters who pass underneath it every day.

Politics, Beer, Hockey, and Arena Rock:
Saint Paul's Walls of Fame

MAYBE I JUST GO TO THE WRONG BARS AND RESTAURANTS, but here is something you see all the time in St. Paul, and almost never see in Minneapolis: framed photos on the walls of all the famous people who have frequented the establishment over the years (with the definition of "famous" varying wildly from "household name" to "vaguely familiar, locally specific face"). Not just a few framed photos on one wall either, but on every wall, covering them.

I can think of one Minneapolis restaurants that does this: Market Bar-B-Que on Nicollet Avenue. Not even the oldest restaurants that you'd imagine decorate their walls in this way seem to do so. For whatever reason, this sort of portrait arrangement, found in institutions all across the United States, is entrusted locally almost entirely to the restaurateurs and bartenders of St. Paul.

There are a few possible reasons for this, and reasons that help answer a question about the Twin Cities frequently asked by outsiders, new arrivals, and even Minnesotans living outside the 694 beltway: How is one different from the other? What is the difference between the two cities, anyway? Aren't they just a few miles apart?

Your answers: In many ways; A lot; Yes, geographically, but no, culturally.

Instead of explaining the whole situation, we can use the presence of so many dining establishments with walls of fame to consider some of the things that make St. Paul different from its conjoined twin. For one, St. Paul is the state's seat of power, and its bars and restaurants attract a more influential clientele. Other possible reasons are that it's because the bars and restaurants are just older, or because the whole city is just more oriented around distinct neighborhoods, or that each of those neighborhoods and the city itself on the whole has a better sense of its own history. Here, a crabby oldtimer Minneapolis partisan might point out it's also because St. Paul is just the more provincial of the two, the kind of place more likely to be impressed with local celebrities and visiting stars. *I* wouldn't personally say that, but some would.

But you can start to see what makes the two cities different: St. Paul's sense of fame, influence, memory, power, and history are much different from Minneapolis's, and this comes through loud and clear in—among other areas—the types of wall decorations I'm talking about.

The pinnacle of this art is the Lexington, a steakhouse and cocktail lounge on Grand Avenue in one of the city's most upscale districts. It has framed photos

of nearly everyone who's held any elected office in the state since the fifties on its walls. In the interest of focusing on a contained geographic area, however, we'll look instead at some establishments located on one of the oldest roads in the state, not far from Grand Avenue. It's West Seventh Street, running several miles from Fort Snelling, located at the confluence of the Mississippi and Minnesota Rivers, and following the Mississippi to the center of downtown St. Paul.

West Seventh was first known as Fort Road, because it carried travelers— by horse, then streetcar, then automobile—parallel to the river from the fort to St. Paul. The oldest residential neighborhood in the cities, Irvine Park, is right here—home to governors, mayors, and congressmen. It was also the end-point for waves of immigration: Italians, Germans, Bohemians, and Poles. The Xcel Energy Center is currently located there, but before that, it was the home of the St. Paul Civic Center Arena, which is where you went to go see the Fighting Saints hockey team and the Clash and Verne Gagne. It's where Bruce Springsteen filmed the video for "Dancing in the Dark." The whole Seven Corners neighborhood—so named because it was once the intersection of seven arterial roads meeting from all directions—and surrounding area has been an incredible nexus of many of the things that make St. Paul such a great city: immigration, wealth, political influence, beer, hockey, and arena rock.

Cossetta's Italian Market & Pizzeria has sat at the top of West Seventh for a hundred years; Mancini's has been less than a mile away down West Seventh since 1948. Both were founded by neighborhood Italian families who lived in the Little Italy section around the old levee, and whose children, grandchildren, and great-grandchildren continue to run the businesses. These establishments serve as micro-museums, preserving the history and culture of the immediate neighborhood in a more immediate way than a formal institution could.

In fact, Cossetta's visual holdings are so vast that it's practically an unofficial museum to the Italian American experience in St. Paul in the twentieth century. Particularly on the second floor, in the dining area, there are dozens of photos of the neighborhood. There are also plenty of photos of dignitaries who've visited—Vikings football great and Minnesota State Supreme Court justice Alan Page, former Governor Tim Pawlenty, former Mayor Norm Coleman, Minnesota Wild star Cal Clutterbuck, actor Henry Winkler, Timberwolves point guard Ricky Rubio, and an enormous photo of Frank Sinatra, mounted near the front of the deli line with a handwritten letter from the Chairman himself personally thanking the proprietors for a great meal. But it's the neighborhood that's really the star. There are images of the store, of people who have lived in the area, pages from yearbooks, members of the Cossetta family, newspaper clippings from the past seventy years, documentation of

ANDY STURDEVANT

the floods that made the area so difficult to settle, photos of parish priests, bishops, and monsignors. All are mounted on red, green, or white mats. Celebrities come and go, but the neighborhood is forever.

Next to Cossetta's is Maharaja's, "your rock and roll headquarters" ("we're the good guys!" implores a handwritten note on the front door). Maharaja's preserves a perhaps equally important legacy of the neighborhood: postwar arena culture. Much of the décor back at Cossetta's is devoted to amateur and professional sports, and hockey in particular. That's because people have been coming down to Seven Corners for almost forty years to go to arenas and see hockey games, but also wrestling matches, rock shows, and other noisy, live events. They've also come here to drink beer, eat pizza and sausages, and ingest numerous other substances while doing so. Maharaja's next door pays tribute to all of these ideas: they sell hockey sticks, incense, T-shirts, jock sweatshirts supporting the Wild, North Stars, and Golden Gophers, jewelry, strobe lights, posters, action figures, signed fan memorabilia, and just about anything else you can think of that a discerning rock and/or sports fan might want to wear, own, or look at.

The real visual tour de force is in the back of the store, however: there is an enormous, walk-in black light room. There are 3D glasses available in a basket on the floor, and I recommend you put a pair on, because this room is amazing. There are posters of the usual black light–oriented heroes: countercultural figures such as Bob Marley, Scarface, and Marmaduke the dog. Wait, *Marmaduke?* Yes, Marmaduke. People love Marmaduke—he thinks he's a person. It's hilarious. On the floor is a yellow brick road, leading to a fantastic painting of Oz on the ground, which appears to be floating in space when you stand on top of it and look down. At the back of the room is a 3D spiral, with Rod Serling standing next to it, smiling with sinister intent and smoking a joint—er, pardon me, a regular hand-rolled tobacco cigarette—as he pops off the wall at you. It is truly mind-boggling.

Back on track. Mancini's Char House and Lounge is less than a mile away down West Seventh, right on the edge of the old Little Italy section of town. In the same way that Cossetta's documents the neighborhood, Mancini's carefully documents the city's other obsessions: sports (hockey, football, baseball, boxing, and basketball, in descending order of importance), music, politics, and religion. The selection is monumental. Don Mattingly. Dave Winfield. Ken Yackel. Vern Gagne. Not one but two photos of 1980 U.S. Olympic hockey team coach Herb Brooks. Hal Holbrook. Helen Reddy. A big one of Tony Bennett. Dozens and dozens of boxers, singers, entertainers, sportsmen, and others I don't recognize. On top of that, there are platoons' worth of soldiers, both G.I.s and officers, of every war of the past sixty years. A whole section of

wall is devoted to the many exploits of nearby athletics powerhouse Cretin-Derham High School's student athletes over the past half-century. If you looked around on a busy night, you might see a few of them in there, aged a decade or two, but still living in the neighborhood and stopping in for drinks.

These portraits are generally arranged thematically, but not necessarily chronologically, which is why the photo of Ms. Reddy is joined by one of Ashlee Simpson, a singer with whom Helen Reddy shares very little in common, save they both ate at Mancini's and enjoyed themselves enough to send a signed photo. This antichronological blending of time is part of what gives Mancini's its timeless quality. The photos and displays are somewhat well-notated, but there's also a clear sense that if you come into Mancini's, you're going to already be somewhat familiar with a lot of what you see: not only the high-level celebrities like Tony Bennett, but also the faces that make up the varsity hockey squad from the local high school that played down the road at the arena in the championships in nineteen whenever. This is St. Paul, they say. You know these people. You can even be one of them. That's the important takeaway; there is a sense initially that this sort of portraiture is exclusionary, that it's only for neighborhood people, but I don't think that's the case at all. Fame, influence, memory, power, and history are pretty fluid. Attaining status in one or more of these categories has more to do with showing up at the right place at the right time than anything else. Everyone likes to have a place to go for dinner and drinks. "The right place" is whatever restaurant, tavern, and bar you most often show up in; it only falls to you to get the timing right.

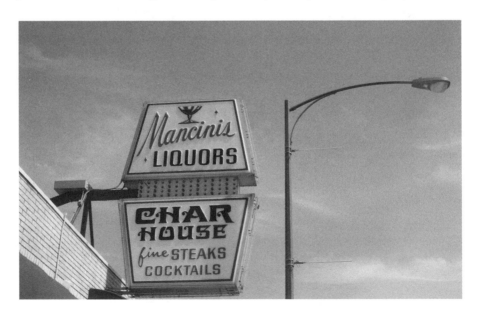

Neighborhood 2: A Trip to Jonathan

JONATHAN, MINNESOTA, IS NO LONGER A TOWN, in the strictest sense—it's a neighborhood association within Chaska, an exurb about a half hour southeast of Minneapolis. Driving past it on Highway 212, it looks very much like many of the postwar suburban developments in that part of the metro. The only thing that looks unusual are a series of wooden signs at the entrances that read, in neat green Helvetica, "Neighborhood 1," "Neighborhood 2," and so on. Each sign has a logo, a stylized daisy-like flower inside a drop-shadowed *J*.

Neighborhoods designated by number? That seems vaguely futuristic. The first time I saw them, actually, I thought of the Village, the mysterious community in which Patrick McGoohan's secret agent finds himself trapped in the cult sixties television show *The Prisoner*.

And you'd be right to think that. Jonathan *is* vaguely futuristic, because the history of Jonathan is utterly unlike any other place in the state. Utopian futurism is Jonathan's heritage, and it's a heritage that's easy to spot once you park your car, get out, and have a walk around.

First, some necessary background: Jonathan, named whimsically for the county's namesake, Jonathan Carver, was created as a "new town" planned community in the sixties, the first of its kind in the nation. It was funded in part by financial assistance from the Department of Housing Urban and Development, headed then by former Michigan governor George Romney—you may have heard of his son, Mitt. The initiative was spearheaded by Henry T. McKnight, a state legislator, rancher, real estate developer, futurist, and conservationist who saw Jonathan as an opportunity to create the model twenty-first-century community. I thought initially this all sounded like classic New Frontier liberalism, but it says something interesting about the times that McKnight caucused with the conservatives in the nonpartisan legislature. At that time, even Republicans could be adamant conservationists. The town of Jonathan would incorporate technology, conservation, and planning into a master plan, and could serve as an alternative to the sprawling suburban growth of the era, a place where citizens lived in close proximity to each other and to these services, but also in an agreeable bucolic setting.

Jonathan was to grow to a population of fifty thousand by the turn of the century, a completely self-contained community with nature preserves laced throughout, high-speed rail access to the core cities, and a ring of industrial parks surrounding it to provide jobs for the families that lived in its technologically sophisticated, fully wired houses.

Now here's where it gets truly science fictionish. Each house was to be wired with interconnected cables as part of a General Electric Community Information Systems (CIS) project that would turn each television into a telephone that allowed you to communicate visually with your neighbors. Each house has a six-digit address that would have acted as an address and ID number: for example, if your house's CIS number was 110612, that means you're in City One, Village One, Neighborhood 6, House 12. Someone dials up 110612 on their television, your TV makes a futuristic ringing sound, and you can have a video conversation. These numeric designations still remain for each house and neighborhood.

McKnight died of a brain tumor in 1972, after which the project lost its momentum. The association folded in the late seventies, and Jonathan was annexed by surrounding Chaska. But much of the original vision remains intact, and Jonathan is nothing like a typical suburb once you've stepped inside it. This is despite the fact that the houses themselves don't look particularly special; they're mostly wood or vinyl siding, built in a uniform, somewhat nondescript modernist style.

However, the patterns in which they're organized are quite unique. The town is built around a series of pedestrian trails that move behind the houses, completely out of sight of the streets and vehicular traffic. It's a complex network, running around oasis-like patches of forest, parks, and marshland. These trails are marked every few hundred feet by a "you are here" map bearing the logo of the Jonathan Association and notated in a very modern sans serif typeface I can't quite identify but which a helpful friend tells me later is called Trade Gothic.

At dusk, as we walk, it's very quiet. In fact, it's almost a ghost town-like experience—we run into one or two joggers, but otherwise, no one seems to be out, except a woman ambling down one of the paths who my companions later claim was drunk. There aren't any kids around, even on the many playgrounds (designated as "tot lots" on the map). This isn't entirely surprising, given the intermittent storms over the course of the evening. But the houses, despite being lit and presumably inhabited, seem very quiet within. We hear some conversation wafting out over the yards, but not much.

Despite very little evidence of people, the yards and gardens of Jonathan are immaculately tended. Nearly every backyard has a garden of some kind, whether with flowers or vegetables or fruits or exotic trees.

As we walk, we come across a ferro-cement abstract sculpture in one of the public areas. It's signed in a corner "Halverson '70." It's the work of D. Halverson, a Minneapolis-born artist who studied sculpture at the University of Minnsota in the sixties. Halverson had a penchant for sailing, so shortly after

completing this commission, he headed west to build boats, and ended up sailing to the South Pacific in the early eighties. Once settling there permanently, he started what he claims is the first and only lost wax bronze foundry in the South Pacific, where he sells bronze sculptures of dancing nude women that bear no resemblance to his work in Jonathan.

Ferro-cement is a method of mixing Portland cement and sand over layers of steel mesh. Unsurprisingly, given Halverson's nautical background, it is often used to construct boat hulls. The piece is an almost textbook example of the sort of monumental public sculpture of the era: massive in scale, ugly but also kind of lyrical, thoroughly nonrepresentational, and completely nonideological. My favorite part of the sculpture is the benches facing it, provided by the city planners so one can sit down and contemplate the artwork with maximum efficiency. In this sense, it's a perfect encapsulation of the sort of modernism that animated much of Jonathan. *Now it is time to sit down and experience Art,* they seem to tell you.

Along one of the paths, leading past what looks like an acre of marshland, there is a colony of truly remarkable modernist birdhouses. I couldn't find much information on them, but they seem to be of the seventies vintage. There are a few varieties, but the best are these white plastic, modular orbs suspended in a starburst pattern. They fit right into the visual landscape of the town. And the best part is *each individual birdhouse is numbered!* I watch a sparrow fly into Birdhouse 4, and wonder if it has built a nest in there permanently. I wonder if it chirps to its colleagues that it lives in City 1, Zone 1, Neighborhood 6, Birdhouse 4. Even the birds of Jonathan, like its human citizens, had numeric designations for their homes. It's hard to know whether this is meant as a tongue-in-cheek gesture or not—is the idea that Jonathan was to be so micromanaged that even the birds were required to be carefully accounted for? Or is it a woolly, early seventies nudge in the ribs, as if to cackle, *Even the birds have it together in the future, man*?

It's hard to tell. Jokes from the past—like big ideas—don't translate well over time. But even if you can't quite grasp the nuances, you can still appreciate the broad strokes.

ANDY STURDEVANT

Flyover Country

MY FRIEND PETE MCLARNAN used to live near Fifty-Sixth Street around Diamond Lake in what I sometimes call the Deep South of Minneapolis. Pete is a filmmaker, and in 2012 he completed a gorgeous gem of a film called *The Sound of Small Things,* about the fitful early months of a new marriage. The film was conceived and written while living in that neighborhood, and is set largely in one of those tiny cottages in Nokomis, in the city's Deep South.

True to life in that part of the city, the film is saturated with aircraft noise. In nearly every single scene, even those shot indoors, there is the distant roar of a jet overhead. The husband, played by Sam Hoolihan, mumbles an apology to out-of-town guests a few times throughout the film. "The city is installing noise-proof windows at some point," he shrugs. His wife, played by Cara Krippner, is deaf, seemingly oblivious to the constant roar of engines overhead. At least she seems to be—the truth is more complex.

"So much of the dialogue was improvised," Pete explained. "And the planes became a part of that dialogue, like a third character. [They] always seemed to show up at the right time." Onscreen, the actors pause in the middle of sentences, wait for aircraft to pass, and then continue. "It's like an ever-present interloper in your life," he added.

Anyone who has ever lived south of Forty-Sixth Street knows about this particular interloper. Aircraft noise in South Minneapolis has been a hot-button political issue for generations. Minneapolis-St. Paul International Airport (MSP) has been located on the city's southside since the early twentieth century. It was called Speedway Field from 1919 to 1923, because it was built on the site of an abandoned motor speedway in an unincorporated part of the county, just south of Sixtieth Street. They didn't even tear up the track—just two sod landing strips, a couple of hangars, and a speedway track circling the whole operation. It didn't bother anyone because there weren't any people to bother. In those days, if you were south of Lake Street, you were essentially in a forest.

The large bucolic gaps between the southernmost reaches of Minneapolis proper and the abandoned speedway in the unincorporated part of Hennepin County have since been filled in by the bungalows, story-and-a-half cottages, and stucco duplexes that make up South Minneapolis. The flight paths still cut over the area, and most parts of the city between Lake Street and the old Speedway Field sound like the trailer for *Tora! Tora! Tora!* at all hours. Onetime journalist and current Mayor R. T. Rybak's involvement in the community group Residents Opposed to Airport Racket (ROAR) was one of his

earliest entrees into civic life, the first step in a path that ended (for now) in the mayor's office.

As irritating as this residential airport racket can be—and I live in Powderhorn Park, a South Minneapolis neighborhood that gets its own share of overhead air traffic—there is something vaguely romantic about the ubiquity of these jetliners, bringing in thousands of visitors to the cities every minute of the day. *Vaguely* romantic, not *totally* romantic.

The majority of jets coming into MSP over the neighborhoods of the Deep South are operated by Delta. These are easy to spot from the ground—each airline's fleet sports a standard livery, or paint scheme, for all its aircraft. With the exception of some of the smaller regional jets, Delta aircraft livery consists of a white fuselage, blue wing-mounted engines, a blue underside, and a blue tail, with a two-tone red wedge (known as the "widget"). In fact, these liveries actually have official names—the current scheme is called "Onward and Upward," and its eight-colored predecessor, which apparently took much longer to paint, was known as "Colors in Motion." I suppose cool livery names like "Screaming Vengeance" and "Here Come the Warm Jets" were already taken.

Other major airlines operating out of MSP are easily identified. American Airlines jets typically still sport polished, unpainted metal fuselages. United has white fuselages with a yellow stripe and a blue tail decorated with a yellow globe. US Airways' livery is light gray and dark blue. There are nine other airlines operating out of MSP as well, many with more lively liveries than these four. But most of the airplanes you see are from one of these airlines.

It's possible to see aircraft roaring in all day and night for your entire life, and not really understand a thing about flight paths, final approaches, or much of anything about how, why, and where aircraft pass over a city. I initially thought (naïvely, it turns out) that there must be some easy way to observe what direction the aircraft were flying in from, and then from there deduce what city they were coming in from. Like if a plane is coming in low and from the west, it must be coming from a nearby western city, like Sioux Falls or Fargo, right?

No. Of course not. Not even close. In fact, that's ridiculous.

A number of aviation enthusiasts explained to me that by the time the aircraft has made its final descent into MSP, it has come in from a predetermined point many miles outside the Twin Cities that has little or nothing to do with its city of origin. Most of the flight paths approach beacons in far-flung suburbs or exurbs like Afton, Anoka, and Farmington. Wind direction affects which of the four runways are in use.

In other words, a flight coming in from JFK looks a lot like one coming in from LAX from the ground in South Minneapolis.

This doesn't mean, however, that you can't make some reasonable speculations about where the jets coming in overhead have come from. This is a very, very simplified guide to spotting various types of aircraft flying over you while you stand near Minnehaha Creek, trying to figure out where they've come from. Let's take Delta's fleet, for example. Delta operates nearly thirty types of aircraft. The largest are the Boeing 747s, which have four wing-mounted engines. They look like this:

A 747 has a range of more than seven thousand miles and was introduced in the late sixties. Apparently you don't see as many of these coming out of MSP as you once might have. Delta operates daily flights from Narita International Airport in Tokyo, and while these once utilized 747s, they now are generally 777s. The 777 looks somewhat like the 747, but with only two wing-mounted engines.

767s, 757s, and 737s are smaller, with similar bodies and also with only two wing-mounted engines. This is what a 767-432 looks like:

Very likely, a craft like this would also be coming in from overseas; Amsterdam, Charles de Gaulle, and Heathrow, for example, all have direct Delta flights. It might also be from a high-volume domestic airport, like Denver, O'Hare, or Atlanta. The stories you might create in your head about the passengers on these planes may involve high finance, long-distance relationships, business deals, conferences, or cross-cultural exchanges of one kind or another.

Quite a lot of the air traffic, though, is made up of connectors from regional airports. These connectors are typically smaller aircraft, like the Bombardier Regional Jet CRJ-200ER, 700, and 900ER. They're perhaps a little over half the size of a 777, and with rear-mounted engines. The CRJ-900 looks like this:

It's probably come from a place like Minot, Madison, or Wausau. It might be on a longer trip, stopping in at these smaller towns between here and Delta's other hubs in Detroit or Memphis. The stories you might create in your head about the passengers on these planes may involve slightly less exotic but no less emotionally fraught situations, involving grandparents, or high school athletics, or breaks in the academic calendar.

This is an absurdly oversimplified introduction to a highly complex subject, one to which hundreds of informal clubs, internet message boards, and international governing bodies have been devoted. Aircraft spotting and tracking is one of those subjects you could get as deep into as you wanted and still have lots to learn. But even just a cursory understanding of the liveries, flight patterns, and designs of our overhead neighbors goes a long way in adding some color and form to this specific breed of hyperlocal noise pollution. It's a distinctly South Minneapolis fact of life. Those of us living here might as well claim some ownership over it. It shapes the course of everyday life, as surely as it shaped the action in Pete's film. For a film that deals so unflinchingly with themes related to personal intimacy, boundaries, and sound, the presence of that "third character," as he called it, becomes indispensable.

The more southsiders I talk to about the presence of constant airline traffic, the more I realize there is a sense of ownership—an annoyance mixed with a sense of pride at understanding the small distinctions involved in identifying the planes overhead.

In fact, some residents I've met over my time in South Minneapolis speak of overheard air traffic in the precise language of an inveterate birdwatcher: "I garden a fair bit, and also run a lot, so when you hear a noise you tend to look up," explains Dimitri Drekonja, a doctor who lives in Deep South Minneapolis and works at the Veterans Administration hospital, located right by the airport. "I collected the little die-cast metal airplanes when I was a kid, so I could recognize most of them, and any that were not recognizable I'd look up in the in-flight magazines next time I flew."

He continues: "You have to make the distinction between wide-bodies and non-wide-bodies. The 747, 777, 767, and Airbus 330 are the standard passenger wide-bodies, and just have a different heft to the sound of their engines. The FedEx MD-11s have a distinctive sound, and when you hear [them] you know something big is about to glide over. And the 747 is unique in that it is the only passenger jet to make our dishes rattle in the cabinet when it takes off."

He's on a roll, and I don't detect the slightest bit of annoyance in his tone. "Then, there's the civilian versus the military aircraft . . ."

ANDY STURDEVANT

Save the Economy, Send More Letters:
A Trip to the Post Office

MARY ROTHLISBERGER IS AN ARTIST living in Palouse, Washington, a town of about a thousand inhabitants two miles from the Idaho border. Palouse is very remote—Mary tells me you can't get a direct train, airplane, or bus there—but she travels widely for her work. I happened to meet her a few winters ago when she was participating in an art festival in town in 2009. As part of the project, she was living on a frozen lake in a structure built to resemble Robert Scott and Ernest Shackleton's capsized Antarctic ship, *Discovery*. In honor of these rugged individuals from the Heroic Age of Antarctic Exploration, she spent much of the residency wearing a fake, ice-bitten cloth beard. Clearly, she has a good eye for detail.

This eye for detail has served her well while on the road. During her travels, Mary maintains a photo blog called *God Bless the USPS*. Whenever in a small town, Mary finds the post office and snaps a shot of it. Most of the post offices aren't the WPA mural-festooned art deco structures of romantic imagination. For the most part, they're pretty squat, utilitarian brick buildings, built in the fifties or sixties.

Look at enough of them, though, and the monotony starts to fall away; especially in more populous small towns, you start to pick out tiny, worthwhile modernist flourishes, details imbued with whatever the bureaucratic equivalent of whimsy is: a bit of turquoise window paneling or limestone façade here, a geometric embellishment or false wall there. They are reassuringly built little structures.

In smaller towns, of course, that reassuring quality seems more and more misplaced. The post offices can seem increasingly ghostly.

"It's so insane to roll through a town with only seventy-two people now, and it's still got a wall full of old metal P.O. boxes inside. There are more boxes than people who live in the town," Mary tells me over the phone. "What's happening to those? Where are they going?" She uses the post office almost daily in Palouse, and she never fails to marvel at how efficient and inexpensive the process of getting a single piece of paper across the country seems: "It's a really remarkable human machine."

When I tell her I don't think many people equate the post office with efficiency, she sounds almost personally offended. "There was a time when there were more letter carriers in America than soldiers," she counters. "I love

ANDY STURDEVANT

imagining a time when that was the case, when that type of precision and discipline was in service of people talking to each other."

Looking through the post offices in Mary's USPS project, which include many in outstate Minnesota towns with names like Sleepy Eye and Hamburg, I am struck by how much the small-town post offices resemble their urban city-mouse counterparts. One of my favorite things about the topography of the Twin Cities is that the commercial districts that sit on old streetcar lines—Bloomington, Como, Grand, Minnehaha, Chicago, Johnson, Broadway—have the feel of small-town Main Streets. The post office stations that sit in each ZIP code have a similar flavor to Mary's small-town post offices. They have that same blocky, reassuring quality.

I'm also struck by how quickly I tend to blow past these buildings while out in the city. After going through the wide variety of post offices Mary captures, I feel more conscious about paying closer attention to them. On a recent long weekend afternoon, I took a walking tour of three stations near Lake Street, starting with the Lake Street station that serves the 55408 zip code near Interstate 35W; then my neighborhood station in Powderhorn, serving 55407; and finally the Minnehaha Station, serving 55406.

Powderhorn is my favorite, with that white concrete geometric pattern taking up most of the front. All three buildings are quite similar, all brick and

concrete, and in fact share one common characteristic: the front of each is decorated by lathe-cut metal lettering reading UNITED STATES POST OFFICE, with the name of the station and the zip code. The typeface is instantly recognizable as some genus of midcentury modern. This typeface seems to have been standard on nearly all post offices built during and after World War II.

I did some poking around on online typographical forums to see if I could identify the exact typeface, but couldn't find an answer; even the typography nerds seem stymied. This is echoed by the fact that a number of the letters on the Longfellow station have been replaced by not-quite matches, suggesting even the USPS itself couldn't figure it out the second time around.

Whatever it is, it's the sort of elegant, simple typeface that is shorthand for efficiency and modernity. Think of how rare it is to come across actual lathe-cut signage or design elements from the sixties anymore. With the exception of the occasional elementary school or hospital, most of it is long gone, whether destroyed, painted over, or replaced with flashier, more contemporary elements. The post offices are really one of the last holdouts for this kind of high bureaucratic vernacular design sensibility.

This sort of lathe-cut lettering is the product of a highly trained artisan with his or her own set of aesthetic sensibilities and skills, who still must closely follow a government style manual outlining the most mundane details of, say, the appropriate height and roundness of the bowl on the letter *P.* It seems both carefully handcrafted and brushingly impersonal.

Which is a little bit like the post office itself: careful handicraft and brushing impersonality. What could be more delicate than a handwritten letter or wrapped package? Once you step in through the false wall and lathe-cut lettering, the post office is, depending on time of day and year, completely bonkers, with lines of people waiting to send and receive packages. City postal workers often possess a certain ironic cheerfulness (or maybe, more precisely, a cheerful irony) in their dealings with the public. They're wry, and almost world-weary sometimes. However, they often also tell weird, inexplicably funny jokes, and they're fast and no-nonsense without seeming like automatons. Unlike many workers in retail sectors, they rarely seem dispirited. Put-upon, and maybe a little irritable, but never dispirited.

Not many people seem to *enjoy* being at the post office, exactly, but there is a pleasing sense of possibility—especially during that most bonkers of the seasons, Christmas—in knowing most of the people there are sending or receiving gifts from their loved ones. Most people walk out seeming satisfied, with a vocal minority mumbling profanities about how they *can't believe the post office couldn't do such-and-such*—observing impartially, it's impossible to know if

ANDY STURDEVANT

these complaints are justified ("they didn't have any forty-four-cent stamps") or not ("they wouldn't let me mail a can of gasoline to a P.O. box").

The post office is still a relatively democratic institution: to a certain extent, you can buy your way out of the system by using home pickup FedEx or UPS, but there's only one way to pick up or mail packages of a certain size in a truly value-conscious way. A post office is still where a neighborhood comes together, and I enjoy observing the pan-ethnic, pan-generational mix of people interacting at the three South Minneapolis stations I visit. The background conversation is typically a blend of Somali, Spanish, and various dialects of American English.

Sadly and predictably, the post office's own advertising around services like stamps.com play on people's apparent distaste for the institution, trumpeting how you can *finally* eliminate trips to that awful post office from your life for good. I've never thought the post office was that unpleasant at all; I like my regular post office, the downtown St. Paul branch, and I like my regular clerk, a good-natured fellow with a flat-top and earring who always makes sure my letters get to where they need to go. In these days of cuts to postal service (the announcement that mail delivery would be reduced to five days a week was made right after I spoke to Mary), cuts to the employees' hours and pensions, and increased automation in the way we send correspondence, just going down to the post office to mail a note to someone can almost seem like a political act. It is, in some ways. "If you hate the post office," a friend of mine who runs a mail-order book and record business told me recently, "you hate small businesses in America."

Mary was quick to point out the personal-is-political dimensions of buying a stamp and supporting the USPS when I talked to her. "Save the economy," she often says. "Send more letters."

House Numbers

1 DIGIT

A tiny street, crisscrossing a grid. Utter darkness, completely hidden in the shadows of taller buildings nearby. The houses are a foot apart. Probably cobblestone streets. The street is named for a person who has been dead for more than three hundred years, or for someone who came over on the Mayflower (Brewster, Winslow). The very rarest, most exotic street address, especially in the Midwest. I have never lived at an address with a single-digit house number. They are primarily reserved for rare book collectors, plutocrats, and magicians.

2 DIGITS

Cozy. A walk-up brownstone, or a row of brownstone walk-ups. A short walk to the bodega, or party store, or news agent, or minimart, or corner shop, or whatever regional term people in your part of the country use for an urban convenience store that sells cigarettes and lottery tickets. It's probably hard to find parking in the immediate area. You'd have to walk a few blocks. Historic preservation markers may be nearby.

ANDY STURDEVANT

3 DIGITS

All my addresses in college, in older parts of the city, had three digits. Urban, but not too crowded. Apartment buildings, clapboard houses, or multistory brick structures. Thirty blocks or so outside the city center.

4 DIGITS

Impossible to say. Every house I lived in up to the age of twenty-two had four digits in the house number (9509, 3604, 1001), as does the house I live in now, as do the next few I expect to live in. Four is the median, the baseline. The smaller or larger the number is than four, the more exotic.

5 DIGITS

Probably on a long, looping street named for a tree, or a miles-long two-lane blacktop with a name like "Airport Way" or "Frontage Road." You can't catch a city bus to an address with five digits. You'll have to drive, and you'll have to drive for a long time. Way out past the proving grounds and the wildlife management area and the most far-flung exurban corporate campuses. There is absolute silence, except for the slow, steady thrum of eighteen-wheelers making their way down the interstate.

6 DIGITS

I pray I never have to visit an address with six digits.

CIRCLE ME, BERT,
IT'S MY BIRTHDAY

*Railyards, ballparks, and
the neighborhood art supply shop*

·

The Next Conrail out of Town

·

Triumph, Desire, Anxiety: Getting Circled down at Target Field

·

"A good-naturedly smart-ass quality"

·

Night Skies in Northern Towns

·

The Next Conrail out of Town

THE AREA AROUND LAKE STREET AND HIAWATHA AVENUE in South Minneapolis has changed greatly in the past fifty years, but the train yards in the Longfellow neighborhood that run parallel to Hiawatha, past the towering Archers-Daniel-Midland silos, look very much as they must have seventy-five years ago.

Trains have been pulling in and out of these yards for more than a hundred years, carrying wheat, fuel, and anything else that has needed transport between Chicago, Canada, and the West Coast. If you're feeling particularly romantic,

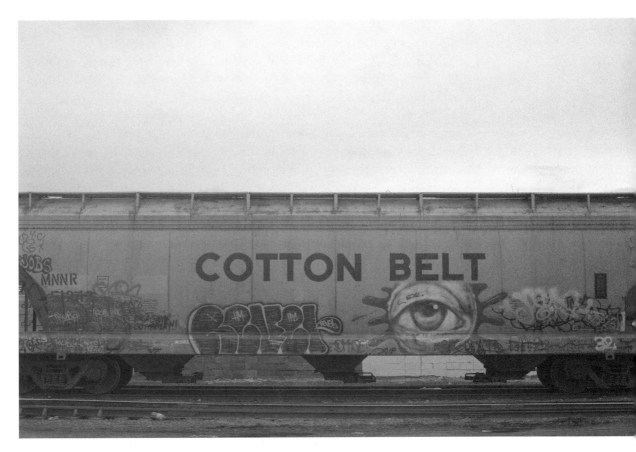

you can imagine that, by simply jumping into an open boxcar door, they could be carrying you across the country too.

Riding the rails strikes a deep nerve in the shared American cultural experience; the modern ideal of the teenager as a roaming, independence-minded

outcast was largely created during the Great Depression boxcar boom. This ideal was cemented for good in sunny southern California after World War II, a landscape filled with teenagers newly mobile in GTOs and Chevy Bel-Airs. But it was all those boxcar kids with their dirty clothes and bindles riding the rails before the advent of the automobile that did a lot of the preliminary myth-making. There is still an active, vibrant subculture of train-hoppers, invisible to mass culture, but making their way back and forth across America.

The most obvious physical evidence of this culture is train graffiti. Take the Northstar commuter rail past the massive Burlington-Northern-Santa Fe rail yards between Minneapolis and Coon Rapids, or poke around in the rail yards in Longfellow or Northeast Minneapolis, and you'll come across hundreds of examples. Anywhere in America, on the margins of industrial parks and in neglected parts of the urban core, you can find train yards with hundreds of examples of train graffiti on nearly every car.

This type of graffiti has a long, strange, and thoroughly American lineage. The first markings to appear on boxcars were made with chalk and pencil by railroad workers, noting arrival and departure times, weights, and other information about the car's contents for the benefit of their colleagues in distant cities who would be unloading them. As Woody Guthrie–style rail riding became a popular, illicit way for people to travel cheaply across long distances in the early part of the twentieth century, a whole taxonomy of hobo markings began to appear on the sides of these boxcars. Like the railroad workers' markings, these were cryptic notations meant for a specific, knowledgeable audience. Perhaps the best document of the evolution of this art form is Bill Daniel's 2005 documentary, *Who is Bozo Texino?* Made over the course of a few years on 8mm and 16mm film, Daniel tracks the evolution of the famed "Bozo Texino" graffito, an image of a cowboy in an infinity-shaped hat that Texino drew on hundreds of boxcars as part of what he called "a continuous project." The resulting video document is a hobo stew of American subcultural styles, drawing equally on Woody Guthrie, the Beats, and postpunk zine culture.

Decades later, first in seventies-era Philadelphia and then New York City, kids associated with the nascent hip-hop subculture began spray-painting the sides of subway cars with tags that, in terms of the way the names sounded, bore some spiritual similarity to hobo/beatnik antecedents like "Bozo Texino"—Stay High 149, Pink Lady, Taki 183, Zephyr. In ten years, hundreds of these artists transformed the city's transit system into a rolling museum of outsider art.

Over the past thirty years, these disparate styles—intimate, rural hobo markings and bold, colorful, urban spray-painted vistas—have fused into a contemporary style that seems to draw equally from each tradition. The sides of train cars today run the gamut, from sloppy gang-style tags and idle signatures to line drawings,

stenciled imagery, and enormously complex color fields. These markings are meant to be examined in close quarters, or viewed from long distances. They are both widely accessible to anyone who might happen see a train roll by, and completely impenetrable to anyone not knowledgeable of the subculture.

One can find boasts, hastily scribbled epigrams, social commentary, threats, jokes, names, notations of date and location, and formal displays of lettering proficiency. It's an endlessly evolving conversation, with work commenting on other work nearby, brighter letters written atop faded, and with callbacks to other artists. It's difficult to know how much of the work originates here, and how much was created in distant cities and is simply passing through on its way elsewhere, seen already by viewers hundreds of miles away. It's hard to know when the work was created—years, months, days ago? It's a jumble of symbolism, styles, and intentions that feels both completely ephemeral and drawing on an old tradition. It seems to spring from a secret history that has only been sparsely recorded.

I can't pretend to have any great knowledge of the names spray-painted and marked on the sides of the boxcars I've seen in Minneapolis. As in any subculture, the artists here have hundreds of admirers who know the intimate details of their work, even as the artists remain invisible to the mass culture. But you don't have to know the biographic details to appreciate the handles, wittily evoking the last seventy five years of American subculture, drawing a fairly direct line from hobos to hip-hop—Sluto, Agono, Bum Nixon, Franco, Maple Spring, Wooden Axle, and the Graf Hick Krew. For many years, there have been memorial graffiti for Conrail Twitty, the alias of Travis Conner, an artist and veteran train-hopper who died in 2008. Twitty's tag was a charming, offhand sketch of a flag, flying in a westward breeze, over a backdrop of billowy Great Plains clouds. Looking him up later, one finds pages and pages of memorials to him on message boards and blogs, posted by admirers in the community. "He will be missed by East coast tramps like me," wrote one, speaking to the geographic reach of his work, and to the way this sort of art is experienced over long distances. "[I] always saw the increasing number of his tags as I came further east as a sign that I was getting closer to 'home.'"

There are a few of the pieces I have seen over the years that have stuck with me. Some of the most striking work is by an artist whose handle I've never managed to see. One reads "TAX THE RICH," and the other, simply "POVERTY" (there are two additional smaller notations on this last one: "$$ for war / But no more for the poor"). Bold pieces, they are meant to be seen from a distance and with political implications easily grasped by the viewer. The artist, in most cases, has left the train's identification number clear. I wonder if there's a code among these artists to leave critical information uncovered, or

if this has been removed after the fact. Up close, one can see in the slashes of the spray paint that the lettering was executed quite rapidly, but from a distance it looks seamless. It's the populist economic philosophy of our time, as surely as it was the populist economic philosophy of the Great Depression.

Not all the work is topical, or as accomplished. Most of it is best described as offhand, lightly surreal non sequiturs. The artist known as Sluto draws an outline of the state, with this rationale for living here: "Shitty football team, shitty climate, cold hands, cold feet. Must be the girls?" I knew Sluto was local when I encountered his boxcar work, because his tags turn up on sidewalks and buildings around the Twin Cities once in a while, most of them done with what appeared to be house paint, dripped on sidewalks and walls right out of the bucket like Jackson Pollock in those old Hans Namuth films. In fact, after Sluto had come across some writing I did about train graffiti online, he sent me an e-mail to introduce himself. He said he'd recognized me from a city bus where he'd seen me reading a Studs Terkel book once, and then he directed me to an autobiographical book he'd written, *2009: An Autopsy*. ("I would just give you a copy but I don't own any because it sort of embarrasses me now," he explained.) I bought a copy and read it over the course of a few days on the same city bus he'd probably seen me on. In it, he recounts in vivid detail the events of the year 2009, in and out of Minneapolis aboard boxcars bound for the west, in various states of intoxication. "On a red Canadian grain car I did a portrait of Jesus Christ, a burning nimbus behind his brain like the cooked moon of a hardboiled egg, a third eye on the forehead and rabbit ears, a personal touch," it begins. "Next to my painting I wrote in white oil paint, 'I FEEL SIMPLY DIVINE.'" He later explained his work in the language many artists use to describe their compulsion to make new work: "Graff is what I do to stop from destroying myself with booze or drugs." In recent months he's relocated to the Ukraine to teach English and dropped the "Sluto" handle. He now goes by Lbrto.

Some other notable pieces seen around local rail yards that have stayed with me: a few lines by Agono, whining (or threatening?), "Love I don't get none, that's why I'm so hostile to the kids that get some." Visceral makes the mysterious, quasi-Oedipal assertion that "my mom is the prettiest lady of all time," alongside a crude sketch of the pretty mom in question, smiling pleasantly.

Like any collection of artwork, what you see in the train yards of your city is all over the place. Some of it is goofy, and some is very poignant and even touching. Some is sloppy, and some is wildly ambitious and imaginative. Taken as a whole, it depicts the mass consciousness of a fluid subculture moving endlessly within a sprawling nation of far-flung borders. It's a subculture that can seem both guileless and possessing a highly refined aesthetic. It seems always on the move, and always looking to catch the next train out of town.

ANDY STURDEVANT

Triumph, Desire, Anxiety:
Getting Circled down at Target Field

THE PUBLIC AREAS AROUND TARGET FIELD in the Warehouse District, where the Minnesota Twins play, are truly public spaces, in both the literal sense of having been paid for by your tax money (at least if you spend money in Hennepin County), and in the more metaphysical sense of really being a space that the public uses to the fullest extent.

The hours before and after Twins games are filled with hundreds of people, acting out very public behaviors. People walk, talk, laugh, sit, wait in line, and interact in a high-density sort of way you don't see in many other places around town—even in wide-open public spaces like Nicollet Mall or Loring Park, places where people are supposed to manifest this kind of behavior. Fans photograph each other, talk to strangers, haggle for tickets with scalpers, and look at high-quality public art. (The planners of Target Field miraculously managed to get most of the public art right.) Outside Target Field on a summer evening right before a game is a lively, exciting place to be.

That is, within certain parameters. For all its liveliness, Target Plaza and the surrounding promenades are also very carefully regulated spaces. Everything is carefully measured and supervised—there are no freewheeling vendors hollering for you to buy homemade pickles in Mason jars and felt pennants. The majority of fans are attired in officially sanctioned Twins gear. While it's often genuinely thrilling to be surrounded by hundreds of passionate fellow citizens outdoors on a beautiful day, all anticipating an exciting game to come, it can sometimes seem more like a simulacrum of an authentic public space.

However, there are a few figures scattered throughout the throng whose commitment to nonsanctioned self-expression makes the space seem not only public in the truest sense, but also genuinely alive. Some are on the fringes of the scene and do impart a sense of unregulated randomness you expect in a true public space: scalpers and buskers.

Each street corner near the stadium is occupied by a couple of guys, asking in an assertive (though often mumbly) voice if anyone walking by needs "secondary market" tickets. Sometimes they'll hold up homemade signs reading, "Need tickets." There's a certain unease in the way scalpers and fans eye each other; they're sizing each other up, trying to figure out if the other is someone they'd like to do business with. Occasionally, you'll see some extravagant gesticulating on the part of the seller or buyer, presumably to ratchet up

the tension in the haggling. Seeing this sort of scene play out is interesting in the way it abuts the wholesome, safe, family-friendly environment the Twins clearly want to promote. A scalper is not wholesome, safe, or family-friendly. A scalper doesn't care where you sit, or if the seat's any good, or if the ticket price is absurdly higher than face value. A scalper doesn't mind humiliating you in front of your kid. They'll have to learn about capitalism someday.

Notable too are the buskers, who present a friendlier variation of creative intervention in public spaces. Trumpet players, guitarists, violinists, percussionists, and other musicians working with easily portable instruments crowd the concourses before and after the game, hooting, banging, and caterwauling popular tunes and original compositions with varying degrees of competence. Interactions vary widely too. Some people—and I hate to pick on suburbanites here, having grown up among that tribe, but the people I am talking about do have a suburban vibe—seem to find buskers frightening, shuffling past them while making that sort of concentrated effort to avoid eye contact that seems three times as noticeable as just making eye contact. But lots of other people will make a crowd, clap, dance, throw some dollar bills into the hats on the ground. You can find buskers on public spaces downtown too, but here they have a more receptive audience. It changes the quality of the performances.

Most of all though, there are the many fans with homemade signage on cardboard and poster board that embody the sort of unsanctioned self-expression I'm talking about. Where else in contemporary cultural life do you encounter so many people who would never identify as "artistic" or even "creative" carrying around objects they have lovingly handcrafted for maximum visual impact? Maybe at political rallies, but more people go to sporting events than political rallies.

In Minnesota, the best expression of this sort of person's need for self-expression is in the ubiquitous "Circle Me Bert" sign that people bring to ballgames. It's certainly one of the great regional folk-art traditions. Presumably it began around 1995 or 1996, when former pitcher Bert Blyleven became a Twins color commentator and began idly circling random fans on the telecasts with his video marker.

Oddly, I can't turn up any early references to the origin of the sign-making practice in the Minneapolis *Star Tribune*'s archives, which is where one would imagine this sort of practice would be first reported. None of the sportswriters I've asked seem to know. This reinforces my belief that sportswriters should be forced to take at least a few visual studies classes in college so they know to look out for this stuff when it's happening. That wouldn't be at all unfair, because most midwestern artists know a lot more about sports than sports fans know about art. Seriously, go to an art opening in Minneapolis in October

ANDY STURDEVANT

and hang around the bar. You think the artists are going to be making small talk about Walter Benjamin's *Das Kunstwerk im Zeitalter seiner technischen Reproduzierbarkeit*? No, they're going to talking about the Twins' inevitable postseason collapse against the Yankees, or whatever went down on Lambeau Field the previous Sunday.

Back to the "Circle Me Bert" signs: Some fans will go as far as to cut circles in the signage and physically stick their own head through the hole, in essence preempting Bert by circling him or herself. Also popular is the appeal to Bert for recognizing them for some life event or accomplishment ("CIRCLE ME BERT, IT'S MY BIRTHDAY," and so on). I wonder how much sway those sorts of appeals hold. Bert's a pretty capricious guy.

While there are conventions for fan signage that one can follow, there are no hard-and-fast templates to which the artist must adhere. Anything goes on a sign, so long as it's clever, attractive, and/or designed with the audience in mind. Homemade ballpark signage is a venue for all sorts of emotions: triumph, anxiety, celebration, wonder, admiration, desire.

Despite the presence of mostly officially sanctioned attire, there are always notable examples of fans going a little overboard with glitter, face paint, color planning, or otherwise over-the-top costuming. I once met a young man named Jack at a Twins game who was sporting some exceptionally attention-grabbing feathery headgear. I asked him, "Jack, what's going on here? Your hat is *crazy*." He shrugged and looked sort of embarrassed. "Well, I just sort of . . . found it," he said. I thought he was being too modest. You don't see enough ballpark fashion aiming for punk Quetzalcoatl.

In fact, I thought about telling him he could have a future making these things and selling them to fans. Maybe, but that sort of regulated commerce is kind of antithetical to the spirit in which the hat was created and worn. The space around the ballpark is a place where anyone can try out public personas that probably wouldn't fly out on the average city streets. Jack was out there wearing his crazy feather Mohawk hat with the fans and scalpers and amateur photographers and buskers and people who want Bert to circle them because they just got engaged, and they're all making up a joyous, roiling public space full of neon colors and novelty foam.

"A good-naturedly smart-ass quality"

SPENDING PART OF A SATURDAY AFTERNOON at the Art Cellar, the art materials store located on the campus of the Minneapolis College of Art and Design, I was reminded of an essay I'd read recently by Scott Timberg. Entitled "The clerk, RIP," it eulogized the golden age of the independent retail clerk, a cultural archetype quickly vanishing from the scene in today's increasingly automated, low-wage economy.

These are the men and women who work behind the counter at record, book, or video stores, and serve as a combination advisor/consultant/scholar in residence for the creative communities they serve. Timberg mentions Jonathan Lethem's formative stint as a bookseller at Pegasus & Pendragon Books in Berkeley ("my university," he called it), and rattles off the names of a few other notable artists who worked formative stints ringing up sales and making recommendations to customers from behind a cash register: author Mary Gaitskill (the Strand in New York), musicians Colin Meloy (Fact & Fiction Bookstore in Missoula, Montana), Patti Smith (the Strand again), Jim James (ear X-tacy in Louisville), and Peter Buck (Wuxtry Records in Athens, Gerogia), and perhaps the most famous video store clerk in American history, future filmmaker Quentin Tarantino, who once held court at Manhattan Beach, California's Video Archives.

All of them were independent store clerks at one time whose experiences informed their later work, and who had the opportunity to work in environments that valued their ingenuity, independence, and initiative. Nearly every town in America, no matter how small or out of the way, has historically had at least one shop lorded over by an all-knowing clerk. Even in the suburb where I grew up, in the most nondescript dry-cleaners-and-supermarkets strip mall imaginable, there was a punk and bluegrass record shop called Blue Moon Records, owned by the former bassist for a legendary local band my cooler friends all loved. I used to buy all my CDs there, taking whatever input he'd offer and hoping to dazzle him by purchasing, for example, Big Star and Jefferson Airplane albums. Never in my life, with the exception of certain college girlfriends, have I gone so out of my way to impress someone with my pop cultural acumen as I did with that shop owner. I remember actually shaking with anticipation the day I went in to go buy the Robert Johnson CD box set I'd had special ordered, in anticipation of his approval. I wasn't disappointed: he looked at me square in the eyes as he handed me the box, and said, "This. Kicks. Ass." I was giddy as my dad drove me home, knowing silently I'd finally distinguished

ANDY STURDEVANT

myself from the other suburban knuckleheads he was forced to sell Third Eye Blind albums to. I was finally one of the elect. I was making a difference in my local creative community!

I find the idea poignant, because I too was once on the other side of the counter myself: From 1999 to 2004, I worked as a clerk at Preston Arts Center, an independent mom-and-pop art materials shop in Louisville. Like our comrades in record, book, and video stores, we, the art supply store clerks, served a creative community by providing access to the raw materials they needed to make their work. Writers need cheap paperbacks of authors they admire, musicians need import-only vinyl pressings of Japanese noise rock albums, and artists need paintbrushes and Micron pens. Not only did we provide these materials, but we lent both solicited and unsolicited expertise on how these materials could be used to their best advantage. And as if these services were not enough, we also provided valuable intelligence on a need-to-know basis to the broader artistic community about who was dating whom, which new shows were brilliant or terrible, and whose purchases were funded by wealthy parents or paramours. Engaging in a little light class warfare goes a long way in making a healthy art scene. Sure, anyone can buy a paintbrush and odorless thinner online. But no Amazon algorithm is going to also tell you which noted local art star came in with his mom last week and bought six hundred dollars' worth of stretched canvases on her credit card.

Of course, I also gained a lot personally. I copied typefaces out of a Dover paperback edition of J. Albert Cavanaugh's *Lettering and Alphabets,* which we sold for $2.50, until I'd learned to hand-letter. The owners didn't require uniform signage for the easels and paints and pen on our shelves. If you could hand-letter a price list legibly with a paint marker on a piece of matboard, you were more than welcome to throw in any supplemental illustrations, visual jokes, or typographical flourishes you desired. You want typeset, uniform in-store signage? Go to Michael's.

There are still havens for this sort of graphic independence and one-on-one experience in the art materials retail sector. The Twin Cities is home to a number of great independent art materials stores, full of smart employees with considered opinions on a full range of professional topics—Wet Paint in St. Paul is excellent, and Penco and Northwest Graphic Supply in Minneapolis both come to mind as well. Among these is the Art Cellar, located inside the Morrison Building at the Minneapolis College of Art and Design.

Because it's located on campus, one often gets the sense the store is for MCAD students only. That's not the case. It's open to the public, seven days a week, and carries the full complement of art materials for professional, student, or amateur.

The clerks at the Art Cellar are keeping the art of handmade signage alive and well. The narrow aisles are crammed full of colorful collages, drawings, paintings, calligraphy, scribblings, and mixed-media pieces, all in the service of presenting prices and selling points for the store's inventory. Other than a generalized good-naturedly smart-ass quality, there's no unifying aesthetic to the store's signs. Each one is like a little zine, with its own style of lettering and level of craftsmanship. Most of them are made in the pre–desktop publishing style of X-ACTO blades and rubber cement, with photocopies or magazine clippings pasted across neon backgrounds and held together with clear packing tape.

In the Art Cellar, you can find depictions of Elvis Presley, Wicket Warwik the Ewok, Count Chocula, Francis Bacon, Kevin Bacon, rabbits, nuns, nude models, Duran Duran, Aquaman, and anyone else who could be copied, cut out, or otherwise appropriated from the annals of material culture. If you're noting a somewhat retro vibe with the pop culture references, you're not wrong; the aesthetic, whether willfully or not, calls back to the eighties and nineties, the heyday of both the cut-and-paste zine and the retail clerk as cultural arbiter.

The staff is collectively responsible for the signage, so no one is individually credited. Jarad Jensen and Robyn Hendrix, the two artists on staff when I visited, explained the process: Making a sign is a privilege, not a right, and it's only after some time on the job that the new employee is invited to contribute. Generally, the signage is anonymous, but the Art Cellar's blog does maintain a list of current and former employees whose handiwork is still out on the floor. There are some regionally familiar names among them.

What I like most about this sort of signage is that it's the sort of material culture that doesn't usually get anthologized or put into retrospectives; it's too utilitarian, too hastily made, too ephemeral. It's work made by practicing artists, but it's generally just an amusing sideline to their regular practice, made while they're on the clock, between recommending acrylic brushes to customers.

But these handmade signs, in their own small way, tell you a great deal about the place you find them, and about the people who made them. They value spontaneity, humor, and independence over order, stodginess, and faceless efficiency. They tell you the sort of people working behind the counter aren't recommendation algorithims, but individuals who cares about their work and the materials they sell. It's something they take seriously and, paradoxically, that seriousness is best expressed with magazine cutouts, double entendres, and pink permanent markers.

ANDY STURDEVANT

Night Skies in Northern Towns

IN 2012, AT THE CONFERENCE OF THE AMERICAN GEOPHYSICAL UNION, a new, high-resolution image of the United States at night was released. Taken from NASA's Suomi NPP satellite, the images show the country as it appears at night from space with a far higher degree of clarity than previous such images. As with any map of the United States, your eyes probably drift inevitably to home, and when I saw it for the first time, my eyes drifted toward the little spiral that makes up the Twin Cities, tucked halfway between the lights of Chicagoland clustered around Lake Michigan and an eerie patch of luminosity created by the burning oil fields in western North Dakota. You can trace I-94 and 35W off of the core by following the little pockets of light that dot the interstates between Fargo, Duluth, Madison, and Des Moines. The Twin Cities are the last sizable cluster of light before the largely darkened interior, the last city of the dense, crowded east and the first city of the windswept prairies of the west. It's fitting that the cities fall almost exactly halfway between western North Dakota, where the boomtown dream of unlimited wealth in squalid conditions lives on in the oil fields of Williston, and Chicago, where the economic and cultural nexus of the old Northwest has rested for a hundred or more

NORTHWEST

years. In most directions out from the cities, there are gradually larger and larger swaths of darkness.

It's an inverse of how the night sky looks from the ground. The lighter the area is on the map, of course, the harder it is to make out the sky from down here. Stargazing is great out in those darker patches, in these farthest reaches of the state. In a place like the Boundary Waters, you can find yourself in complete darkness. In the farthest parts of the north, not only can you clearly make out the Milky Way, but the Aurora Borealis as well.

Or so I've heard. The fact is—and this is something I must regularly admit to the people of this aggressively outdoorsy part of the country—that I actually don't make it out of the core cities very often. I'm too tethered to bus lines, taco trucks, Wi-Fi, and art museum public programming. While there are some excellent resources around Minneapolis and St. Paul for dedicated stargazers and amateur astronomers, for the most part, your view of the night sky—even from darkest stretches of city streets or urban parks—is pretty limited by light pollution.

While it's *limited,* this isn't to say that living in the city must completely deprive you of the pleasures of stargazing; you just have a smaller palette to work with. Identifying a whole sky's worth of twinkling stars is potentially quite a difficult task, but there's no reason you couldn't learn to correctly identify

SOUTHWEST

ANDY STURDEVANT

the scaled-back handful of stars that are visible from city streets. Why shouldn't citydwellers have a map of the night sky that only highlights what's visible to them? In northern latitudes, the view of the night sky is much the same wherever you are in North America. I always imagine a smug, frosty Snow Belt camaraderie with fellow L.L. Bean–clad stargazing compatriots in the great northern cities like Detroit, Boston, Montreal, Toronto, Milwaukee, Burlington, Winnipeg, Bangor, and Calgary, looking to the skies.

The stars themselves fall somewhat out of the urban stroller's interest in material culture, but in winter months, the material culture is mostly covered in snow. The skies can be quite clear on good nights, and the darkness and silence reward heavenly contemplation.

These four maps, created in ink and watercolor, show each quadrant of the sky in the winter—specifically, I've tried to place them in mid-December, around the solstice. It's how the sky appears at around 11:00 p.m., the best time to be coming back home from a bar or show and walking from the transit stop to your home. I've included only stars of the brightest magnitude, the ones that break through the light pollution and the haze. It's entirely likely I've missed a few, but for the most part, these will be among the brightest objects in the winter sky this time of year if you're out for a late-night stroll anywhere north of the forty-fifth parallel.

NORTHEAST

Starting in the southeast, one finds the brightest star in the sky, **Sirius**, part of the Canis Major constellation. (I've included the full constellations in these maps, though many parts of these heavenly groups will probably be missing key points, like a connect-the-dots on the back of a children's menu half-completed by a very lazy child.) Sirius makes its way back into the sky in late November, and is more than twice as bright as any other star in the sky. This time of year it's quite low in the sky, so it may be blocked by buildings, trees, light posts, or statues of unusually tall individuals, but it's fairly hard to miss if you've got an unobstructed view of the whole sky. You may be able to make out some of the other stars in Canis Major, such **Mirzum, Wezen,** and **Adhara.** Farther up, you may also be able to make out **Castor** and **Pollux,** the twins that give the Gemini constellation its name.

In the southwest quadrant, you can make out the two planets in our solar system visible at this time of night, **Jupiter** (within the constellation of Taurus) and **Uranus.** High up in the sky you may also find **Mirphak,** alternately known as Alpha Persei or Algenib, a star that is only visible to those of us living in northern latitudes.

In the northwest quadrant, Mirphak remains visible. Closer to the horizon, you may find **Deneb,** the brightest star in the constellation Cygnus (mislabeled on this otherwise delicately rendered map—oops). Most of the stars in this

S O U T H E A S T

ANDY STURDEVANT

part of the sky are not bright enough to be seen from the city on all but the darkest, clearest nights. If you could make out the other points here, you'd see the asterism known as the northern cross. In the center of the sky directly to the north, of course, is **Polaris,** or the North Star, the heavenly body that gives Minnesota its nickname and motto: the North Star State and l'etoile du nord. Polaris's other names—the Guide Star, the Lode Star, the Pole Star—give a sense for how important it's been historically for navigation, and, by logical extension, a symbol of consistency and unerring trueness.

Lastly, in the northeast quadrant, the Auriga constellation is highest in the sky; its most visible star is **Capella,** a binary star system located a mere forty-two light years from Earth. Lower in the horizon there is **Dubhe,** the brightest star in Ursa Major, a well-known constellation that is nonetheless not greatly visible from the city. **Regulus,** another one of the brightest stars in the night sky, also lies close to the horizon in the eastern part of the sky.

And that's the winter sky in your northern city at around 11:00 p.m. This information should keep you occupied for a while. For the rest of the seasons (or other parts of the night), consult *The National Audubon Society Pocket Guide: Constellations of the Northern Skies* (New York: Knopf Doubleday Publishing Group, 1995). When your cooler friends living on rural communes and in small college towns try to shame you about your lackluster stargazing knowledge, don't take any shit from them. Maybe you've only got a few stars in your night sky, even on the clearest winter nights, but you can tell them you know the ones you've got.

THE WRY MYTHOLOGY

―――~―――

Minneapolis explained: by Mary McCarthy,
Jorge Luis Borges, Studs Terkel, and others

•

"Snakker du norsk?"

•

Golden Glow and Sickly Nasturtiums:
Mary McCarthy's Whittier

•

The Season and the Condition of the Viewer:
A Trip to Minnehaha Falls

•

A Beacon for All Twin Citians

•

"Snakker du norsk?"

LIKE THOSE OF MOST PEOPLE who didn't grow up in Minnesota—and probably many who did—a lot of my earliest perceptions of what life in this snowy, mysterious northern region of the country must be like were informed by *A Prairie Home Companion,* which my family listened to fairly regularly. I remember being genuinely shocked, in fact, in my first year in Minneapolis that I never seemed to hear people on the street speaking Norwegian. To this day, in fact, I have only seen one person—one single solitary person!—speaking Norwegian on a sidewalk in the city of Minneapolis. It only half counts too, since he appeared to be an outstate farmer (I could tell by his neckbeard and seed cap) trying to make his way out of the city, apparently getting directions from a friend or family member back on the farm via his cell phone.

While I did notice there were a lot of Lutheran churches around, there didn't seem to be a great deal more than those of other mainline Protestant denominations. There were plenty of Catholic and Orthodox churches, and actually quite a few more synagogues than we had back in Kentucky. This is not to mention the many church buildings for Presbyterians, Unitarians, Methodists, Episcopalians, and nonspecifically evangelical congregations, as well as Christian Science reading rooms, Buddhist meditation centers, and lots and lots of mosques.

"Where are all the Scandinavians?" I remember puzzling many times. Besides a much larger than average number of Petersens, Andersens, and Olsons in my cell phone contacts, the reality never seemed to quite match the myth.

For example, there are only two places within walking distance of my house where I can buy lefse—this is more than in most cities, obviously. But it's still much, much easier to find goat meat, burritos, injera, banh mi, and other assorted pan-ethnic culinary delicacies nearby than it is to find the sorts of traditionally Scandinavian foods I expected to find on every street corner in my earliest years as a resident.

No doubt that fifty years ago, many parts of Minneapolis were very, very Lutheran, and very, very Scandinavian. Of course, many parts of Greater Minnesota still are. But as far as day-to-day life is concerned, it seems to me that the Lutheran Scandinavian heritage of Minnesota's self-identity is now only one small thread in the city's larger cultural tapestry.

But there remains a great deal of evidence, especially around South Minneapolis, of where this perception originally came from. The area was settled heavily by Norwegians, Danes, and Swedes throughout the late nineteenth

century and early twentieth century, and the religious and cultural institutions they built remain part of the physical landscape.

At Sixteenth Street and Portland Avenue, there's a large, authoritative-looking brick building that, according to the Gothic script signage over the front doors, once housed the Lutheran Bible Institute. The school was founded in St. Paul in 1919, and built on this site in 1929. It remained for only about thirty-five years before moving to Golden Valley in the early sixties (along with a lot of other white flighters). The Golden Valley location closed in 1985. The old campus on the Olson Memorial Highway has gone on to play a major role in the artistic life of the Twin Cities: it became the home of the Perpich Center for Arts Education, a public arts high school that has turned out hundreds of the best artists, musicians, and performers at work in Minnesota today.

Farther south, you'll come across a bright red painted storefront dominated by a neon white cross. It's easily one of my favorite storefronts in Minneapolis. I clearly remember seeing it for the first time, years ago, on one of those long, night-time rides on the 5 bus down Chicago Avenue back to my home in Powderhorn Park. Chicago between downtown and Lake Street is not particularly well lit, and the glowing white cross stands out from its surroundings in the dramatic sort of way its creators clearly intended it to; the evening I first saw it, the cross was reflecting doubly bright in puddles of melted snow on the sidewalk. Under it were the words "LUTHERAN COLPORTAGE SERVICE," rendered in red, yellow, and orange, in a perfect midcentury hand by a highly skilled sign painter who'd very likely ascended to Lutheran heaven at least a few decades before I was born.

Coming across a storefront offering "colportage" in the middle of Chicago Avenue in the twenty-first century seems as unlikely as encountering a tallow chandler, shipwright, drysalter, slopseller, or ironmonger.

Colportage? I grabbed a pen out of my pocket and wrote the word on a scrap of paper, because I'd never heard it before. It turns out that colportage is the distribution and sale of religious publications: tracts, books, pamphlets, and other similar items. It's a word that's fallen largely out of use—in fact, you don't even see the word *tract* in the context of religious publications very often anymore. You still see Chick tracts on the bus sometimes. That's about it.

As much as I'd admired the building, I'd never actually taken a look inside to see what purpose it was now serving. I returned recently to see if there was any chance it was still a warehouse for colportage—I think I was hoping to find stacks of biblical tracts, with titles asking something like "What Do the Lutherans Believe?" typeset in Futura, along with offset-printed images of smiling, blond Max Von Sydow Jesuses, sitting in piles untouched since the forties.

While such a treasure trove of printed midcentury ephemera may exist somewhere, it's not here. An active congregation of nondenominational Protestants

ANDY STURDEVANT

now occupies the onetime home of the Lutheran Colportage Service; it looks as if they have worship services several times a week. How long the storefront will continue to exist in its current physical configuration is anyone's guess. To give you a clue of what an outdated term it is, and just how rare it feels to come across it: the publishing arm of the famed Moody Bible Institute of Chicago dropped any reference to "colportage" in its own name way, way back in 1941. The word was already passé seventy years ago. Perhaps the current congregation in the building now will someday wish to update the signage, which is completely understandable. But I hope they keep it.

A few blocks east is the Norwegian Lutheran Memorial Church, or Den Norske Lutherske Mindekirken, as it reads over the front entrance, in similar type to that on the old Lutheran Bible Institute. Mindekirken is the only Norwegian-language church in Minneapolis, devoting one service every week to Norwegian. I happened upon it by accident—I was biking by from the colportage, looking at churches in the neighborhood, and stopped to have a closer look at this one, which was flying the Norwegian flag. A congregation member who was outside gardening approached me. Maybe it's my red beard, but he asked me right away, "Snakker du norsk?" I know enough Norwegian to reply, "Oh, no, no, just looking."

We talked for a few minutes about the history of the church, and he invited me to come back for the Norwegian-language service at 11:00 a.m. that Sunday. The interior sanctuary is beautifully preserved, looking much as it must have in 1929, when it was built—an altar with gorgeous woodwork, and a large-scale oil painting of the resurrection by August Flagstad, a Minneapolis painter who lived and worked on the West Bank, another neighborhood that was once a Scandinavian stronghold and remains to this day an immigrant community. Flagstad's work is based on an altar painting at a church in Molde, Norway.

As noted, I speak no Norwegian, but the rhythms of the language and songs in the service were striking all the same. I imagined this is very much what the sidewalks and storefronts of this neighborhood must have sounded like a hundred years ago. Keeping an immigrant language and culture alive for nearly a century is a remarkable accomplishment, particularly through those decades where immigrant populations were expected to jettison Old World traditions and assimilate quietly. I was very touched, and even more touched when I was invited to a classic church basement lunch after the service, with coffee, sandwiches, and cake, and some conversation with members of the congregation. "I've always thought," the pastor explained over finger foods, "that city churches were some of the hidden gems of the urban experience." The lunch also served as a going-away party for an older member of the congregation. She was an older woman, leaving that week to live with her family in Florida. She'd

been a member of the church for decades, and listened quietly with a smile while congregation members read tributes to her, both from them and from former members now living in Norway. Finally, she stepped up to the lectern herself to speak. Her remarks were brief. "I don't like to draw attention to myself," she said in a lilting Scandinavian-inflected accent, "but thank you for your many years of kindness. I will miss you all." Then she nodded and walked back to her seat as the congregation applauded. Most people in the room were in tears. I certainly was.

There must be a balance between preserving the past and remaining in the present. You can see that balancing act walking through the southside, where old buildings, traditions, languages, artistic works, and cultures are constantly in a state of flux, negotiating between the two. Over time, these negotiations require a participant to move from a passive role into an active one in these experiences. There certainly once was a time when the Norwegian that the farmer I saw downtown speaking into his cell phone would have just been a part of the background noise of everyday life in the city. One now has to take

ANDY STURDEVANT

a more active part in weaving these experiences into their own life. The further away the past gets, the more carefully you have to listen for its echoes.

Bicycling back home, I passed the Masjid Omar Islamic Center, one of the gathering places for the substantial Somali and East African community that lives in the area—for nearly a century, the neighborhood has been a home for immigrants. A group of kids were standing outside, speaking to each other excitedly in Somali. I wonder if, sixty years from now, these kids' great-grandchildren will still assemble at the mosque, keeping the Somali language alive in the neighborhood long after it's passed from everyday, vernacular use. I wonder too if by that time, there may be just as many historic East African cultural institutions in the area as there is evidence of Scandinavian institutions today. I wonder if future visitors to the city, like me in my first months, may be surprised and a little disappointed at how infrequently one hears Somali spoken on street corners in the course of everyday life.

Golden Glow and Sickly Nasturtiums:
Mary McCarthy's Whittier

MARY McCARTHY'S 1957 AUTOBIOGRAPHY, *Memories of a Catholic Girlhood,* is the first of several memoirs she'd written after some early literary successes but before her best-known novels. McCarthy was one of the great essayists of the twentieth century, and certainly one of the wittiest. Her quip about her rival Lillian Hellman on *The Dick Cavett Show* in the late seventies—"every word she writes is a lie, including 'and' and 'the'"—remains perhaps my favorite literary insult of all time.

The first part of *Memories of a Catholic Girlhood* takes place in Minneapolis, primarily within a ten-block radius of the Whittier neighborhood on the city's southside. This sharp, thoughtful memoir is primarily a look at the influences and factors that would shape her later career as a writer, so I thought it would be interesting to take a walk around and see some of the key sites she describes, as they appear today. Though McCarthy was born in Seattle, when her parents died in the 1918 flu epidemic, she and her brothers were sent to live with an abusive great uncle in Minneapolis. Here she remained for five miserable years, until her maternal grandparents finally took her back to Seattle.

From 1918 to 1923, McCarthy lived with her cruel, pathetic Uncle Myers and his wife in a small yellow house at 2427 Blaisdell Avenue. "Flanked by two-family houses," she writes, "it was simply a crude box in which to stow furniture, and lives, like a warehouse." This is a striking description of the soullessness of certain types of little houses you often come across, in both urban and suburban settings. It's somewhat difficult, though, as modern viewers, to agree with this specific aesthetic assessment. Whittier is now generally thought to have some of the more lovely housing stock in the city. Compared to the rickety little ramblers and stucco duplexes that make up much of the rest of Minneapolis's post-1918 housing, Whittier's solid, well-built, turn-of-the-century wood-framed residences, with their wood floors and interiors, seem wildly more appealing. In fact, the "crude box" at 2427 Blaisdell is now gone—in its place is an inoffensive and unattractive multiunit brick apartment building, built in 1958 and truly boxlike in appearance. How perceptions change.

Young McCarthy was an exceptionally devout child, and much of the memoir is about how the intellectual experience of Catholicism shaped her adult

thinking, although she abandoned the Church at quite an early age. She writes of her experiences at St. Stephen's, located at 2201 Clinton Avenue:

> Looking back, I see that it was religion that saved me. Our ugly church and parochial school provided me with my only aesthetic outlet, in the words of the Mass and the litanies and the old Latin hymns, in the Easter lilies around the altar, rosaries, ornamented prayer books, votive lamps, holy cards stamped in gold and decorated with flower wreaths and a saint's picture. This side of Catholicism, much of it cheapened and debased by mass production, was for me, nevertheless, the equivalent of Gothic cathedrals and illuminated manuscripts and mystery plays. I threw myself into it with ardor, this sensuous life.

St. Stephen's itself appears quite unchanged a century later. The building itself—again, difficult now to think of such a stately church as "ugly" in any way—was built in 1889. Inside, the displays of votive candles, ornaments, and statuary that so moved McCarthy as a child remain surprisingly intact, much as she must have experienced them in 1918. It's easy to forget just how Catholic a state Minnesota was at this time—more than 40 percent of churchgoers professed the Catholic faith, nearly twice as many as those professing Lutheranism. (A side note from McCarthy here: "Lutheranism to us children was, first of all, a religion for servant girls and, secondly, a sort of yellow corruption associated with original sin and with Martin Luther's tongue rotting in his mouth as God's punishment.") Entire neighborhoods were organized around the local parish. In Whittier, McCarthy's social, educational, cultural, and spiritual life revolved around St. Stephen's, only blocks from her house.

The neighborhood around the church has changed greatly, though. If St. Stephen's had stood two blocks to the east, it would have been obliterated by 35W, a fact to which the looming, nearby sound barrier wall attests. Indeed, the interstate tore a swath through twenty-five blocks of the parish in the sixties, obliterating hundreds of houses, displacing numerous families, and upending the neighborhood. One can only imagine how disruptive this event would have been to the area.

The church was perhaps not Mary's only aesthetic outlet. Though her Uncle Myers hated museums, the Minneapolis Institute of Arts stood only blocks away from Twenty-Fourth and Blaisdell. On at least one occasion, McCarthy ran away from home, an act she called "her only form of complaint." She spent the day hiding behind a statue of Laocoön, the Trojan priest of antiquity who

coined the phrase "beware of Greeks bearing gifts" before being strangled to death by sea serpents. The most famous depiction is at the Vatican.

I went to the museum to see the statue, only to find it did not exist. "The MIA does not have—and never had—a statue of the Laocoön," says Eike D. Schmidt, James Ford Bell Curator of Decorative Arts and Sculpture and head of the Department of Decorative Arts, Textiles & Sculpture at the MIA. He continues:

> Having said that, it is possible—and given Mary McCarthy's account, I would say it is likely—that a plaster cast after the Laocoön was displayed at the museum at the time. As many other American museums, plaster casts of famous sculptures played an important role in museum displays in the nineteenth and early twentieth century, but they soon came out of fashion, and in fact, the MIA's plaster casts were deaccessioned in 1958. Unfortunately no cast of the Laocoön has survived, nor do we have positive evidence at this time for the presence of such a cast in the galleries in the 1920s. But that is really what it must have been.

It's tempting to want to claim McCarthy as one of Minneapolis's own—our civic character loves any reason to claim a homegrown artist—but the experiences outlined in this beautiful book are so uniformly bleak it would be quite perverse to do so. Even her descriptions of the physical details of the city around her are grim: "The people I was forced to live with in Minneapolis had a positive gift for turning everything sour and ugly," she notes. "Even our flowers were hideous; we had golden glow and sickly nasturtiums in our yard."

In the text of the book, McCarthy is upfront about liberties she took with the sequence of events, and with embellishments to events that were too hazy and too far off in childhood to remember clearly as an adult. By the time she'd written it, she was best known not as a midwestern or Pacific Northwest literary figure, but as a figure closely associated with the East Coast, studying at Vassar and contributing to legendary New York–based journals such as the *Partisan Review*. Several of her novels were set in and around the East Coast in affluent, leftist, and academic circles, and were assumed by some readers to be romans à clef, based on her upbringing and informed by those experiences. ("What I really do is take real plums and put them in an imaginary cake," she told the *Paris Review* in 1961.) But by the time she'd arrived at that point in her life, the Midwest was only a small and unpleasant part of the story, one that had primarily given her a backdrop to consider issues of faith as they related to her intellectual development later in life. McCarthy was, by then, the consummate New York City intellectual.

The city neighborhood she depicts in her brief time here—a close-knit, repressive Catholic enclave of parish priests and Scandinavian servant girls—is

fascinating in just how unrecognizable it seems today. The Whittier of the twenty-first century is a multiethnic neighborhood, the second densest in the city. Its population is about 20 percent African American, and 20 percent Hispanic, with many Asian and East African residents. In contrast to its older identity as a neighborhood of great wealth with enormous mansions lining private parks, it's now comprised primarily of renters. It's lined with tiny, delicious Asian and Latin American restaurants, some of the best in the city. It's one of the best neighborhoods for walking—dense and lively where other neighborhoods can seem sleepy and diffuse. Seeing this part of the city through this very narrow literary and historical lens that McCarthy focuses on it is to be reminded how subjective experiencing a place can be. Anyone you meet while you're on the street, as you walk through looking at its buildings and houses and churches, has his or her own private experience of those places. McCarthy's evocative descriptions of this neighborhood say less about the place in strict historic terms, and perhaps more about the ways in which place can be used to consider one of the biggest questions of all: why do I believe what I believe?

ANDY STURDEVANT

The Season and the Condition of the Viewer:
A Trip to Minnehaha Falls

ONE OF THE BEST PARTS OF EARLY SPRING is taking the first trip on the light rail down to Minnehaha Falls for an afternoon of beer and fried fish and walking around in the outdoors. Minnehaha Falls is a fifty-three-foot waterfall, surprisingly sizable for being located on a small creek in a city park. There's a seafood restaurant there, built in an old Parks Board recreation building complete with outdoor seating, and it opens seasonally. For many people, its opening portends more than anything else in town the start of spring. It's also one of the best places to bring out-of-town guests—it's right on the rail line, there's always lots of people around, and you can either take it easy with a beer on an outdoor patio and listen to buskers, or hike down into the wilds along the banks of the creek, in one of the few topographically varied parts of a very flat city. The first time my mom visited me in Minneapolis, I took her here, and we had such a good time she still asks me if I ever see the busker we met around town, years later. (I haven't.)

On an Easter Sunday a few years ago, I had another out-of-town visitor in for the weekend, and although it wasn't even particularly pleasant out (hovering around fifty degrees), I thought that she ought to see the falls on that holy day.

Spring doesn't bring the sort of sustained, studied focus that results from being driven indoors in the winter. The winter season is when everyone holes up inside and works intently on long-term projects, whether artistic, emotional, or otherwise. Spring is when you finally get a chance to throw all that away for a few months and focus on enjoying the present. Being outdoors, especially in a place like Minnehaha Park, makes for too many distractions to remain focused on any task more complicated than eating a fried oyster. Near where we were sitting, a gang of kids took turns smashing a piñata as a half circle of adults stood around them, chanting; as soon as the piñata burst open, the kids ran in, grabbing up handfuls of candy, and then vanished from the scene completely, leaving only a dangling string. This trip to the falls had a similar quality. There is an intent focus on one object, and then we flit off instantly to the next thing.

And there is a lot to flit around and see around Minnehaha Falls, both natural and man-made. One of the first objects you encounter walking toward the falls themselves is a historic marker, commemorating a June 1964 trip to the site by President Lyndon B. Johnson, Minnesota Senator Hubert H. Humphrey,

and Minnesota Governor Karl Rolvaag. At that time, Humphrey was not yet LBJ's Vice President. Less than two months later, Humphrey would be Johnson's running mate, and LBJ would go on to win the presidency in November in one of the most lopsided victories in American electoral history.

The photo this drawing is based on is attributed to the *Minneapolis Tribune*. It's the sort of quality photojournalism made by the sort of competent, efficient professional that the local papers once employed by the dozens. It's a picturesque shot of Humphrey, Rolvaag, and Johnson looking down at the falls. "In order to create the beautiful display of the falls pictured here," reads the inscription, "the city had to open many fire hydrants, upstream and out of sight, to feed water to the creek." Johnson is ignoring Rolvaag and Humphrey, looking past the falls. As in any classic newspaper photo shot, there's some psychological intrigue playing out in this arrangement. The now mostly forgotten Rolvaag's back is to the camera, and Humphrey regards him with a characteristic good-natured guffaw. Towering over the Minnesota senator, Johnson's steady gaze and wry grin oozes confidence and power, but also appears calculating, even vaguely menacing. Knowing that two months later Johnson would choose Humphrey as his running mate gives the scene an added layer of psychological intrigue.

Standing in Humphrey's hometown, what was Johnson thinking about the man in that moment? Says Robert Caro of the two men's relationship in his definitive 2002 LBJ biography *Master of the Senate*: "At the bottom of Humphrey's character, as Johnson saw, was a fundamental sweetness, a gentleness, a reluctance to cause pain; a desire, if he fought with someone, to seek a reconciliation. . . . To Lyndon Johnson that meant at the bottom of Humphrey's character,

beneath the strength and the energy and the ambition, there was weakness." This may explain the predatory quality Johnson seems to exude here.

Also on the way is a sculpture by the New Mexico–based artist Ed Archie NoiseCat, depicting Taoyateduta, the Dakota chief also known as Little Crow. So much of Minnehaha Park is rooted in romantic nineteenth-century notions of nature, its sublimity, and the noble lives of the "savages" imagined to have lived there by Eastern writers like Henry Wadsworth Longfellow. He gives this part of Minneapolis its name, and his epic poem "The Song of Hiawatha" gives both Minnehaha Park and Falls theirs. Longfellow casually studied some Ojibwe lore published in his lifetime, but the poem has very little to do with any of the actual stories of the Ojibwe—"Hiawatha" isn't even an Ojibwe name, but an Iroquois name. Longfellow's famous poem has more to do with New England's intellectual traditions, yet it's been adopted here as a sort of shorthand for the Native experience, without really having much to do with it. NoiseCat's sculpture depicts a mask, resting on pillars, looking resolute, but also, without eyes, quite blank. NoiseCat seems to be inviting you, the viewer, to look through Little Crow's eyes, and consider the story of the indigenous people of this region through that perspective.

Little Crow himself was something of an enigmatic figure—a leader who was murdered by white settlers in retaliation for his participation in the 1862 Dakota War, he was a charismatic negotiator whose primary interest was in compromise and coexistence between the Dakota and white settlers prior to the outbreak of violence. He was a figure who moved in both white and Native circles who "refused to cut his hair and modified his dress as circumstances required . . . [who] understood English but was never heard to speak it in public," according to historian Mary Lethert Wingerd. The sculpture commemorating him is a bracing corrective to the condescending, overblown romanticism of the park's other Native-themed sculptures. Most notable is an early twentieth-century sculpture of Minnehaha and Hiawatha by Norwegian American sculptor Jacob Fjelde, depicting a scene from Longfellow's poem. The warrior Hiawatha lifts the princess Minnehaha aloft, both of them clad in buckskins and feathers. Like Longfellow's poem, it has everything to do with Romantic poetry, and very little to do with the people who lived in this area for hundreds of years before there was a state of Minnesota. It is, like Senator Humphrey's eagerness to please President Johnson by activating the parched Minnehaha Falls with thousands of gallons of fire hydrant runoff, a fiction.

One final out-of-town visitor to the falls, and no stranger to fictions himself: the great Argentine writer Jorge Luis Borges visited on his eighty-third birthday in 1983, and had his photo snapped by photographer Stuart Klipper, who was accompanying him while in town. Borges stands in front of Fjelde's

sculpture of Hiawatha and Minnehaha. He was in town for a lecture at the University of Minnesota, and Klipper took him—as Humphrey took Johnson, as I took my mom, as we always do with our out-of-town visitors—down to Minnehaha Falls for a visit. Part of this was because Borges was such an admirer of Longfellow. But part of it was also the attraction of the falls themselves. Borges, blind by this time, could not see them, but you don't need to see the falls in order to appreciate them. The sounds of the water falling into the cavernous, tree-lined basin, in the middle of a city park, is one of the most remarkable sonic experiences you'll find inside the city limits.

I am not sure if Borges wrote much about Minnesota, but I am aware of some lovely passages he included in his 1967 *Book of Imaginary Beings,* a collection of short descriptions of mythological creatures. Here he is, on one of the imaginary creatures one could encounter in the Upper Midwest, maybe in Minnehaha Park: "The wry mythology of the Wisconsin and Minnesota lumber camps includes remarkable creatures—creatures that no one, surely, has ever believed in. The Pinnacle Grouse had just one wing, so it could only fly in one direction, and it flew around one particular mountain day and night."

Borges adds one final detail about the pinnacle grouse that seems appropriate for the shifting, occasionally illusory allure of Minnehaha Falls—a place where everything from the origins of its name on down to the water pressure of the falls can be fictionalized, but still a place where we'll bring our visiting guests in the spring, because there's nowhere in the city more beautiful. "The color of its plumage would change," Borges writes, "depending on the season and the condition of the observer."

A Beacon for All Twin Citians

Despite NOT BEING MUCH OF A TWITTER USER, one of my favorite books of the past few years was Chicago writer Dan Sinker's annotated compilation of his @MayorEmanuel tweets from the winter of 2010–2011. It recounted the entire epic of Rahm Emanuel's campaign for mayor of Chicago, as told in real time over Twitter using a fake account, but also supplied some backstory and some context for the whole prank. Not just a political satire but also a character study, it featured a memorable supporting cast that was part Preston Sturges, part Narnia, and part Matt Groening's Springfield. Real-life characters like famously mustachioed Democratic strategist David Axelrod were in there, but so was a puppy named Hambone, an intern named Carl, and an Axelrodian duck with his own mustache named Quaxelrod.

The Twitter account and the book it spawned were great for many, many reasons. The greatest of them all is the fact that while it started as a one-note joke (the joke being Rahm Emanuel likes to say "fuck"), once it had captured its audience's attention, it slowly built over time into a sprawling, surreal love letter to the city of Chicago, full of inside jokes, local references, cameos from Chicagoans noted and obscure, and an abiding sense of place. The fact that most of it took place over the course of a miserable, wet Chicago winter—and that Sinker was able to incorporate actual weather conditions into the narrative in real time—made the setting all the more exciting. Sinker's identity wasn't revealed until it was all over, but even when the real author wasn't known, the whole thing was clearly written by a person who knew and loved Chicago.

The following is my favorite passage, where Rahm ascends to the top of a tower of "dib chairs"—chairs left in empty parking spots during winter storms in order to claim them in absentia, as per Chicago custom—and then into the clouds.

It's motherfucking beautiful up here, the sun making this tower of junk glow with the righteous power of millions of saved parking spaces. I've climbed up to another landing. Up here, the motherfucking heart of Studs Terkel is shining like a fucking beacon. A figure walks in front of the heart, its bright light still filtering through his translucent form. "Thumbs up, my friend." Siskel!

Gene Siskel's smile competes with the light of Studs' heart. His thumbs are fucking enormous. He's floating just slightly above the ground, but Siskel speaks with fucking gravity: "Studs' heart beats for all Chicagoans. Their shoulders are broad, but their hearts are fragile. You have to feel the pulse of the city," and he waves me towards the fucking heart. I'm hugging the glowing fucking heart of Studs Terkel, and it's wet and it's bright,

and I can feel all of you beat inside it. And now Siskel is trying to pull me away with his giant fucking thumbs, but I want to stay holding this glowing heart forever.

The fact that I had recently been rereading Studs Terkel's *Working* and *"The Good War"* about this time made it all the more touching. I grew up listening to Studs's interview show on public radio, played at the earliest hours of the morning. I knew even then, even before I associated him with Chicago, that this was a guy that had a deep love for humanity, a guy with a glowing heart I wanted to hold close to me. That may be less true of Gene Siskel, the chillier of Chicago's two most famous film critics, but I get the sense here that Sinker is using Siskel as a stand-in for his old colleague Roger Ebert, another native Chicagoan whose plainspokenness and warmth seemed as inextricably tied to the best qualities of his hometown as Terkel's did. Of course, when Ebert died in 2013, I thought immediately of this scene, and imaged Studs and Ebert together at the top of the pile of dub chairs.

Around this time, I'd also come across a lengthy *City Pages* cover story from 2002 written by Brad Zellar, then making its way again, ten years later, through local social media. It should be required reading for everyone who lives in the Twin Cities, and maybe anyone who lives in a second- or third-tier city and is thinking about how the literature of that place fits into a national context.

Specifically, this passage struck me:

It says something—it says a lot, actually—about the Twin Cities and their notoriously short-sighted institutional and cultural memory that there is so little sense here of a literary history. The average Twin Cities resident perhaps knows that F. Scott Fitzgerald was born in St. Paul. There is some recollection, diminishing every year, that the poet John Berryman jumped to his death from the Washington Avenue Bridge on the University of Minnesota campus. There's A Prairie Home Companion, *of course, and the wide recognition and acclaim accorded Garrison Keillor and his fictional creation Lake Wobegon. But what else is there? What else do you know? Could you, for instance, name a definitive Twin Cities novel, one book that has defined these cities to the world outside our borders? Not much comes to mind.*

This brings me back to Mayor Emanuel. Let's imagine a similarly surreal journey through the heart of Minneapolis—your protagonist scales one of the dozens of interchangeable parking garages along Washington Avenue. He or she comes across a motherfucking heart, shining like a fucking beacon for all Twin Citians.

Whose heart would it be? Who is *our* Studs Terkel?

Hmm. Like Brad said: no one comes to mind.

Maybe you argue it would be Prince, and that's a fair point. Minneapolis has always taken better care of its musical heritage than those of other disci-

plines. It's possible to walk through any part of Minneapolis and feel the weight and depth of the musical history around you. You could walk into almost any rock and roll bar in town and shout, "Hey, anyone know where the house is that they shot the cover of *Let It Be*? You know, the Replacements album?" People might be irritated that you're shouting tourist questions at them while they're trying to drink, but most Minneapolis rock fans will know to point you to Bryant Avenue and Twenty-Second Street near Uptown. Any glowing, beating heart specific to the Twin Cities would probably belong to a musician. Maybe Paul Westerberg. That makes sense too.

Bob Dylan is often mentioned too, though I'd say he barely counts. He only lived in Minneapolis for a brief time, and left pretty quickly for New York. He's come back a few times and is certainly an important part of local lore—any landlord trying to lease you an old apartment in the neighborhoods around the University of Minnesota will swear that young Bob Zimmerman was once a tenant—but the devotion of so many Twin Citians to Dylan as a locally specific icon has always struck me as counterproductive. Dylan, as we know him, was much more the product of the Greenwich Village folk scene in which he reinvented himself. Reinvention of oneself is the greatest American myth there is, but the myth in this case has more to do with New York City's supernatural ability to create an environment for this type of reinvention, and much less to do with some innate qualities in a midwestern upbringing.

Given the challenge to name great Twin Cities literary figures in this place, people often mention—besides Berryman or Keillor, whom Zellar names—someone like St. Paul's F. Scott Fitzgerald. Or maybe Charles Schulz, creator of *Peanuts*. All are good choices, in their own ways. Schulz's *Peanuts* strips seem to be set in a landscape very much like St. Paul, full of neighborhood baseball diamonds and snowy parks and backyards and small one-family houses—it's certainly not much like the Southern California landscape where he lived after moving away from Minnesota. At its core, it's uncharacteristically warm and affectionate.

Many Minnesota natives have often warned me about reading too much into the ambiguous relationships some of those other legendary figures had with their hometowns. On the very first page of *The Great Gatsby*, Fitzgerald—speaking through the character of Nick Carraway—takes a close look at St. Paul and can't decide whether it's the warm center of the universe or the ragged edges of civilization. I'd personally have some difficulty placing Fitzgerald the man around that wet, bright Terkel heart. Not that a proper literary icon can't have some ambivalence, but Fitzgerald's seemed to me to overwhelm him.

The impulse here and in rest of the Midwest is to lionize local cultural luminaries who have left for good to make their careers elsewhere. The worst example of this in Minneapolis is several "Walk of Fame" stars we have on

Hennepin Avenue, the main commercial thoroughfare running through down-town. One of these stars—the one that drives me the craziest—commemo-rates actor Vince Vaughan, who happens to have been born in Minneapolis and to have spent a tiny part of his childhood here before moving to Chicago, a city he typically claims as his hometown. Why anyone in a position of influence has taken the time to commemorate a lesser comedic actor whose ties to Minnesota are beyond tenuous and whose contributions to the cultural well-being of the city are almost zero, is an absolute mystery to me. I can think of a dozen local artists and personalities that deserve that spot more than Vince Vaughan. I'm going to rip that thing out of the sidewalk with a crowbar some-day when no one is looking

The fact is, we do have our own Studs Terkels. We have an abundance of them. We do have a literary tradition, in the way we have an artistic tradition, and a musical tradition, and a theatrical tradition. Many of these figures work-ing in this tradition are overlooked, or not well known beyond the region. But these are the people whose civic legacies we should be most careful to culti-vate. You may have found a few local heroes of your own. I look to Meridel Le Sueur, the twentieth-century activist, writer, actor, stuntwoman, union organizer, journalist, and historian, whose books *North Star Country* and *The Girl* are two of the best about this place ever written. Or Barbara Flanagan, the journalist and flaneur whose wanderings around the city have shaped its iden-tity over the past six decades in ways I think are still underappreciated. And it's not just the skyways she championed, though every time I'm unfortunate enough to have to walk through one of those damned Habitrail skyways in downtown Minneapolis, where corporate workers flee the streets six months a year to walk in the most boring, carpeted, temperature-controlled interiors imaginable, I have to smile anyway and think fondly of her. I can't deny that Flanagan is to the skyways as Wordsworth was to the crumbling abbeys of the English Midlands. Or Frances Cranmer Greenman, another polymath painter, writer, and woman-about-town, born on the prairies of South Dakota and spending most of her life shuttling between Minneapolis, New York City, Florida, and Hollywood, painting portraits of anyone who'd sit for her, famous and not-so-famous alike. *Higher than the Sky,* her 1954 memoir of her life and art, is the one loopiest, messiest kisses on the cheek of the city out there. Over the course of its three hundred pages, she is able to appear folksy without seeming corny, and sophisticated without seeming pretentious, at home with WPA workers and film stars, with heiresses and streetcar conductors.

This is just my own pantheon. You could easily put dozens of names in your own, some widely known, some nearly forgotten. You could list dozens and dozens of writers and literary figures who have lived in the city, led their

lives here, loved it here, felt ambivalence about it here, left it and then returned again, and written books, poems, blogs, songs, newspaper columns, zines, and letters about the sidewalks and street corners and buildings and, yes, even the damned Habitrail skyways downtown.

My point here is this: if you're a writer in the Twin Cities, you're a part of this tradition. Assemble those heroes in your library and dig deeper. This is your time. Write about Minneapolis. Write about St. Paul. Write about Loring Park and Highland Park and Windom Park and Uptown and Lowertown and Frogtown and Near North and the Southside and the West Side and the North End. Write about the neighborhoods where you grew up, or live, or work, or visit. Write about what these places mean to you. Write in your own voice about them. Don't fall back on stock rural clichés. Celebrate the histories and heritages you find, but be disrespectful—be contemptuous, even!—of the received wisdom that this is a nice, quiet, modest little prairie town full of milquetoast Scandinavians and quirky DSM-IV disorders. This is a sprawling, multifaceted pair of quietly bustling, weird American cities with millions of stories between the two of them.

Start telling those stories.

Credits

Photo of Jorge Luis Borges at Minnehaha Falls by Stuart Klipper (pg. 231) used by permission of the photographer. Copyright © 1983 by Stuart Klipper.

Photo from *Deep North* by Chris Larson (pg. 32) used by permission of the photographer. Copyright © 2008 by Chris Larson.

Photos from *On Thin Ice, In a Blizzard* by Paula McCartney (pps. 37–38) used by permission of the photographer. Copyright © 2012 by Paula McCartney.

Photos from *God Bless the USPS* by Mary Rothlisberger (pps. 188–189) used by permission of the photographer. Copyright © 2012 by Mary Rothlisberger.

Photos of various Twin Cities landmarks by Carrie Thompson (pps. 28, 42–43, 68–69, 81, 85, 116, 158–159, 161, 163, 170–172, 176–178, 181, 197, 206–207, 220, 226) used by permission of the photographer. Copyright © 2013 by Carrie Thompson.

All other illustrations by the author.

COFFEE HOUSE PRESS

The mission of Coffee House Press is to publish exciting, vital, and enduring authors of our time; to delight and inspire readers; to contribute to the cultural life of our community; and to enrich our literary heritage. By building on the best traditions of publishing and the book arts, we produce books that celebrate imagination, innovation in the craft of writing, and the many authentic voices of the American experience.

Funder Acknowledgments

COFFEE HOUSE PRESS is an independent, nonprofit literary publisher. Our books are made possible through the generous support of grants and gifts from many foundations, corporate giving programs, state and federal support, and through donations from individuals who believe in the transformational power of literature. Coffee House Press receives major operating support from Amazon, the Bush Foundation, the McKnight Foundation, from the National Endowment for the Arts—a federal agency, from Target, and in part from a grant provided by the Minnesota State Arts Board through an appropriation by the Minnesota State Legislature from the State's general fund and its arts and cultural heritage fund with money from the vote of the people of Minnesota on November 4, 2008, and a grant from the Wells Fargo Foundation of Minnesota. Support for this title was received through special project support from the Jerome Foundation and the Carolyn Foundation. Coffee House also receives support from: several anonymous donors; Suzanne Allen; Elmer L. and Eleanor J. Andersen Foundation; Around Town Agency; Patricia Beithon; Bill Berkson; the E. Thomas Binger and Rebecca Rand Fund of the Minneapolis Foundation; the Patrick and Aimee Butler Family Foundation; the Buuck Family Foundation, Ruth Dayton; Dorsey & Whitney, LLP; Mary Ebert and Paul Stembler; Chris Fischbach and Katie Dublinski; Fredrikson & Byron, P.A.; Sally French; Anselm Hollo and Jane Dalrymple-Hollo; Jeffrey Hom; Carl and Heidi Horsch; Kenneth Kahn; Alex and Ada Katz; Stephen and Isabel Keating; the Kenneth Koch Literary Estate; Kathy and Dean Koutsky; the Lenfestey Family Foundation; Carol and Aaron Mack; Mary McDermid; Sjur Midness and Briar Andresen; the Nash Foundation; the Rehael Fund of the Minneapolis Foundation; Schwegman, Lundberg & Woessner, P.A.; Kiki Smith; Jeffrey Sugerman and Sarah Schultz; Patricia Tilton; the Archie D. & Bertha H. Walker Foundation; Stu Wilson and Mel Barker; the Woessner Freeman Family Foundation; Margaret and Angus Wurtele; and many other generous individual donors.

To you and our many readers across the country,
we send our thanks for your continuing support.

ANDY STURDEVANT IS AN ARTIST, WRITER, AND ARTS ADMINISTRATOR LIVING IN South Minneapolis. His essays have also appeared in publications of the Walker Art Center, and he writes a weekly column on arts and visual culture in Minneapolis-St. Paul for *MinnPost*. His work has been exhibited at the Minneapolis Institute of Art and the Soap Factory. Andy was born in Ohio, raised in Kentucky and has lived in Minneapolis since 2005.